David Hockney

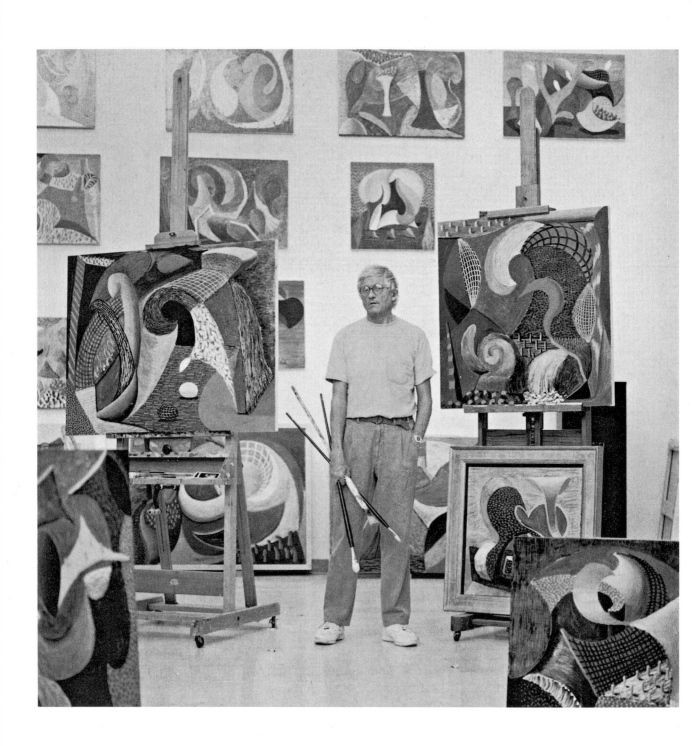

DAVID HOCKNEY

Paul Melia
Ulrich Luckhardt

PRESTEL

MUNICH · BERLIN · LONDON · NEW YORK

Front cover: *Portrait of an Artist* (Pool with Two Figures)*, 1972* (detail of plate 33)
Back cover: *Savings and Loan Building, 1967* (detail of plate 25)
Frontispiece: *Hockney in his Los Angeles studio surrounded by 'Some Very New Paintings', 1992* (see plate 62)

Library of Congress Control Number: 2006940594

British Library Cataloguing-in-Publication Data: a catalogue record for this book is available from the British Library
Deutsche Bibliothek holds a record of this publication in the Deutsche Nationalbibliografie; detailed bibliographical data can be found under: http://dnb.ddb.de

© Prestel Verlag
Munich · Berlin · London · New York 2007
(First published in hardback in 1994)

© David Hockney Studio, Los Angeles, 2007

© of works illustrated by Jasper Johns and Kenneth Noland by VG Bild-Kunst, Bonn, 2007

© of works illustrated by Pablo Picasso by Succession Picasso/VG Bild-Kunst, Bonn, 2007

© of plates 49–52 by Vogue (Paris), 2007
Photographic Acknowledgments: see p. 200

Prestel Verlag
Königinstrasse 9
80539 Munich
Tel. (089) 38 17 09-0
fax (089) 38 17 09-35

Prestel Publishing Ltd.
4 Bloomsbury Place
London WC1A 2QA
Tel. (020) 7323-5004
fax (020) 7636-8004

Prestel Publishing
900 Broadway, Suite 603
New York, NY 10003
Tel. (212) 995-2720
fax (212) 995-2733

www.prestel.com

Chapters One and Six translated from the German by Elizabeth Clegg, London

Production: Sebastian Runow
Cover design: René Güttler
Origination: Reproline Mediateam, Munich
Printing and binding: MKT Print d.d, Ljubljana, Slovenia

Printed on acid-free paper

ISBN 978-3-7913-3718-0

Foreword

One problem is, I'm a popular painter – probably for the wrong reasons. My work is misinterpreted a great deal; but there's nothing I can do about that. I don't think I should worry about it too much.

David Hockney in conversation with Peter Fuller, 1977

Something of a David Hockney industry has existed over the last twenty-five years. This period has seen the publication of two volumes of his auto-biography, an unauthorized biography and numerous picture books, the production of a film and various television programmes on the artist and, of course, countless reproductions of his work on book jackets, posters, T-shirts, shopping bags, serviettes, and so on. Yet, despite this popularity and, one assumes, the abiding power of Hockney's work to move people, there is a dearth of substantial studies devoted to him – a monograph and a collection of essays are all that is readily available. Although the artist's *œuvre* to date is not in danger of falling into oblivion, as is that of many of his contemporaries, its significance may well be.

Many have concluded that that *œuvre* is lightweight: 'real' art is inim-ical to commerce, they argue, and Hockney has not attracted the attention of academics to the same extent as some other contemporary artists. That Hockney does not conform to conventional ideas concerning both the nature of the artist and the manner in which art should be practised – in the popular imagination, he is a colourful 'personality', a pop star of paint-ing, a hedonist languishing by a Californian swimming pool – has served only to confirm this judgment. A respected critic, intending to disparage, has described him as the Cole Porter of modern art.

Hockney's early admirers thought that the 1970 retrospective of his work would vindicate their assessment of its worth – 'at last the real David Hockney steps forward', began a typical review of that exhibition. That it was necessary for sympathetic critics to repeat such claims eight-een years later, on the occasion of the artist's second retrospective, may suggest that they believed the popular image of him had succeeded in deflecting attention away from his work: 'Pop goes the myth....David Hockney is revealed at last as a brave, serious master of his art.' If the re-views of the 1988 exhibition are to be believed, an intensely serious Hock-ney had 'at last' been found behind the popular image of him. This may, however, represent a spurious victory for his admirers: the significance of his *œuvre* is still in danger of being obscured by the belief that an artist's life causes, and explains, his or her art.

To discuss Hockney's work without giving priority to the conditions of its production is to misrepresent, if not to ignore, the labour that went into its making. Accounts that emphasize the artist's inner life, the emo-tional well-springs of his art, ultimately have recourse to such nebulous no-tions as 'creativity' and 'genius'. These do not so much explain as mystify his work, often leaving the reader in awe but unenlightened. Although Hockney's life and his presumed intentions may be highly relevant to an understanding of his practice, they cannot stand in for interpretation. His

conception of painting, like that of many twentieth-century artists, recognizes that the demands of art can be only trivially satisfied by depicting incidents in his own life. The significance of his *œuvre* is not to be found in his biography, but in the way that individual works relate to the cultural and social conditions, and to the definitions of gender, that characterized the environment in which they were produced.

Despite the limitations inherent in the monograph format, we believe that the present volume performs many useful tasks: it offers new documentary research, it dispels certain myths and it opens up new lines of enquiry for the reader to pursue. Throughout, we have sought to suggest ways in which Hockney's paintings can be thought about in terms of the conditions just mentioned, for it is in relation to those conditions that they acquire their true meaning. The book is not intended for academics, although the authors and publishers hope that students of modern painting will find it helpful. We believe that a guide to the artist's work is required which does not assume the reader to be well versed in the theories or the history of art, since Hockney's imagery is almost alone among that of contemporary artists in arousing the interest of the proverbial man in the street. (When the artist's 1988 retrospective was shown at the Tate Gallery in London it attracted over 170,000 visitors.) It is our hope that this monograph will persuade readers to study Hockney's work, and also that of the other contemporary artists we mention, in further detail.

This book is concerned primarily with Hockney's paintings. An extensive consideration of his drawings, prints, photo-collages and theatre designs would require a far more ambitious undertaking. We deal with paintings that are not well known and others that will be familiar — some, perhaps, almost too familiar. Included are works being reproduced for the first time and other important paintings — for example, *Domestic Scene, Notting Hill* and *California* (plates 12, 23) — that have rarely been exhibited or reproduced in colour. We have divided them between six chapters. Broadly chronological in arrangement, these address moments or themes in Hockney's practice that seem to us to be of particular interest. The plate commentaries complement the necessarily general remarks in the essay introducing each chapter by providing a focus on individual works. Occasionally, the commentaries attempt to enter into the process of the artist's decision-making and to grasp the 'logic' of a work's production. As for earlier critics and historians, it has proved impossible for us to write about Hockney's paintings without recourse to his published writings. This is not because we subscribe to the belief that an artist's work can be understood only by reference to his or her presumed intentions; rather, it is because Hockney's own interpretations are so persuasive. On the other hand, those familiar with the artist's highly amusing anecdotes about the genesis of his work may regret that we do not reproduce or discuss them at length. Yet these stories detract one's attention from other issues — the subject-matter of the paintings, for instance. Perhaps that is what Hockney intended them to do.

Hockney first came to public prominence in the early sixties, as a post-graduate student of painting at the Royal College of Art in London. His work, like that of his fellow students Derek Boshier, Pauline Boty, Allen Jones, R. B. Kitaj and Peter Phillips, demonstrates a wish to uphold the human figure as a fit subject of painting, as well as an interest in imagery drawn from the urban environment. Despite his shouting 'I am not a Pop artist' during a private view party in 1962, Hockney's student work is conventionally seen as contributing to the development of Pop Art in Britain, a topic discussed in Chapter One. The paintings examined in Chapters Two and Three were produced between 1962 and 1967, when the artist was regarded as a leading figure in 'Swinging London' – even though he spent much of his time living and working in Southern California. They include some of his best-known works, ones that question, parody and undermine influential ideas about modern art.

Until the late sixties, Hockney was also preoccupied with representing the male nude as an erotic object, rather than in the traditional manner, as a symbol of strength or power (see plates 17, 23). Of particular interest to gays – especially before 1967, when sexual acts between men were a criminal offence in Britain – these images have helped many to forge a personal identity organized around their difference from norms. It is important that such works are not marginalized by those who wish to establish Hockney as a 'serious' artist. Julian Spalding observed that the exclusion of so many of the artist's homo-erotic works from the 1988 retrospective seriously devalued that undertaking: 'Hockney's homosexuality cannot be easily disguised, but this exhibition does its best, believe it or not, to present Hockney as a family man'.

Chapters Four and Five are concerned with Hockney's practice during the seventies and early eighties, a period when he experienced great artistic difficulties. He abandoned painting for a time in the mid-seventies to concentrate on drawing and print-making. Neither were many paintings produced during the early eighties, the artist preferring to spend his time constructing collages from photographs. As Chapter Five argues, these photo-collages should not be regarded as the divertissements that some have seen them as. Hockney himself has wondered whether they might not be remembered by future generations as his most substantial contribution to the development of art after the demise of Modernism.

The mixing together of different styles of representation is a characteristic of Hockney's practice and is frequently linked to his interest in depicting incongruous relationships between people or between people and objects (see plates 11, 19). In many works, no one style claims priority over another, and these images will probably attract the attention of future historians of post-modernism. On the evidence of some works discussed in Chapter Five (plate 50, for instance), it would appear that, during the mid-eighties, Hockney believed that his most important contribution to visual culture was yet to be made. His recent paintings (for example, plate 62), unlike the works of the mid-eighties, are not marked by a collage of styles. In producing them, the artist has evidently taken great care

to leave each brushstroke visible, as though the painted surface were to represent not so much a scene as the work of the brush – and, by extension, the activity of the artist's own body – in space and time. To find comparable procedures, we must look outside European painting – perhaps, as Hockney did, to traditional Chinese art. In *Vision and Painting*, a book of great subtlety and force of analysis, Norman Bryson notes: 'The work of production [in ancient Chinese art] is constantly displayed in the wake of its traces; in this tradition the body of labour is on constant display, just as it is judged in terms which, in the West, would apply only to a *performing* art.... How are we to *think* that other space of duration, that other body of labour?' The same question is posed by Hockney's recent paintings, discussed in the final chapter, which he has described as 'narrative abstractions'.

We must resist the temptation to think of Hockney's works as inert cultural monuments, as though their meanings have been, or could be, fixed once and for all. A characteristic of a successful painting is that successive explanations will always leave something unaccounted for. If Hockney's works illuminate values that continue to be of relevance to subsequent generations, they will, of course, 'survive'. If they do not, then their ultimate significance will be as indices of a complex phase of cultural development in the West – not as indices of a personality.

The authors would like to thank Paul Dewhirst, who helped them enormously by commenting on and correcting drafts of some chapters, and the staff at Prestel for their advice, support and efficiency at every stage of the project. The authors and publishers are most grateful both to David Hockney, without whose co-operation this book would not have been published, and to Karen S. Kuhlman and Cavan Butler, who supervised the authors' access to the artist's personal archives and provided material for many of the illustrations. We are further indebted to Peter Goulds of the L. A. Louver Gallery, Venice, California, for his advice and to those collectors and institutions who provided photographs.

Paul Melia
Ulrich Luckhardt

1955-1962

Demonstrations of Versatility

'I paint what I like, when I like, and where I like, with occasional nostalgic journeys. When asked to write on "the strange possibilities of inspiration" it did occur to me that my own sources of inspiration were wide, but acceptable. In fact, I am sure my own sources are classic, or even epic themes. Landscapes of foreign lands, beautiful people, love, propaganda, and major incidents (of my own life). These seem to me to be reasonably traditional.'

David Hockney was 25, and had just completed his course at the Royal College of Art in London, when he published this statement in the catalogue of the exhibition 'Four Young Artists', held at the Grabowski Gallery in the summer of 1962. It was not the first time his pictures had been shown in public. He had already made quite a name for himself as an artist in London, and collectors were starting to take a firm interest in his work. With such artist friends as Derek Boshier, Allen Jones, R. B. Kitaj, Peter Phillips and Patrick Procktor, and the slightly older Peter Blake, Hockney stood at the centre of the radical, new art world of the incipient 'Swinging London' of the early sixties. The group was marked by an uninhibited, self-confident and provocative zest for life, and the work of its members often disregarded the conventional separation of art and everyday experience.

Hockney signalled his own challenge to convention by wearing a gold lamé jacket to the diploma ceremony held at the Royal College at the end of the academic year 1961/2. This gesture was, however, no more than a logical conclusion to the transformations that his work had undergone during the three years of his course in London, from 1959 to 1962. In addition to its significance for Hockney's artistic development, this period was one in which the true strength and individuality of his character emerged, a process that can be traced within the images he devised.

Before studying at the Royal College, Hockney had attended Bradford School of Art, from 1953 to 1957. His paintings, and in particular

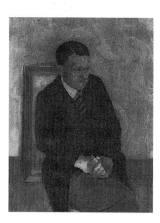

Fig. 1 *Portrait of My Father*, 1955. Oil on canvas, 50.8 x 40.6 cm (20 x 16 in.). Collection of the artist

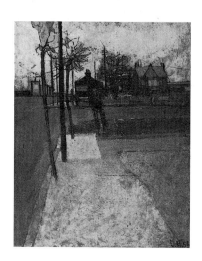

Fig. 2 *Bolton Junction, Eccleshill*, 1956. Oil on board, 122 x 101.5 cm (48 x 40 in.). Bradford Art Galleries and Museums

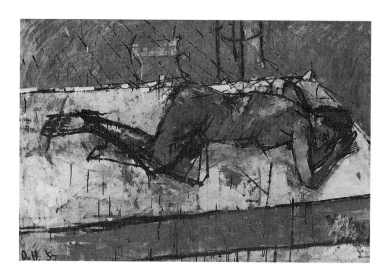

Fig. 3 *Nude*, 1957. Oil on canvas, 122 x 183 cm (48 x 72 in.). Bradford Art Galleries and Museums

his drawings, from this period constitute a distinct group within his *œuvre*, their traditionally academic character testifying to the thoroughness of Hockney's training. Nevertheless, in spite of their evident reliance on certain models, many of the artist's paintings from this time display an astonishing independence, even though never going beyond the bounds of academicism. *Portrait of My Father* of 1955 (fig. 1), for example, is wholly traditional in its subtle, painterly use of blue and grey tones to model form. What is surprising is how Hockney renders the portrait the more expressive through the calculated and economical use of line, above all in the face and hands. The draughtsman's contribution is also crucial to the composition of the subsequent pictures – views of Bradford and its environs. Hockney would record a view on the spot in a number of sketches, which he would later work up into a painting. In many of these images, all very subdued in colouring and almost gloomy in mood, he would include isolated figures (see fig. 2). These function as little more than indicators of relative proportion within the perspectively composed scenes. Individually, they convey hardly any impression of corporeality; rather, they are subsumed within the graphic painterliness of the planar composition as a whole.

At this time, Hockney paid almost no attention to the individual human figure, apart from in portraits, even though drawing from the nude model was part of his college training. *Nude* of 1957 (fig. 3), showing a model reclining on her side on a mattress, must be regarded as an exception in this respect. Here, too, the emphasis on line, derived from drawing, determines the character of the image.

Abstract forms, which in these years had become fashionable in painting, did not feature in the artist's training in Bradford, a city far removed from the main British centres of art. It was only after Hockney had finished his course at Bradford, and begun his two years of National Service (working in hospitals in lieu of serving in the armed forces), that he saw the work of Alan Davie and Roger Hilton, the leading abstract artists in Britain at this time. It was late 1958 before Hockney encountered paintings by Jackson Pollock, in London.

In the two-year interval between Bradford and the Royal College, Hockney painted very little; on the whole, his work from this time may be described as experimental, for he was attempting to come to terms with the new abstraction. The flat, abstract composition of *Painting 58* (fig. 4), the paint apparently applied with a palette knife, recalls the style of the Ecole de Paris of those days, above all the work of Nicolas de Staël and Pierre Soulages.

By September 1959, and the start of Hockney's course at the Royal College, the preconditions had thus been established for the subsequent, and crucial, stage in his development as an artist. The painter R. B. Kitaj reports that he met Hockney during their first days at the Royal College, when Hockney was engaged in drawing a human skeleton. At least five such works have survived, evidence that Hockney concentrated on drawing from nature in spite of the strong influence of the abstract painting then

Fig. 4 *Painting 58*, 1958. Oil on canvas, 92 x 71 cm (36 $^1/_4$ x 28 in.). Private collection

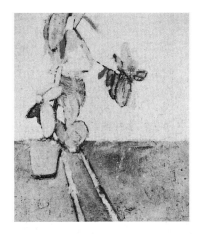

Fig. 5 *Rubber Plant and Skeleton*, *c.* 1959. Oil on board, 128 x 114.5 cm (50 $^1/_2$ x 45 in.). Private collection

fashionable. In fact, he only dabbled in abstraction during his first months at the Royal College: Kitaj has spoken of Hockney's 'two-week abstract period'. It is possible that it was in connection with these first London drawings that Hockney produced the painting *Rubber Plant and Skeleton* (fig. 5), which retains the planarity and the emphatic use of line of his Bradford years. The plant motif is still clear in this picture, but it was soon to be transformed, in the next paintings (produced under the influence of Alan Davie), into a series of abstract abbreviations eluding specific identification. The title of *November* (fig. 6) appears to be nothing more than a reference to the month in which this work was painted, and *Erection* (fig. 7) alludes only to the apparent movement of an anonymous and indeterminate form at the centre of the composition. These pictures are linked formally by the vertically striving, elongated form that is common to both. A little later, this was to take on unambiguously phallic associations through the addition of the word 'Love', or simply the letter 'L', inscribed within the picture.

With the introduction of words and concepts into his paintings, Hockney overcame abstraction. Even if some of his subsequent compositions still appear at first glance to be non-representational, their inclusion of words invests them with specific implications: *Queer* (plate 1) and, slightly later, *Queen* (fig. 8), for instance. These works play with the scope for ambiguity in such terms as then used. In two further abstract compositions from this period, *My Carol for Comrades and Lovers* and *Going to be a Queen for Tonight*, the titles have a direct, personal relation to the artist. In none of these works, however, was Hockney able to develop fully the themes at which he hinted. He first succeeded in doing so during the course of 1960, with his series of 'Love Paintings'. In the third of these (plate 2), homosexual desire becomes the image's real subject, rather than something merely intimated by a title or an inscription. Nevertheless, Hockney still had to make his meaning clear through the words and phrases introduced into the abstract composition. He had not yet found a figurative means of presenting the subject of homosexuality.

In a series of three paintings that appear to have been produced after Hockney finished work on *The Third Love Painting*, and before he started on *Doll Boy*, the human figure suddenly takes on significance. Each of the pictures – *Bertha alias Bernie*, *For the Dear Love of Comrades* and *Adhesiveness* – is a composition with two figures. In the first painting, the man is also presented as a woman ('Bertha'); in the second, they are both 'comrades' (a term Hockney adopted from Walt Whitman's work); and in the third, with its far less ambiguous poses, they are a couple engaged in love-making. *Adhesiveness* (fig. 9) is not only the most radical picture of this group from the point of view of its explicitness; it is also the first work in which Hockney himself appears, thereby declaring his own homosexuality. He does so by invoking the coded presentation of letters as numerals used by Whitman, with numerical order corresponding to alphabetical order. It is thus clear that the figure on the left, marked '4.8.' – that is, 'D.H.' – is intended to be the artist himself, here shown interlocked with the figure

Fig. 6 *November, c.* 1958/9. Oil on board, 122 x 94.5 cm (48 x 37 in.). Private collection

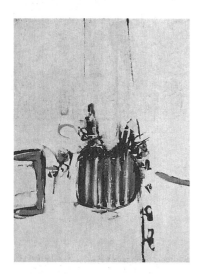

Fig. 7 *Erection, c.* 1959/60. Oil on board, 122 x 91.5 cm (48 x 36 in.). Private collection

of his literary model (23.23 = W. W = Walt Whitman). The following year, Whitman and Mahatma Gandhi were to be depicted alongside Hockney in the etching *Myself and My Heroes* (fig. 10).

The provocation contained in *Adhesiveness* – the abstracted but none the less clearly discernible representation of the sexual act – does not itself rely on the explanation provided in the numerical code. The message it conveys to the viewer is of general import. Thus, for the first time in Hockney's work, homosexuality has become an autonomous subject.

During the next few months, Hockney further developed this theme, producing the large compositions *Doll Boy, The Most Beautiful Boy in the World* and *We Two Boys Together Clinging* (plates 3-5). In these, the relief and excitement of his newly found freedom from social oppression and homosexual anonymity issued in public declarations of love. Thus, by means of his new self-confidence, Hockney attained artistic independence; and this, in turn, was inevitably to arouse wider interest in his work.

At the annual Young Contemporaries exhibition for 1960, held in February, Hockney showed abstract paintings: *Accumulation, Painting – January* and perhaps also *Growing Discontent*. In the following year's show, he exhibited works that were quite different: the recently completed *Doll Boy, The Third Love Painting* and the first two 'Tea Paintings'. In the latter (figs. 24, 25), as in other compositions from the same period, Hockney evolved for himself a new type of picture, consciously opposed to the subjective, narrative structure of *The Third Love Painting* and *Doll Boy*. With the representation of a packet of Typhoo tea, and of an Alka-Seltzer advertisement in *The Most Beautiful Boy in the World*, and with clearly legible inscriptions and additions in other pictures, Hockney introduces an apparently impersonal, ready-made element. On the other hand, however familiar these objects, they hardly offer the spectator concrete clues towards understanding the images. Essentially, such additions are the artist's playful approximations to the devices favoured by Pop Art, here combined with his own pictorial vocabulary. This approach also underlies the composition of the playing card series (see plate 7), produced during the same period as the 'Love Paintings' and the first two 'Tea Paintings'.

While the four works that Hockney showed in the Young Contemporaries exhibition of 1961 constituted a homogeneous group, testifying to his artistic development over the previous year, he planned his participation in the 1962 show in a far more programmatic manner. Again represented with four pictures, he was concerned above all to display as many different aspects of his painting as possible. To this end – and also, of course, to attract greater attention – he prefixed each of the picture titles with the phrase 'Demonstration of Versatility'. This, he hoped, would prompt the viewer to a more sophisticated investigation of the paintings, and of their interconnection.

The works that Hockney showed on this occasion were *Tea Painting in an Illusionistic Style, Figure in a Flat Style, A Grand Procession of Dignitaries in the Semi-Egyptian Style* (all painted in 1961) and a composition finished only shortly before the exhibition, *Swiss Landscape in a Scenic Style*, based

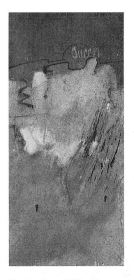

Fig. 8 *Queen*, 1960. Oil on canvas, 61 x 30.5 cm (24 x 12 in.). Private collection

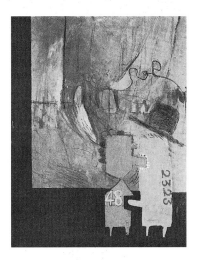

Fig. 9 *Adhesiveness*, 1960. Oil on board, 127 x 102 cm (50 x 40 in.). Private collection

Fig. 10 *Myself and My Heroes*, 1961. Etching and aquatint, 26 x 50.1 cm (10$^{1}/_{8}$ x 19$^{3}/_{4}$ in.). Edition of approx. 50

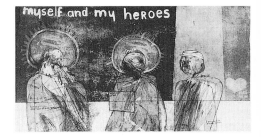

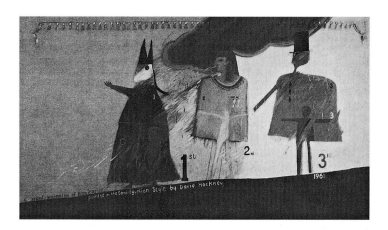

Fig. 11 *A Grand Procession of Dignitaries in the Semi-Egyptian Style*, 1961. Oil on canvas, 214 x 367 cm (84 x 144 in.). Edwin Janss, Thousand Oaks, California

Fig. 12 *Figure in a Flat Style*, 1961. Oil on two canvases, 91.5 x 61 cm (36 x 24 in.). Private collection

Fig. 13 *The Diploma*, 1962. Etching and aquatint, 40.2 x 28 cm (15 ³/₄ x 11 in.). Edition of approx. 40

on the artist's trip to Italy around New Year 1962. As the titles themselves specify, each of these paintings takes on another meaning in the context of Hockney's deliberate emphasis on his own artistic versatility. As he explained later, in his autobiography: 'Each painting was supposedly in a different style. I had become interested in style then. I realized you could play with style in a painting to make a "collage" without using different materials; you could paint something one way in this corner and another way in another corner, and the picture didn't need unity of style to have unity.'

A Grand Procession of Dignitaries in the Semi-Egyptian Style (fig. 11), the artist's largest work so far, draws on the rigid composition of the friezes of Ancient Egyptian tomb painting in its presentation of a clergyman, a soldier and an industrialist. Hockney's initial inspiration came from the poem 'Waiting for the Barbarians' by the Greek poet Constantine Cavafy, who had lived in Alexandria at the beginning of the century, and whose work Hockney was to illustrate with etchings in 1966. With the stiff alignment of these personages as sequentially numbered figurines, the hint of a smaller figure within each of the three costumes and of a curtain above them (there is, at least, a decorative border with tassles), Hockney produced his first 'theatrical' composition. His 'curtain paintings' of 1963 (see plates 13, 14) were to be a further development of this genre.

The composition of *Figure in a Flat Style* (fig. 12), meanwhile, is related to that of the 'Love Paintings' and the figurative works produced earlier in 1961. The seemingly hurried application of paint, the dominant heart shape and the phrase 'the fires of furious desire' (a play on the title of William Blake's poem 'The Flames of Furious Desire') reveal the close connection between this composition and the earlier paintings. Here, however, Hockney employs the abstraction offered by a 'collage' of distinct objects – two rectangular canvases, representing the head and the torso, and two sections of a stretcher set at an angle to suggest the legs – so as to convey the idea of flatness established by the picture's title. Hockney again combines several canvases in *Tea Painting in an Illusionistic Style*

(plate 8), though in this case they are not all rectangular. In contrast to *Figure in a Flat Style*, they are arranged so as to present the illusion of three-dimensionality. The fourth exhibited work, *Swiss Landscape in a Scenic Style* (fig. 26), is an early version of *Flight into Italy – Swiss Landscape* (plate 9), the title of which makes it clear that the motif of both pictures is a temporal sequence – a car journey through the Alps.

In these canvases, Hockney was able to focus attention on various problems of form, composition and painting technique. The paintings embody a series of contrasts that arise from the opposition of a static rendering of setting to the representation of movement, and of planarity to the illusion of depth. These works of 1961/2 effectively mark the end of Hockney's period of training at the Royal College: even before the receipt of his diploma in the summer of the following year, the obvious versatility of his work reveals that he had no more to learn in the context of formal training. Initially, the Royal College was, in fact, reluctant to grant Hockney his diploma, on account of his perceived failure to provide evidence of work from the live model, as prescribed, or of sufficient art historical study. It is characteristic of the artist's self-confidence that he responded to this situation with wit and irony, producing his own diploma in the form of a coloured etching (fig. 13). He delivered the required painting from life in the shape of *Life Painting for a Diploma* (fig. 14), in which a muscular male nude, copied from the cover of the homo-erotic magazine *Physique Pictorial*, was contrasted with a carefully executed drawing of a skeleton from his first days at the Royal College. It was only after completing this picture, and thus after a gap of five years, that Hockney again produced a figure painting executed directly after the model: *Life Painting for Myself* (fig. 15). He did not, however, use one of the models supplied by the college, having never developed any interest in these, but rather his friend Mo McDermott, who is to be found in a similar pose in *Domestic Scene, Notting Hill* (plate 12), painted the following year.

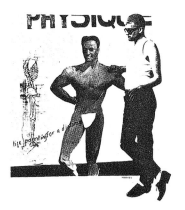

Fig. 14 The artist with *Life Painting for a Diploma*, 1962. Oil and paper on canvas, 122 x 91.5 cm (48 x 36 in.). Whereabouts unknown

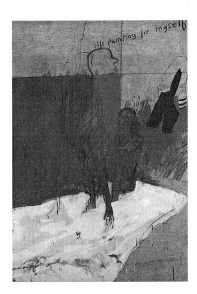

Fig. 15 *Life Painting for Myself*, 1962. Oil on canvas, 122 x 91.5 cm (48 x 36 in.). Ferens Art Gallery, Hull

1 *Queer* 1960

Oil and sand on canvas, 25 x 17.7 cm
($9^3/_4$ x 7 in.)
Private collection, Hamburg

Hockney painted this small picture, which marks a decisive turning-point in his early career, at the end of his first year at the Royal College of Art. Previous works of this phase had been influenced by Abstract Expressionism. In these, the artist had employed a non-representational language of signs and forms which, although they bore marked anthropomorphic or botanical connotations, were not explicitly developed as such. Hockney went against the contemporary trend of titling such works simply 'compositions', and gave his paintings seemingly descriptive titles: *Growing Discontent*, *Gamadhi* or *Sadhyas* (fig. 16), for example. These do not, however, clarify the form or the content of the respective works.

Abstract morphological forms also dominate in *Queer*. By inscribing the title at the centre of the painting (even though this is in delicate pink and only barely detectable), Hockney for the first time dealt with homosexuality in his work, initiating a series of compositions that culminated the following year in *Doll Boy* and *We Two Boys Together Clinging* (plates 3, 5).

Some features of *Queer*, such as the slanting division of the composition and the vague hint of a figure in the lower section, anticipate *Doll Boy*. Yet the spare pictorial means – the cryptic markings on an almost monochrome ground – show the painting still to be rooted in Hockney's abstract works.

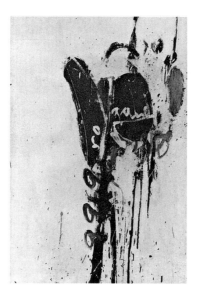

Fig. 16 *Sadhyas*, 1960. Oil on board,
92 x 61 cm ($36^1/_4$ x 24 in.). Galerie
Brockstedt, Hamburg

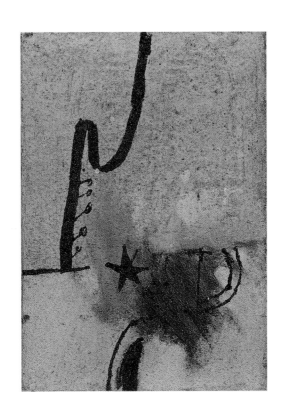

2 *The Third Love Painting* 1960
Oil on board, 119 x 119 cm
(46³/₄ x 46³/₄ in.)
Trustees of the Tate Gallery, London

As an ironic comment on the fashion for titling paintings by number, as Jackson Pollock had done, Hockney numbered his 'Love Paintings' from one to four. The first three were painted in 1960, and they constitute a further development of the abstract works of that and the previous year. *The Fourth Love Painting*, a figure painting that includes Letraset letters, dates from 1961.

The composition of *The Third Love Painting* is based on that of the two previous ones, which had also been dominated by a phallic form rising from the lower edge. In both these works, the prominently displayed word 'Love', and the associations prompted by the phallic form, were the only allusions to the subject indicated in the title. *The Third Love Painting* is far more complex in form and meaning.

The red phallic form, now moved towards the centre of the picture, is much more prominent. Like a palimpsest, the picture plane is strewn with graffiti – obscene drawings and words or phrases, most of

which Hockney had seen in the public lavatory at Earls Court Underground Station. (They inspired him to produce, at this time, a series of 'Fuck' drawings, in which graffiti are developed into independent compositions; see fig. 17.) Phrases such as 'My brother is only 17', 'Ring me anytime at home' and 'Britain's future is in your hands' are typical of what might be found on the walls of a public lavatory – Hockney has, indeed, sketched in one in white at the extreme right of the painting. The large '6' and small '9' in this area refer to a position during sexual intercourse. Apparently as his own contribution to these lavatory messages, the artist has added 'come on David admit it'.

Hockney counters this crudely explicit eroticism with a literary quotation, written, significantly, on the surface of the phallic form: the closing lines of Walt Whitman's poem 'When I Heard at the Close of Day', which tell of the happiness felt when lying at night under the same cover as the beloved.

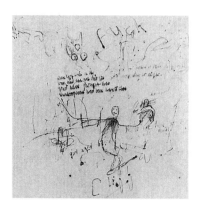

Fig. 17 *Fuck (Cliff)*, 1960; detail. Ink on paper, 40.5 x 51 cm (16 x 20 in.). Collection of the artist

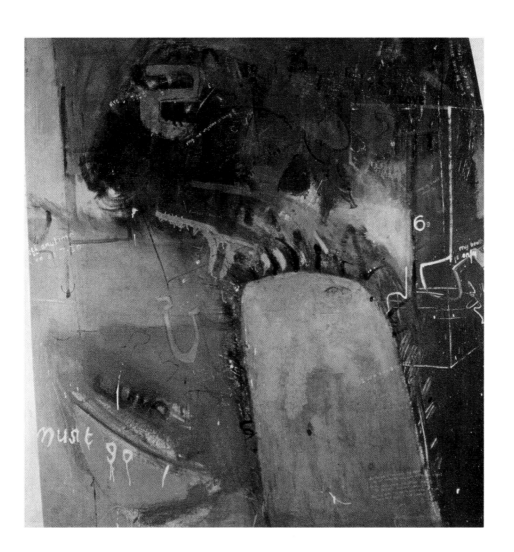

3 *Doll Boy* 1960-1
 Oil on canvas, 122 x 99 cm (48 x 39 in.)
 Hamburger Kunsthalle, Hamburg

Hockney started work on *Doll Boy* in the autumn of 1960. In preparation for the painting, he made at least one drawing and two small oil studies. The composition changed, none the less, from one study to the next and during the execution of the final version. The chalk drawing (fig. 19) comes closest to the finished painting, containing all its principal elements, except for the grey rectangle in the lower right corner. This is also missing from the oil sketches. The bowed head of the 'doll boy', on the other hand, was present from the start: in the drawing and in *Study for 'Doll Boy'*, a large, solid area presses down threateningly on the head, while in *Study for 'Doll Boy' (No. 2)* (fig. 18), a huge heart pushes the head to one side. The inscription 'dollboy' appears in all the preparatory works.

The word 'queen' – in combination with 'dollboy', an explicit indication that the image is concerned with homosexual love – occurs in the drawing and in the second painted study. In the first oil sketch, however, this is indicated by the inscription 'unorthodox lover', which leaves the viewer in no doubt as to the meaning of the term 'doll boy'.

Two details are crucial to an understanding of the painting: the musical notes issuing from the mouth of the 'doll boy', which show that he is singing, and the numerals '3.18', which, in the code used by Walt Whitman, signify 'C.R'. Together with the title – a reference to Cliff Richard's hit song of 1959, 'Living Doll' – these two elements identify the figure as Richard.

It is striking that the reference to music does not occur until the final preparatory work, rather confusingly known as *Study for 'Doll Boy' (No. 2)*. Initially, therefore, Hockney may not have planned *Doll Boy* as a personal statement of his attraction to Cliff Richard, but as a more general treatment of the theme of homosexuality. The numerals, which provide the key to deciphering the image, were not included until the final version. Furthermore, the grey area in the lower right corner – a postcard bearing a lover's message – seems to have been added by Hockney at the end of his work on the painting, which he must have finished, at the latest, by Valentine's Day 1961.

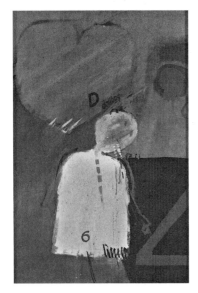

Fig. 18 *Study for 'Doll Boy' (No. 2)*, 1960.
Oil on board, 75 x 49 cm (29$\frac{1}{2}$ x 19$\frac{1}{4}$ in.).
Private collection

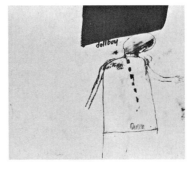

Fig. 19 Preparatory drawing for *Doll Boy*,
1960. Chalk on paper, 40.5 x 51 cm
(16 x 20 in.). Private collection, London

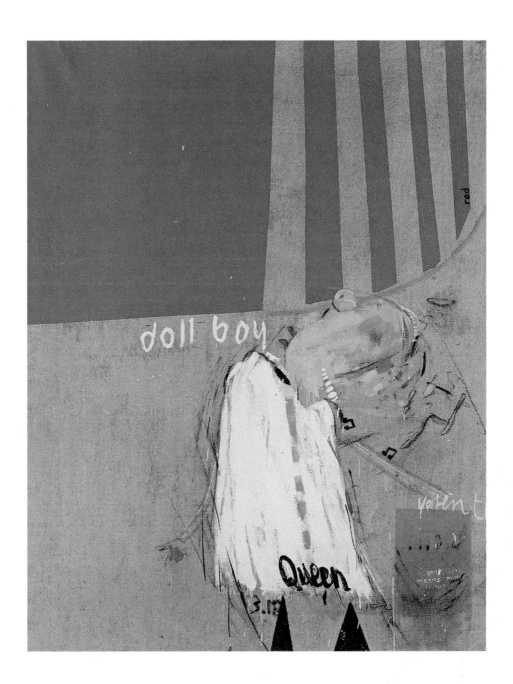

4 *The Most Beautiful Boy in the World* 1961

Oil on canvas, 178 x 100 cm
(70 x 39 $^1/_2$ in.)
Private collection

The Most Beautiful Boy in the World is one of the group of paintings that Hockney produced immediately after *Doll Boy* (plate 3). It, too, depicts a 'doll boy', but this time he is almost naked, dressed only in a 'baby doll', a style of night-dress popularized by Carroll Baker in the film of that name and associated with sex appeal and sexual freedom. As in the case of *Doll Boy*, the painting includes a number of coded messages from the artist to the viewer, once again derived from Hockney's store of signs and graffiti. Here, however, the artist introduces two clearly distinguished perceptual levels into his picture: the advertisement for Alka-Seltzer, though serving a largely formal purpose, opposes an element of concrete reality to the encodings and cryptic signs.

For the viewer, the desire expressed in *The Most Beautiful Boy in the World* is even more clearly legible than that conveyed in *The Third Love Painting* (plate 2). The graffiti discernible in the dark, almost black

area above the red heart convey, however, a more subtle message than do those in the earlier painting. They read: 'Pete', the final 'r' cut off by the Alka-Seltzer advertisement; 'cu', standing for 'see you', but also short for 'cunt'; 'come home with', again interrupted by the advertisement, but no doubt to be completed by 'me'; 'I love wrestling'; and, directly above the heart, 'let's all make', the word 'love' presumably cut off by the advertisement.

Although the 'doll boy' here is still to be associated with Cliff Richard, the numerals '16.3.' ('P.C.' in Walt Whitman's code) on the back of the figure, together with the fragments 'Pete' and 'cu', show that the figure is also to be identified as Peter Crutch, Hockney's fellow student at the Royal College of Art. Both Richard and Crutch thus serve as a projection of the artist's sexual desires. The impossibility of fulfilling these may be indicated by the letters 'ne' (never) immediately above the heart.

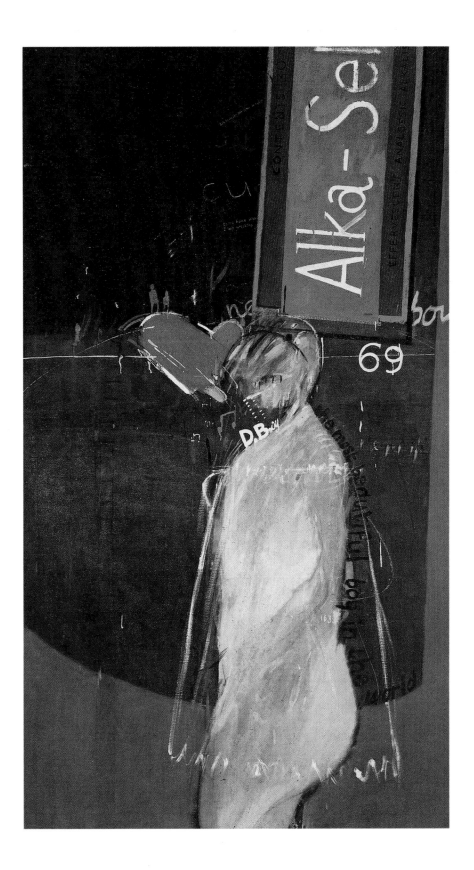

5 *We Two Boys Together
 Clinging* 1961
 Oil on board, 122 x 152 cm (48 x 60 in.)
 The Arts Council of Great Britain

We Two Boys Together Clinging was painted in the first months of 1961, when Hockney had finished working on *Doll Boy* and probably also on *The Most Beautiful Boy in the World* (plates 3, 4). Here, he marks off the left edge of the picture as a gleaming blue band. In this area, the graffiti and, in particular, the numerals '4.2.' ('D.B.' in Walt Whitman's code; that is, 'Doll Boy') provide a link with *Doll Boy*, the key work of this period. The central motif consists of two figures clinging to each other, their bodies recalling the phallic forms in the 'Love Paintings' (see plate 2). The title inscribed in the picture – that of a poem by Whitman – encloses both figures like a bracket. Tentacles of desire appear to bind one to the other, as though in illustration of Whitman's concept of adhesiveness; and indeed, below the red heart at the right edge of the picture, Hockney quotes from Whitman, as he had done in *The Third Love Painting* and in other paintings of this period. In this case, he cites two lines from the poem that gives the picture its title.

Once again, numerical codes are given to enable us to identify the figures and to interpret the presented scene: on the left, Hockney's self-portrait, holding in his arms a figure that combines Cliff Richard and Peter Crutch. The conversation inscribed within both faces makes the hopelessness of the artist's attraction clear.

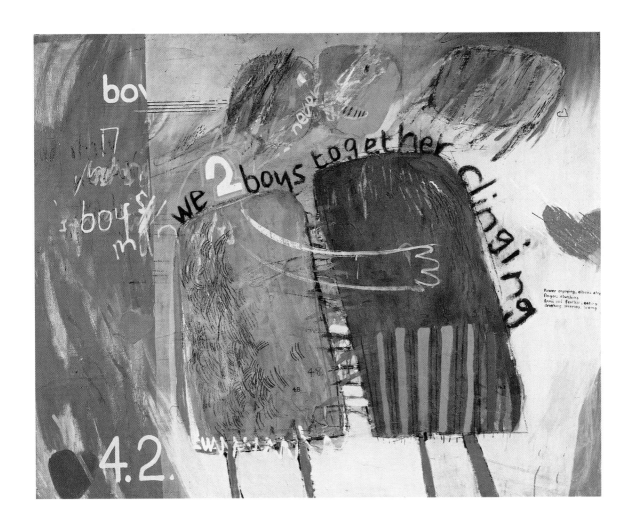

6 *I'm in the Mood for Love* 1961
Oil on board, 127 x 101.5 cm
(50 x 40 in.)
Royal College of Art, London

I'm in the Mood for Love is among the paintings made after Hockney returned, in September 1961, from his first trip to the United States (though preparatory drawings were probably made while he was still in New York). Its title is that of a popular song of the time. The picture shows Hockney himself, as a horned devil, walking between two phallically thrusting skyscrapers. The wittily ambiguous inscription on his outstretched arm, 'to QUEENS UPTOWN', refers both to an indication of direction in the New York subway and to the chance of meeting other overtly homosexual men in Manhattan. The large letter 'P' that can just be detected against the black night sky at the left edge of the painting is a reference to

Hockney's fellow student Peter Crutch, who had remained in London while Hockney was in America. The sketchy form of a ship, inscribed '4.2.' (that is, 'Doll Boy'), would seem to be an allusion to the Atlantic Ocean, which separates the two friends. This is also the subject of the etching *My Bonnie Lies Over the Ocean*, made when Hockney was still in New York (though not printed as an edition until the following year).

An unusual feature of this painting is the pale strip along the lower picture edge marked, in calendrical order, with the days from 7 to 9 July (this last, in 1961, being the date of Hockney's 24th birthday) and then to 10 July (at the extreme right), the date of the artist's arrival in New York.

Fig. 20 *To Queens* (preparatory drawing for *I'm in the Mood for Love*), 1961. Chalk and ink on paper, 44.5 x 50 cm (17 $^1/_2$ x 19 $^3/_4$ in.). Whereabouts unknown

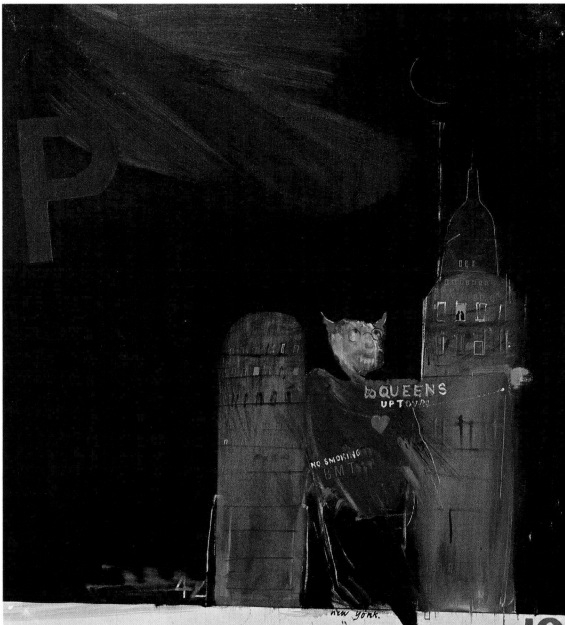

7 *K is for King* 1960
Oil on canvas, 114.5 x 80.5 cm
(45 x 31 ³/₄ in.)
Private collection

In the autumn of 1960, inspired by the illustrations in a book on the history of card games (see fig. 22), Hockney started work on a series of paintings (probably four in all) in which he played on the motif of the king. The first of the series, *Composition e3*, displays elements of playing card decoration alongside the code 'e3', which has eluded interpretation. Such two-dimensional abstractions also formed the central motif in each of the next two pictures, *Kingy B.* (fig. 21) and *K is for King*. Like

the playing cards that Hockney took as his models, the compositions are notable for a colourful planarity that allows for very little sense of depth. The vigorous brushstrokes, in contrast, partly break up the closed picture surface and render it transparent. In all these images derived from playing cards, the letter 'K' indicates that the figure is a king; on occasions when it is omitted, as in one of the figures in the etching *Three Kings and a Queen* of 1961, the king becomes a queen.

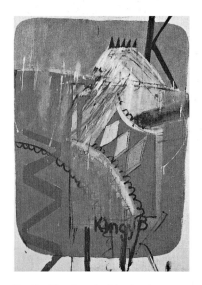

Fig. 21 *Kingy B.*, 1960. Oil on board,
122 x 91.5 cm (48 x 36 in.). Private collection

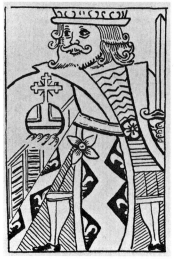

Fig. 22 King of Clubs, English playing
card, *c.* 1675

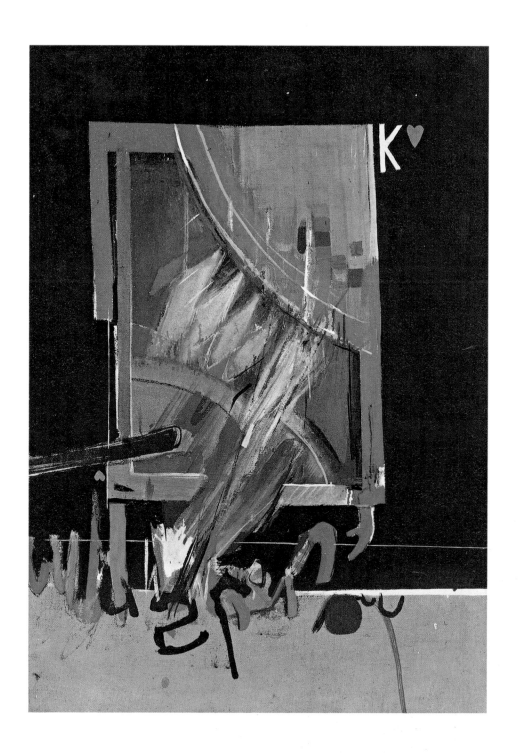

8 *Tea Painting in an Illusionistic Style* (also called *The Third Tea Painting*) 1961

Oil on four canvases, 198 x 76 cm (78 x 30 in.)
Private collection, London

In *Tea Painting in an Illusionistic Style*, Hockney achieved a type of illusionistic painting that was new in his work. Two previous paintings make clear the evolution of this new type of picture. In the autumn of 1960, Hockney had painted *The First Tea Painting* (fig. 24), a small still life showing, in its upper half, the frontal view of a packet of Typhoo tea, something that the artist always kept to hand when he was a student at the Royal College of Art. The lower half of the picture, with its looser style of painting and with a heart shape accompanied by the letter 'L' (for 'Love'), is close to the series of 'Love Paintings' (see plate 2), made shortly before, or at the same time as, *The First Tea Painting*.

In *The Second Tea Painting* (fig. 25), produced in 1961, Hockney's interest is again focused on the vibrant red front of the packet of tea. In contrast to his procedure in the earlier picture, however, he ties the packet of tea into a form of pictorial continuity that ensures a sense of depth in the image. This continuity is suggested by the dark foreground (which we can read as a base), the hint of a standing figure (again a clear connection with the 'Love Paintings') and the linear construction of a background painted on to the unprimed canvas. Lastly, by means of the addition of a grey plane at the right edge of the picture,

a side view of the packet of tea is suggested.

In *Tea Painting in an Illusionistic Style*, Hockney departs from the traditional rectangular shape of the canvas. This allows him to convey the illusion of space without abandoning the two-dimensionality of painting. A preparatory drawing (fig. 23) shows an isometric representation of a packet of tea; inside this is a seated figure, who appears to fill out the interior from the base to the upper edges. In the painting, Hockney alters the previous composition by adding a fourth plane – the open lid of the packet – to the three presented hitherto. He was thus able to construct the painting from four separate canvases. This procedure underscores the spatiality of the composition and the idea that the canvas is itself an 'object'.

In showing the figure of the naked man sitting in the packet in *Tea Painting in an Illusionistic Style*, Hockney demonstrates the simultaneous existence of the outer shape of the painted object and the closed space of its interior, to which we are also alerted by the hinted inside view of the base. The thin strips of wood with which the four canvases are framed, and so linked together, allow Hockney to strengthen the illusionistic character of this picture-object.

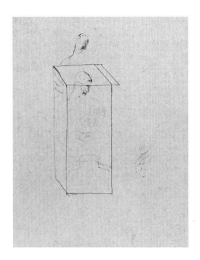

Fig. 23 Preparatory drawing for *Tea Painting in an Illusionistic Style*, 1961. Pencil on paper, 56 x 40.5 cm (22 x 16 in.). Collection of the artist

Fig. 24 *The First Tea Painting*, 1960. Oil on canvas, 76 x 33 cm (30 x 13 in.). Private collection, Switzerland

Fig. 25 *The Second Tea Painting*, 1961. Oil on canvas, 155 x 91.5 cm (61 x 36 in.). Private collection

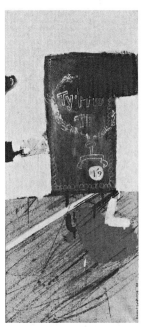

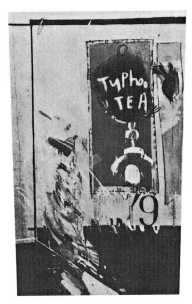

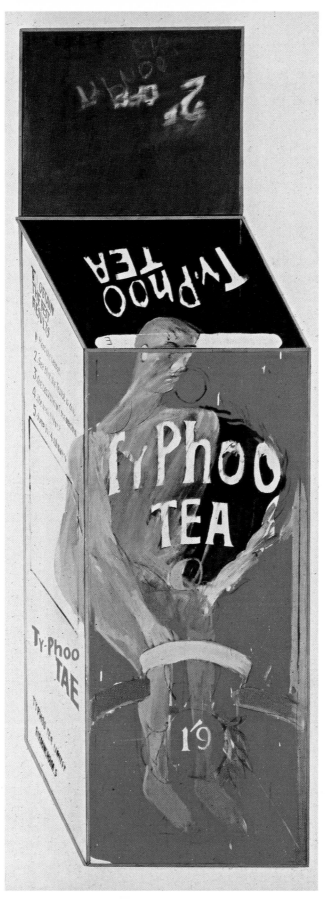

9 *Flight into Italy – Swiss Landscape* 1962
Oil on canvas, 183 x 183 cm
(72 x 72 in.)
Kunstmuseum, Düsseldorf

In December 1961, Hockney set off with two friends on his first trip to Italy. They made the journey from Paris to Berne in a small van with Hockney sitting in the back. As a result, he saw hardly anything of the Alps. Hockney's first sketches for a picture of this largely unobserved crossing of the Alps were made while he was still in Italy. After his return to London, he completed the first version of this composition, *Demonstration of Versatility – Swiss Landscape in a Scenic Style* (fig. 26). Here, he presented the mountains as superimposed ribbons of plain and speckled colour, in ironic allusion to geological diagrams and to paintings made at this time by Bernard and Harold Cohen. As in his *Tea Painting in an Illusionistic Style* (plate 8), Hockney is here commenting on illusion-

ism by circumventing it. The action indicated in the title, the journey through Switzerland, is embodied in the seated figures, their presentation suggesting movement.

Flight into Italy takes this composition as its starting point, altering it above all through the spatial expansion of the foreground and the addition of the vehicle. Hockney also retains the first picture's two-dimensional character and, accordingly, its only minimally illusionistic style. It is solely in the presentation of the mountain peak seen directly above the driving seat of the van that a connection is established with the view that the artist could hardly have perceived from his position during the journey. He based his rendering of this on a postcard image.

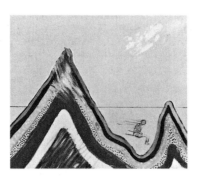

Fig. 26 *Swiss Landscape in a Scenic Style*, 1962. Oil on canvas, 51 x 61 cm (20 x 24 in.). Private collection

1962-1963

A Young Iconoclast

Following his graduation from the Royal College of Art, Hockney continued to preoccupied with questions of style. As he told Guy Brett early in 1963: 'I want to use different styles, or a vocabulary of different styles, in the same way a writer uses different words. I think it is part of the technique of painting to be able to adapt yourself to different styles....In a way I would like to paint a picture that was completely anonymous, that no one could tell was by me. Not in the style of another individual, but in the anonymous style of a school, like the Egyptian or Byzantine style.'

In his work of 1962 and 1963, Hockney did indeed combine different styles of painting on one canvas. In *The First Marriage (A Marriage of Styles I)* (plate 11) and *Berlin: A Souvenir*, for example, he juxtaposed a stylistic mode associated with Ancient Egyptian art with one characteristic of much modern abstract painting, while in the background of *Play within a Play* (plate 13), he included a figure painted in the style of an ancient Persian or Indian miniature. As these works demonstrate, and as the title of his 1961 painting *A Grand Procession of Dignitaries in the Semi-Egyptian Style* (fig. 11) may suggest, Hockney did not so much copy as simply mimic.

Hockney's self-consciousness about style, and his interest in using one that did not betray individuality, indicates that the received idea of style as an index of the artist's inner self could no longer facilitate a full, imaginative engagement: it was capable of giving rise only to work characterized by visual cliché. This experience was not peculiar to him; it was one that many artists of his generation, in both Britain and America, shared, and one that they, too, dealt with in their work. For instance, Jasper Johns's seemingly spontaneous handling of paint in *Painting with Two Balls* (fig. 27) is, on closer inspection, revealed to be a fiction: he does not present the viewer with traces of impetuosity – as might have been expected of one familiar with Abstract Expressionism – but with representations of it. The use of both shorter, more controlled brushstrokes and the encaustic technique shows that what had earlier been understood as vehicles of feeling could now be regarded, by Johns at least, only as a series of conventions.

In addition to styles, Hockney also often brought two contrasting conceptions of painting into sharp focus on one canvas, to point to weaknesses, the pretentiousness and the lack of self-awareness in conventional notions of art. In *Picture Emphasizing Stillness* (plate 10), for example, he juxtaposed the image of a large leopard in mid-air, about to descend upon two unsuspecting figures, with a line of small text that reads: 'THEY ARE PERFECTLY SAFE THIS IS A STILL'. Hockney included the text because spectators automatically tend to assume that paintings can depict movement: '[the text] has robbed you of what you were thinking before, and you've to look at it another way', he wrote in his autobiography. In *Accident Caused by a Flaw in the Canvas* (fig. 28), he used a stencil to depict three runners carrying Olympic torches. The athlete on the left is shown stumbling, his fall not attributable to his relentless pursuit of an ideal, but to

Fig. 27 Jasper Johns, *Painting with Two Balls*, 1960. Encaustic and collage on canvas, with objects, 165 x 137 cm (65 x 54 in.). Collection of the artist

Fig. 28 *Accident Caused by a Flaw in the Canvas*, 1963. Oil on canvas, 61 x 61 cm (24 x 24 in.). Lady D'Avigor Goldsmid, Kent

something far more mundane: a flaw in the canvas. This visual burlesque, like the line of text in *Picture Emphasizing Stillness*, prompts the viewer to rethink his or her understanding of the status or role of paintings.

Hockney not only parodies received ideas about art: several works are addressed to an audience familiar with arguments for, and justifications of, modern abstraction. *The Snake* (fig. 29), for instance, produced in early 1962, is the result of the artist's systematic appropriation of the concentric circles and chevrons that are a hallmark of the work of Kenneth Noland (see fig. 31). Affecting admiration of the motifs he borrows, Hockney actually mocks modern abstraction by implying that it amounts to little more than decoration. That he continued to impersonate Noland's style – he does so in *The First Marriage (A Marriage of Styles I)* simply to represent the bride's ear-ring, her breasts and the sun – may suggest that he was also concerned to question Noland's growing reputation. Similarly, a characteristic feature of Morris Louis's work – rivulets of paint on bare canvas – is appropriated to depict the hillock in *Picture Emphasizing Stillness*. These works rely on paradox and visual puns to express incongruities.

Subjects that were deeply felt and personal to Hockney could, by means of comic irony, be referred to in the full knowledge that they would be disregarded, or at least played down, in descriptions of his work: the comedy would prove distracting. Critics have rarely enquired into the nature of the relationship of the couple depicted in *Picture Emphasizing Stillness*, for example, or into what they are doing. That the figure on the right is based on a photograph of a shower scene in a homo-erotic physique magazine, and that the one on the left wears clothing whose design refers to Hockney's earlier paintings of 'queens', suggests that they are a homosexual couple. The sexual character of their relationship is underlined by the inclusion of a leopard – the cat, particularly a wild one, is traditionally associated with licentiousness. Though often overlooked, sexual connotations are equally obvious in *The Snake*, whose theme was developed in *Jungle Boy* (fig. 30).

In *Picture Emphasizing Stillness* and *Accident Caused by a Flaw in the Canvas*, Hockney invests the interaction between viewer and painting with drama: he makes it 'theatrical'. *The Hypnotist* (fig. 32) is one of several paintings from 1962/3 in which, as the curtain indicates, the figures are shown as actually occupying a stage, delineating the spectator's space as that of an auditorium. Paintings such as this imply, therefore, that viewers are to understand themselves as viewers. (This is an effect that Hockney had begun to explore as early as 1961, in paintings such as *Boy with a Portable Mirror* [fig. 33] and *A Grand Procession of Dignitaries in the Semi-Egyptian Style*.) In front of such works, the viewer is, as Christopher Knight has observed, 'no longer a passive consumer of quotidian data but an actively engaged spectator. Made aware of his status as perceiver, a spectator watches while watching himself watch.' This emphasis upon the beholder's role suggests that Hockney believed that viewing habits had become debased by the early sixties, with conventional ways of looking at images preventing a full engagement with, or a critical response to, con-

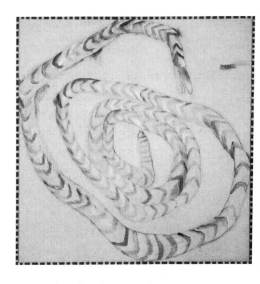

Fig. 29 *The Snake*, 1962. Oil on canvas, 183 x 183 cm (72 x 72 in.). Private collection, Berlin

Fig. 30 *Jungle Boy*, 1964. Etching and aquatint, 40.2 x 49.2 cm (15 $^3/_4$ x 19 $^1/_4$ in.). Edition of 100

Fig. 31 Kenneth Noland, *Bloom*, 1960. Acrylic on canvas, 170 x 171 cm (67 x 67 $^1/_4$ in.). Kunstsammlung Nordrhein-Westfalen, Düsseldorf

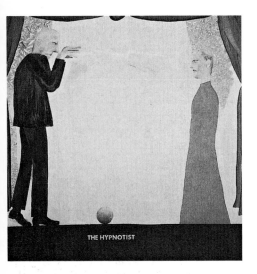

Fig. 32 *The Hypnotist*, 1963. Oil on canvas,
214 x 214 cm (84 x 84 in.). Private collec-
tion, Sweden

Fig. 33 *Boy with a Portable Mirror*, 1961.
Oil on canvas, 99 x 140 cm (39 x 55 in.).
Whereabouts unknown

temporary art. He was not alone in prompting the viewer to become con-
scious of his or her self: it was a theme of much new art at the time. For
instance, the artist Richard Smith, writing in *Living Arts* in 1963, com-
mented: 'My interest is in the fact of the message, in the form of the mes-
sage and its relationship to the spectator It is not quite a question of
bringing painting to the people but of bringing more of the spectator to
art.'

Hockney's self-consciousness about art can be regarded as one con-
sequence of a difficult and confused phase of cultural and social develop-
ment in British society. By the sixties, received ideas about the separation
of culture from everyday life were being undermined: British advertising
had, for example, appropriated many of the visual techniques previously
characteristic of fine art practice, and much new art – Hockney's included
– drew on imagery from advertisements. Richard Smith, writing in the
summer 1962 issue of *Ark*, observed: 'Hockney's paintings have the look
of an ad-man's Sunday painting. This is not a criticism for it demonstrates
that there is now the possibility of a two-way exchange between the sell-
ing arts and the fine.' At this time, the traditional association of art with
the socially privileged classes was also being called into question. The Pop
artist Peter Blake told his students: 'don't do a painting of a bottle of
wine and a piece of camembert – do a painting of something that means
something to *you*'. A 1964 article by David Sylvester on contemporary
British painting, published in *The Sunday Times*, was presciently entitled
'Art in a Coke Climate' and pointed to the pressing need for Britain's
ruling class to rethink its definition of fine art and of culture in general.
He began with a recollection: '"There's as much culture in a bottle of
Coca-Cola as there is in a bottle of wine." An American painter said that
to me 15 years ago – in Paris, which made it more unnerving. I rose to
the bait, told him how depraved he was. It wasn't that I personally didn't
like Coke as well as Côte du Rhône, Cadillacs as well as Bugattis, Holly-
wood films better than French films; I only couldn't take the juxtaposition
of "Coca-Cola" and "culture", and of course I was wrong.'

This was also a period in which it was becoming increasingly evident
that, whatever else they might be, paintings were commodities. Kasmin
Limited, which represented Hockney, was just one of many new galleries
that opened in London during the sixties to promote the work of young
artists. That Hockney thought it necessary to emphasize the role of the
viewer may suggest that he believed an appreciation of painting was be-
coming indistinguishable from an interest in its market value.

Perhaps Hockney's most iconoclastic act during this period was not
his parody of received notions of style, painting or the role of the spec-
tator, but his decision to mock the conventional idea of the artist. Rodrigo
Moynihan's 1951 portrait of the painting tutors at the Royal College of
Art (fig. 34) depicts them as learned gentlemen in casual poses, sur-
rounded by the attributes of their profession. Carel Weight, who had be-
come head of the painting department by the time Hockney enrolled, is
shown gazing intently at the still-life arrangement, used to signify not

only a traditional subject of academic painting, but also one often associated with the vanity of all human endeavour. Moynihan's painting is clearly as much about the nature of the artist and the manner in which art should be practised as it is about the appearance of the tutors. In total contrast to this image of the artist, Hockney allowed himself to be photographed for 'British Painting Now', a 1963 article written by Sylvester for *The Sunday Times*, in a gold lamé jacket, once on the street, carrying a golden shopping bag, and once in his studio, in front of *Domestic Scene, Los Angeles* (plate 16). This portrait of a glittering artist, a superstar who shops in his spare time, flagrantly opposes the *belle peinture* tradition, as represented by Moynihan's literally grey portrait of the college tutors. It seems that Hockney's parodic intention was completely missed by many at the time – they failed to establish the context within which the photographs acquired their meaning – and such people have spent the intervening decades wondering whether an artist who apparently led a shallow life could actually produce 'serious' art. Hockney later said: 'In a way, I regret buying that Bloody Gold Coat. For I think people thought I had worn it every day. In actual fact I only ever wore it twice.'

This appears to have been one occasion when Hockney's analytical, deflationary and comic iconoclasm backfired, yet his interest in prompting viewers to think about the status of paintings and their own role as spectators continued unabated after his move to Los Angeles early the following year.

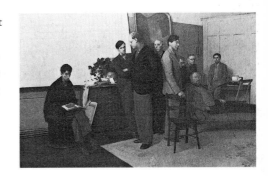

Fig. 34 Rodrigo Moynihan, *Portrait Group*, 1951. Oil on canvas, 213 x 334.5 cm (84 x 131 $^3/_4$ in.). Tate Gallery, London

10 *Picture Emphasizing
 Stillness* 1962

Oil with Letraset on canvas,
183 x 157.5 cm (72 x 62 in.)
Mr and Mrs J.J. Sher

After seeing paintings of battle scenes at
the Tate Gallery, London, during the
autumn of 1962, Hockney was forcibly
struck by the fact that painting is ill-
suited to the representation of movement.
'Things don't actually move [in paint-
ings]', he told Guy Brett in 1963, 'the fig-
ures are, and will always remain, exactly
where the painter put them. The same
thing that struck Keats when he saw the
Grecian Urn.'

Soon afterwards, the artist came across
a drawing he had made that August of a
leopard leaping on to a man (fig. 35), and
determined to use it as a study for this
painting. It may well have been the detail
of the man taking evasive action that made
this drawing appealing since, following his

visit to the Tate, Hockney realized that the
man need not bother: the leopard would
never land; it would remain exactly where
it had been drawn. For the painting, he de-
cided to show both figures as untroubled
by the leaping leopard, in order to emphas-
ize – as with the term 'still' in the legend
that runs across the picture surface – the
unsuitability of painting to depict the pass-
ing of time.

This painting, unlike the drawing, ex-
tends the series of works, begun in the
autumn of 1960, that explores homosexual
relationships. It is one of the last in which
a couple is depicted in a public space; the
'Domestic Scenes' of the following year (see
plates 12, 16) investigate relationships in
domestic interiors.

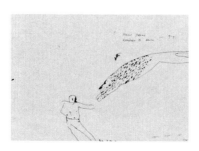

Fig. 35 *Leaping Leopard*, 1962. Ink on paper,
33.5 x 49 cm (13$^1/_4$ x 19$^1/_4$ in.). Private
collection

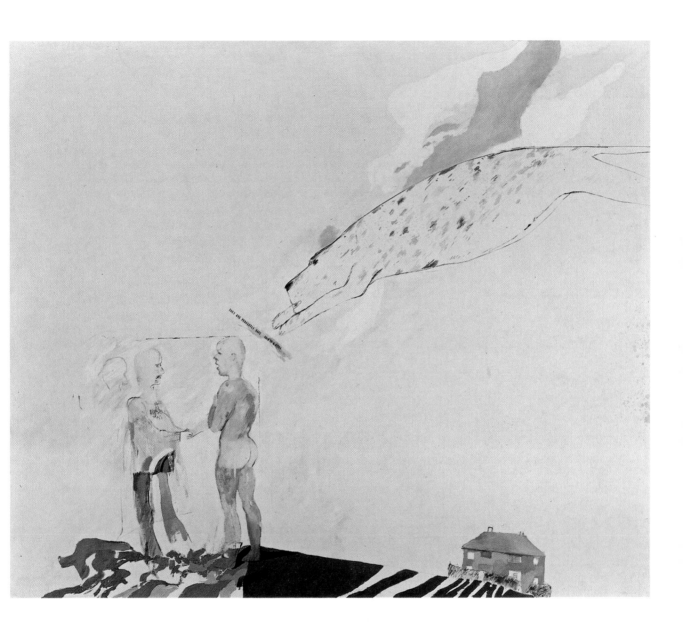

11 *The First Marriage*
 (A Marriage of Styles I) 1962
 Oil on canvas, 153 x 183 cm
 (60 x 72 in.)
 Trustees of the Tate Gallery, London

In the catalogue of the 1970 retrospective exhibition of his work, Hockney is quoted as saying that, during a tour of a museum in 1962, he caught sight of a friend, Jeff Goodman, 'looking at something on a wall – so I saw him in profile. To one side of him, also in profile, was a sculpture in wood of a seated woman, of a heavily stylized kind (Egyptian, I believe).'

It is likely that this view interested him because of his concern to combine different styles of painting on a single canvas. *Man in a Museum (or You're in the Wrong Movie)* (fig. 36) may be understood as an illustration of Hockney's recollection of the scene, the artist having exaggerated both the appearance and the formal qualities of the wooden sculpture so as to facilitate a contrast of styles.

Hockney completed *The First Marriage (A Marriage of Styles I)* towards the end of 1962. It can be seen as a develop-

ment of *Man in a Museum*, the sculpture having become a red-faced woman and Goodman a bald man wearing a fashionable striped Italian jacket. Their proximity to one another, and the religious connotations of the arch towards the lower-left corner, may suggest that the two figures are now joined together not by accident, but in matrimony; and both the palm-tree and the sun indicate that they are no longer in a museum, but in exotic surroundings – perhaps on honeymoon. It would seem that the combination of styles in *Man in a Museum* suggested to Hockney the subject of a marriage of different personalities, also explored in *The Second Marriage* (fig. 37) and *Domestic Scene, Notting Hill* (plate 12), both painted the following year. It is indicative of the artist's priorities that, in his two depictions of a heterosexual couple, the effect is less one of intimacy than of irony.

Fig. 36 *Man in a Museum (or You're in the Wrong Movie)*, 1962. Oil on canvas, 153 x 153 cm (60 x 60 in.). The British Council

Fig. 37 *The Second Marriage*, 1963. Oil on canvas, 197.5 x 229 cm (77 3/4 x 90 in.). National Gallery of Victoria, Melbourne, presented by Contemporary Art Society, London, 1965

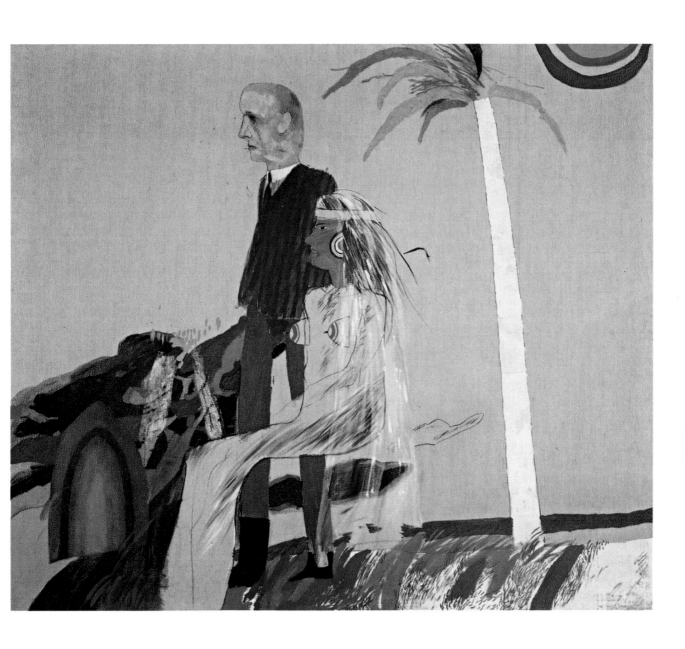

12 *Domestic Scene,*
 Notting Hill 1963
 Oil on canvas, 183 x 183 cm
 (72 x 72 in.)
 Private collection

In his autobiography, Hockney discusses this painting in terms of the selectivity of human vision: 'When you walk into a room you don't notice everything at once and, depending on your taste, there is a descending order in which you observe things. I assume alcoholics notice the booze first, or claustrophobics the height of the ceiling, and so on. Consequently, I deliberately ignored the walls and I didn't paint the floor or anything I considered wasn't important.' While there is no reason to doubt that this concern conditioned the appearance of the painting, it scarcely warrants the overriding degree of importance accorded it by critics in their discussions of the work.

Domestic Scene, Notting Hill is an image of a homosexual couple – probably an imaginary one, like that in *Domestic Scene, Los Angeles* (plate 16). Unlike in the latter painting, however, a number of oppositions have been employed in this work in order to present the couple as a sharply contrasted pair: the figure on the left is shown standing, naked and *en face*, the other seated, clothed and in profile. These physical polarities may be intended to connote psychological ones – masculine and feminine, for example. That the man on the left is to be understood as active is certainly suggested by aspects of the setting: the cigarette and lamp – veritable phallic symbols – are associated with him.

Despite the left-hand figure's nudity, the couple – like the one in *The First Marriage (A Marriage of Styles I)* (plate 11) – are not actually shown to be close to one another; indeed, the curtain suggests that the painting represents a domestic drama. Incongruous relationships appear to have fascinated Hockney: they are the subject of many other large paintings by him (see plates 19, 31, 32).

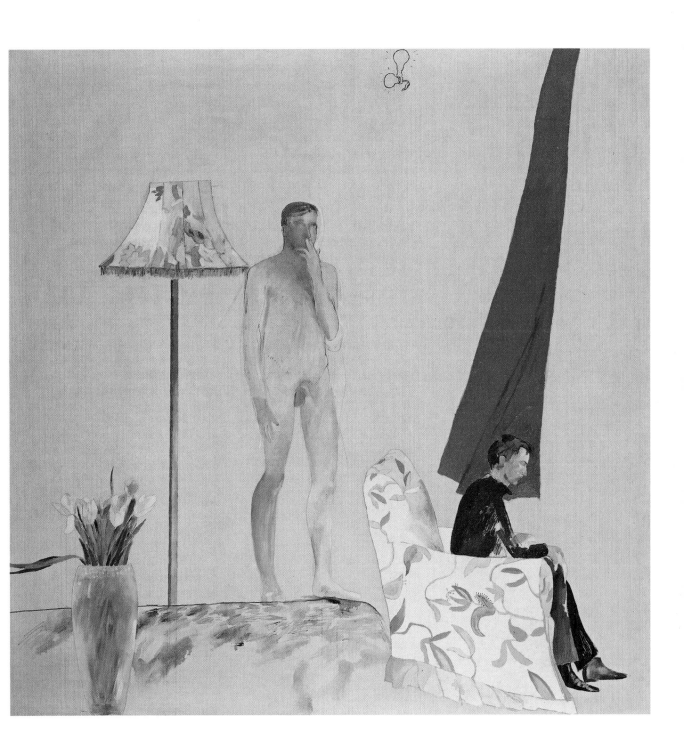

13 *Play Within a Play* 1963
Oil on canvas and Plexiglass,
183 x 198 cm (72 x 78 in.)
Private collection

While a student at the Royal College of
Art in London, Hockney became interested
in drawing the viewer's attention to the
actual surface of his paintings, which he
often posited as a boundary between real
and fictive space. The surface-as-boundary
became a resource for complex exploitation
in his 'curtain paintings', produced during
1963. In this portrait of John Kasmin, for
example, the boundary takes the concrete
form of a vertical strip of Plexiglass, which
represents the pane of glass that customar-
ily protects a work of art. The floor-boards
indicate that only a shallow space separates
the surface of the tapestry – comprised of
images drawn from Persian miniatures,
modern abstract art and Hockney's own
work (see fig. 32) – from the boundary.
Kasmin, the artist's dealer, is shown trying
to escape from this indeterminate space;
the presence of only one chair suggests
that, if he does not succeed, he will have
to resign himself to being separated from
other human beings.

The idea of showing Kasmin in front
of a tapestry occurred to the artist after he
had seen *Apollo Killing Cyclops* by the Ital-
ian baroque painter Domenichino, in
which a peasant and a cat sit in front of a
tapestry; Domenichino's model, in turn,
had been a tapestry based on a painting
that depicted a dramatic episode from
Greek mythology. In 1969, and again in
1972/3, the Edinburgh Tapestry Company
produced a tapestry of Hockney's painting.
In his autobiography, the artist recalled:
'when David Oxtoby, a fellow artist and
old friend from Bradford, called to see me,
he looked at the tapestry which I'd hung
on my wall and asked me why it had been
made. I told him It's from my painting
done from another painting of a tapestry
done from a painting. He said Oh Dave
could you lend me it? I'll make a painting
of it. A lovely spiral!' A year after the first
tapestry had been woven, Hockney painted
Le Parc des sources, Vichy (plate 38), which
also features a picture within a picture.

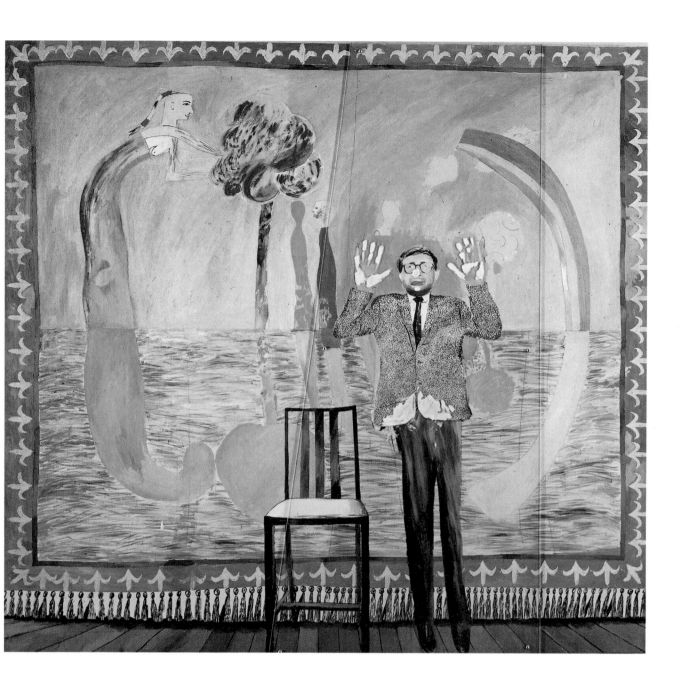

14 *Closing Scene* 1963
Oil on canvas, 122 x 122 cm
(48 x 48 in.)
Private collection, New York

In 1960, Hockney began a series of paint-
ings based on playing cards (see plate 7) in
which he depicted the border of the card as
concurrent with the boundary of the can-
vas, thereby equating the painting with
the object. The issue of literalness that
these works address first came to the fore
in post-war art, particularly in Jasper
Johns's paintings of flags, targets, maps,
numerals and letters.

Three years after the first playing card
pictures, Hockney returned to investigate
the implications of literalness by painting
curtains. As the artist wrote in his autobio-
graphy: 'A curtain, after all, is exactly like
a painting; you can take a painting off a
stretcher, hang it up like a curtain; so a
painted curtain could be very real.' *Closing
Scene* is an ingenious comment on the aus-
terity that literalness can lead to: the paint-
ing is almost completely white; only a frac-
tion of it affords any sensuous pleasure.

Fig. 38 *Still Life with Figure and Curtain*,
1963. Oil on canvas, 198 x 214 cm (78 x
84 in.). Private collection

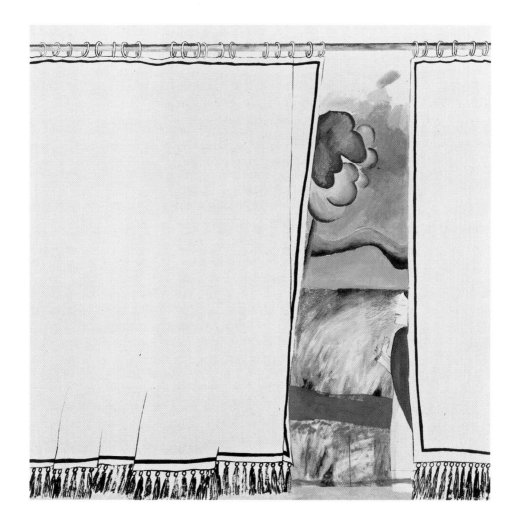

15 *Great Pyramid at Giza with
 Broken Head from Thebes* 1963
 Oil on canvas, 183 x 183 cm
 (72 x 72 in.)
 Tops Trustees Ltd

Knowing of Hockney's interest in Ancient Egyptian art, the editor and the art critic of *The Sunday Times* colour supplement, Mark Boxer and David Sylvester, asked the artist in 1963 if he would travel to Egypt in order to produce a portfolio of drawings for an ongoing series in the magazine. Hockney naturally agreed, and so spent much of October visiting Cairo, Alexandria, Karnak and Luxor. The resulting drawings (see fig. 40), although admired, were not reproduced in the supplement, the series having been replaced in the meantime by articles on political events, including the assassination of President Kennedy.

During the following winter, Hockney produced a number of paintings based on his visit to Egypt. In the present example, it would appear that the modern pipeline interested him as much as the ancient pyramid.

Fig. 39 *First Version of the Great Pyramid at Giza*, 1963. Oil on canvas, 122 x 91.5 cm (48 x 36 in.). Private collection, Switzerland

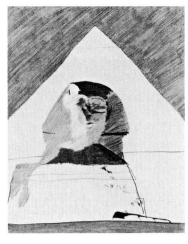

Fig. 40 *The Sphinx*, 1963. Pencil and crayon on paper, 32.5 x 26.5 cm ($12^3/_4$ x $10^1/_2$ in.). Private collection

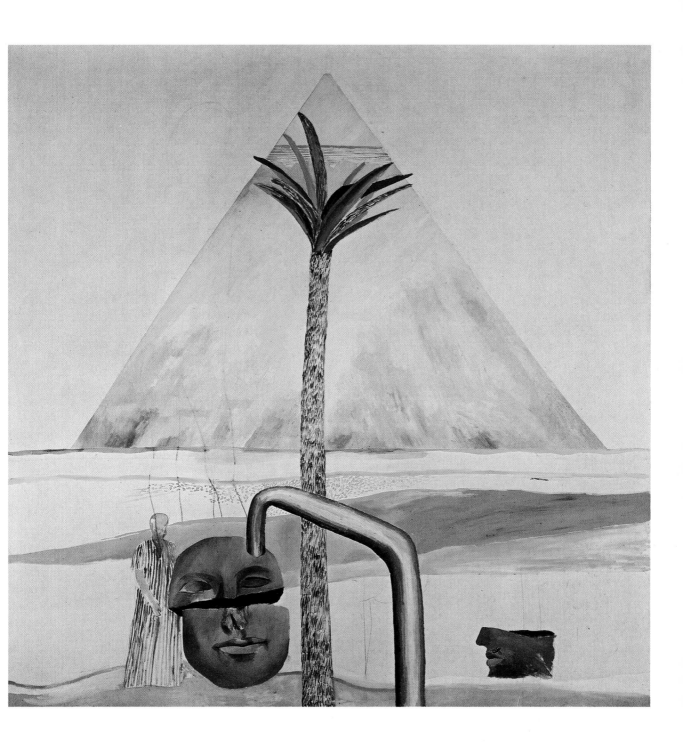

1963-1967

Images of Southern California

At the beginning of 1964, Hockney arrived in Los Angeles, thereby fulfilling a long-standing ambition. He had painted *Domestic Scene, Los Angeles* (plate 16) in anticipation of his visit and, to his delight, found that his imaginative portrayal corresponded to the life-style he was able to lead in California. Although his first visit lasted less than a year, he decided to use Los Angeles as a base throughout the sixties and, by the end of that decade, had come to be identified as *the* painter of Southern California. The works discussed in this chapter should not be regarded as ingenuous portrayals of either his first, or subsequent, impressions, however. Although ideas for paintings did derive from incidents in his own life, they are rarely self-revelatory. His education at the Royal College of Art, largely conducted through informal conversations with his peers, had taught him that he could no longer conceive of art as he had done in Bradford, as a relay either between the artist and reality or between the artist and the spectator. The work of Jasper Johns and Robert Rauschenberg from the late fifties raised serious questions that undermined 'common-sense' ideas concerning the difference between the visual and the linguistic, the figurative and the abstract, illusion and reality. The ways in which modern art was thought about and defined continued to preoccupy Hockney when he started to paint in Southern California. As *Portrait Surrounded by Artistic Devices*, *Savings and Loan Building* and *A Lawn Being Sprinkled* (plates 22, 25, 26) suggest, the means of representation were as important as the subject.

A painting from 1965 demonstrates how sophisticated his understanding of the debates surrounding the practice of modern art was. In *Monochrome Landscape with Lettering* (fig. 41), the artist labelled the scene by including the legend 'Monochrome Landscape' inside the painted frame. However, by then placing the title, 'Monochrome Landscape with Lettering', outside this frame, as though it were a museum label, he both made the original inscription an integral part of the picture and ironically proclaimed the whole work to be a masterpiece worthy of a museum. (The fact that it is a monochrome landscape suggests that his painting represents a black-and-white reproduction made by a museum of his 'masterpiece'.) Hockney not only incorporates the legend in the picture, conflating picturing and naming, but also points to the relationship between his work and existing representational codes, thereby distancing the piece from himself and forcing us to reconsider our assumptions concerning originality and creativity. His practice also addressed arguments which suggested that physical and institutional parameters determine access to, and perceptions of, art works. In his autobiography, he states: '[I] originally intended to put lettering on the wall – "Wall with Monochrome Landscape and Lettering and Frame" – but I realized I had to stop somewhere, otherwise it could have finished up "England, London, Bond Street, Kasmin Gallery, Wall with Monochrome Landscape and Lettering and Frame". Simple comment can be taken too far.'

That the devices of art are laid bare in Hockney's work suggests he was preoccupied with the status, role and function of modern painting. By the late fifties, the form of abstraction commonly referred to as Modernist

had laid claim to be the only rightful heir to the pre-war European tradi-
tion of modern painting. According to the theories expounded by the art
critic Clement Greenberg, the history of modern painting was understood
to involve the gradual elimination of all illusion of three dimensions, com-
bined with an increasing emphasis on the flatness of the picture plane.
The surface of the painting – its flatness, its colour, its edge – was, by the
sixties, understood to be painting's only legitimate subject, and references
to anything beyond the picture plane were, in the words of Greenberg, 'to
be avoided like the plague'. Painting was to be addressed to the eye alone.
When Mark Glazebrook interviewed Hockney in 1970 in connection with
a retrospective exhibition of his work, he asked the artist whether he ad-
mired the intellectual content of Modernist abstraction, to which Hockney
replied: 'But I'm not sure what intellectual content there is you see. Some
of those painters do ask you after all to think of nothing but the canvas.
It's there in front of your eyes and your eyes must delight in it or get
everything from it.'

A significant number of works reproduced in this chapter challenge
directly (or ironically) this conception. In these, the artist evoked and
brought into play those very ideas that he sought to disparage (see plate
25). Later in his career, Hockney repeatedly stated that he had wanted to
be involved with Modernism during the sixties, but since his main con-
cern then was to establish a conception of painting that offered a definit-
ive advance on Modernist aesthetics and criticism, it was only a peripheral
involvement. As he told *The London Magazine* in April 1963; 'I cannot
paint objectively. A heap of empty cigarette packets, say, has no meaning
for me as a combination of shapes, lines and colours. A pile of empty
cigarette packets means I've smoked a hundred cigarettes; and then I
wonder why, and where, and whether I shared them or smoked them all
myself – and from there, with luck, a picture may begin.'

The lines from George Herbert's poem *The Elixer* that Hockney mem-
orized as a boy suggested a real way for forward:

> A man that looks on glasse
> on it may stay his eye
> Or if he pleaseth, through it pass
> and then the heav'n espie.

Although Hockney understood the necessity of showing that his paintings
were composed of a collection of painted marks existing on the flat surface
of a canvas (thus allowing the spectator to 'stay his eye'), he was not will-
ing to abandon the representational possibilities of those marks (and the
world or 'heav'n' they could conjure up). The task he set himself was to es-
tablish a practice that synthesized these two concerns (see plate 22). It is
Hockney's awareness of the conditions governing modern painting that
prevents his images of California from appearing clichéd, like those of his
imitators. From 1965 to 1967, his work demonstrates his excitement at
the way objects can be represented by signs that hardly resemble them. In

Fig. 41 *Monochrome Landscape with Lettering,*
1965. Acrylic and Letraset on canvas,
122 x 122 cm (48 x 48 in.). Private collection

Fig. 42 *Striped Water*, 1965. Crayon on paper, 35 x 42 cm (13 ³/₄ x 16 ¹/₂ in.). Private collection

Fig. 43 *Swimming Pool and Garden, Beverly Hills*, 1965. Pencil and crayon on paper, 48.3 x 61 cm (19 x 24 in.). J. Kasmin, London

paintings, prints and drawings, he worked his way through a whole series of different types of sign, nowhere more abundantly than in his depictions of transparent surfaces, such as water: *California* and *A Bigger Splash* (plates 23, 27) are but two examples. What we see is a great variety of decorative marks, abstract coloured shapes and carefully delineated contours. Our delight in seeing how these unnaturalistic signs can, indeed do, represent water is a consequence of the artist's intelligence and wit.

Yet Hockney was also excited by the inherent ambiguity of nonnaturalistic signs; our 'readings' are therefore never absolutely secure. Do the white lines towards the centre of *A Bigger Splash* really represent a splash? If so, can we be sure that that is all they represent? In *Striped Water* (fig. 42), what do the stripes refer to – patterns formed by flowing water or water that is, somehow, actually striped?

Hockney's concern with formal issues was, however, of relative, not absolute, importance. His interest in water and swimming pools also allowed him to extend the European tradition of the bather as a subject of art. Travelling from London to Los Angeles, he joined a long line of European artists who had journeyed in search of exotic climes or pre-modern societies where they could reconnect with basic human sensations through unfettered sexuality, and thereby transform their artistic practice. (In his autobiography, Hockney recalls that the only time he had been promiscuous was on his arrival in Los Angeles.) The artist has compared Los Angeles to Egypt, to the Mediterranean in general and Cavafy's Alexandria in particular; never does it appear as one of the most advanced centres of industry in the world. For Hockney, Southern California is a tropical utopia. His paintings of male nudes climbing in or out of swimming pools, sleeping by the pool's edge or floating on inflatable beds appear to represent a return to a pre-modern world of sensuality and plenty, a second Eden (see plate 23; figs. 44, 45). Yet these images also betray a desire to

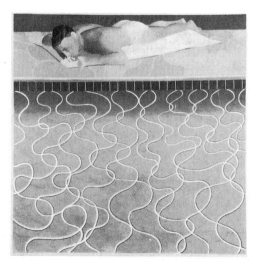

Fig. 44 *Sunbather*, 1966. Acrylic on canvas, 183 x 183 cm (72 x 72 in.). Museum Ludwig, Cologne

maintain a distance, a desire to master (the look he represents is always a voyeuristic one) and to establish California as different from Europe (the figures are always reduced to stereotypes; see plate 29). California is not a second Eden, after all, but a 'colonially' conceived utopia, just as Tahiti was for Gauguin or Morocco for Matisse. In these paintings, soon shown publicly in London or New York, but not in Los Angeles, the European maintains his supposed superiority. It is appropriate that much imagery in these works derives from photographs of adolescents in homo-erotic magazines.

Since Los Angeles is portrayed as a colonially conceived utopia, Hockney's paintings, unlike those of his American peers, do not address the social realities of the city or of Southern California as a whole (cf. fig. 46). _The_ representation he made of the region, _California_ (plate 23), was created at a moment in time when the racist attitudes of certain sections of Californian society turned an incident into a riot: in the 1965 Watts Riots, thirty-four people were killed, over one thousand injured and forty million dollars' worth of damage done to property. In Hockney's images, the social realities of Los Angeles are erased so as to present the city as a spectacle. (Problems are caused when his work is used, as it increasingly has been, to represent the region.) The only occasion on which Hockney attempted to deal with the social life of the city – and also to depict a Hispanic American – was in _Santa Monica Blvd._ (fig. 77), a painting begun in 1978. After two years working on this piece – its size suggests that it was intended to be a monumental painting in the 'great' tradition – he abandoned it and, instead, turned to landscape painting. Although this symbolizes a retreat from engagement with the social realities of Los Angeles, the paintings he subsequently produced are not without social significance, despite the artist's avowed intentions (on this, see page 138).

If Hockney paints Los Angeles as a spectacle, it is as a spectacle of the good life offered to the white middle class by real-estate companies and life-style magazines, whose images were intended to persuade these people of the way life should be led. Hockney's detractors claim that he reproduces the meanings of his source material uncritically, but the locations, buildings and life-styles featured in his art are transformed into signs that, when read collectively, constitute a metaphor for middle-class isolation. Hockney paints homes of impersonal tidiness; lawns that, carefully groomed to impress, serve, like the water sprinklers, to keep the passer-by at a distance (see figs. 47, 48). His work suggests that the lifestyle promised is based upon a deception. Hockney's subject is not social inequality; rather, it is the middle class's disavowal of social realities through the unremitting maintenance of a facade.

Despite being a city whose identity has been legitimized through an emphasis on signs of the past (its architectural forms have revived a bewildering collection of styles, including the Antique, the Alpine, the Neocolonial and the Spanish Revival), Hockney's images show it is constructed from only the most modern materials. Its modernity, however, is superfi-

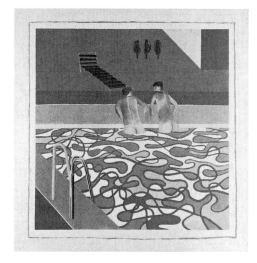

Fig. 45 _Two Boys in a Pool, Hollywood,_ 1965. Acrylic on canvas, 152.5 x 152.5 cm (60 x 60 in.). Private collection, Germany

Fig. 46 Ed Kienholz, _Back Seat Dodge '38,_ 1964. Mixed media tableau. Los Angeles County Museum of Art, purchased with funds provided by the Art Museum Council

Fig. 47 *A Neat Lawn*, 1967. Acrylic on canvas, 244 x 244 cm (96 x 96 in.). Private collection

Fig. 48 *Some Neat Cushions*, 1967. Acrylic on canvas, 157.5 x 157.5 cm (62 x 62 in.). Fujii Gallery, Tokyo

Fig. 49 *Picture of Melrose Avenue in an Ornate Gold Frame*, 1965. Colour lithograph, 76.5 x 56.5 cm (30 x 22 1/4 in.). From *A Hollywood Collection*. Edition of 65

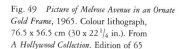

cial, for it is not contemporary in the sense that nineteenth-century Paris was to its painters. Hockney does not depict Los Angeles as a vital, bustling place – nor could he, since his subject, the isolation of the middle class, prevents him. Instead, it is shown unpopulated. Hockney's images have much in common with tourist brochures and, although they may signify a period or 'time', it is not one that is actually *in* time. Los Angeles is, in effect, frozen.

The brittle facade of middle-class life in Southern California is complemented by the impregnable front that Hockney gives his work. As the artist has said: 'I make pretty pictures that are subversive. I love that.' Masking expressions of subversion or alienation behind an impenetrable facade is, of course, a tactic of cultural dandyism. Yet in his paintings of collectors whom he met in Beverly Hills shortly after his arrival, Hockney did allow his front to slip. In *California Art Collector* (plate 19), he represented a typical collector as ignorant, as incapable of appreciating the cultural significance of her acquisitions, while in *The Actor* (plate 20), he shows a collector to be little more than a whore. (Such criticisms were not lost on Frederick and Marcia Weisman in 1968 when they viewed their portrait; plate 30.)

It was not only the wealthy, established collectors who were the target of Hockney's scorn. In 1965, he offered a suite of six prints for sale (see figs. 49, 50) that, as the title of each lithograph informs us, consisted simply of imitations of framed pictures representing a variety of genre subjects in different styles. By titling the series *A Hollywood Collection*, however, he points to the inability of the *nouveaux riches* to distinguish a fake from an original; his implicit subject is their habit of collecting art for social prestige or investment purposes, rather than for appreciation. (Given that, by this date, Hockney had already cited Picasso's work as a major source of inspiration, it might prove fruitful to compare works

such as these with Picasso's 1914 collages, in which he mocks the cultural aspirations of the bourgeoisie.)

The paintings by Hockney reproduced in this chapter are concerned with surfaces: the Modernist picture plane; the play of light across water; the facade of the life offered to the white middle class; and the veneer of glamour that he lends his own work in order to camouflage its real subject. For an artist as preoccupied with surfaces as Hockney, Los Angeles and especially Hollywood (which has derived great rewards from exhibiting itself) provided an ideal setting. Here, reality had been turned into images so often that it was, and still is, sometimes difficult to distinguish between image and reality. Hence the artist's comment: 'I love California; everything is so artificial.'

Fig. 50 *Picture of a Pointless Abstraction Framed under Glass*, 1965. Colour lithograph, 76.5 x 56.5 cm (30 x 22 1/$_4$ in.). From *A Hollywood Collection*. Edition of 65

16 *Domestic Scene, Los Angeles* 1963
Oil on canvas, 153 x 153 cm
(60 x 60 in.)
Private collection

Hockney stated that his image of Los Angeles was formed principally by John Rechy's novel *City of Night* and by the homo-erotic Californian magazine *Physique Pictorial*. The latter was an unusual publication, as its wholesome images of virile adolescents (frequently posed alone in showers or, as couples, either at ease or wrestling in domestic interiors) had, despite the burden of legal persecution, only a perfunctory link to the physique culture traditionally used to legitimize such images. The chatty text accompanying these scenes even made reference to the Los Angeles gay subculture, campaigned for a change in the laws relating to homosexuality and inveighed against censorship and hypocrisy.

The magazine provided Hockney with a source of imagery for many paintings from the early to mid-sixties. The idea for *Domestic Scene, Los Angeles* probably derived from the stills that *Physique Pictorial* reproduced from short fictional movies concerning the vicissitudes of a domestic relationship between a scantily clad teenager

(who assumed the feminine role) and his elder, more masculine 'brother'. This would explain Hockney's choice of an apron, rather than the customary jockstrap, for the figure on the left. Despite the painting's title, the telephone, shower and chintz-covered armchair (which reappeared in *Domestic Scene, Notting Hill*; plate 12) were all drawn from life at the artist's home and studio in Powis Terrace, London. The vase of flowers, copied from an illustration in a women's magazine, can be seen again in *Seated Woman Drinking Tea, Being Served by Standing Companion* and in plate 1A of *A Rake's Progress*, both also from 1963. The image is relatively advanced for the period, as it was customary for homosexuality to be conceptualized by reference to the Classical past rather than to athletics (emphasized here by the white socks). This fictional scene serves as a reliable guide to Hockney's fantasy of Los Angeles six months before his first visit and was painted at the same time as *The Second Marriage* (fig. 37).

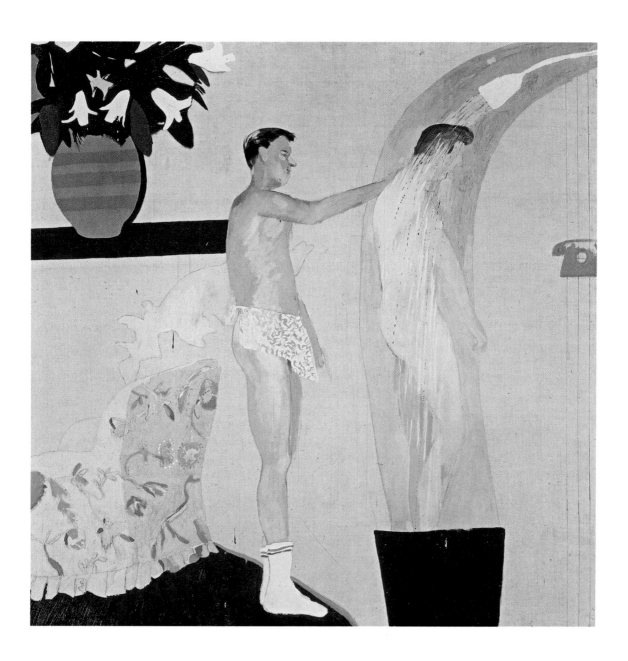

17 *Boy About to Take a*
 Shower 1964
 Acrylic on canvas, 91 x 91 cm
 (36 x 36 in.)
 World Co. Ltd, Kobe, Japan

Painted in Los Angeles, this is the first of three paintings of a male figure in a black, blue and grey tiled shower, and the only one not to include water. Although exhibited at the Alan Gallery, New York, during the autumn of 1964, it remained in the artist's collection until 1969, when he added the leaves in the lower left-hand corner.

The youth's head hangs down, as in *Doll Boy* (plate 3), and his pose is some-what awkward as he handles the shower head. By emphasizing the shower head and omitting the water, Hockney transforms the image in *Physique Pictorial* (fig. 51) into a metaphor for burgeoning male sexuality. When the boy finally has a shower (a metaphor for orgasm), he will have made the transition from passive feeling to active desire and will necessarily have begun to assume the mantle of adulthood.

Fig. 51 Photograph published in *Physique Pictorial*, April 1961, p. 6

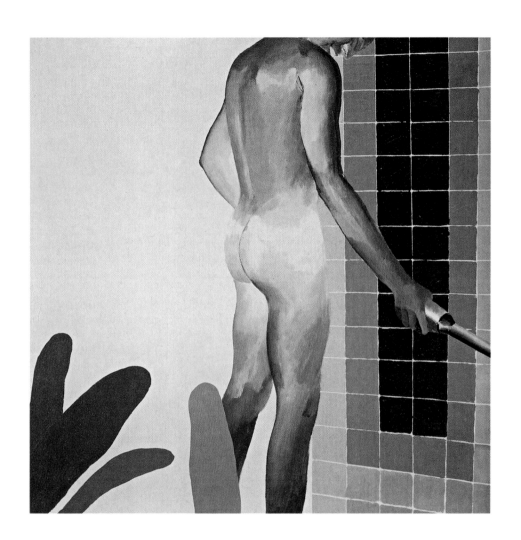

18 *Olympic Blvd., Los Angeles* 1964
Acrylic on canvas with Letraset,
91 x 61 cm (36 x 24 in.)
Private collection, Germany

Painted in Hockney's Santa Monica studio, this picture appears to offer a disarmingly frank commemoration of his first impressions of life in downtown Los Angeles. This effect, however, is illusory. Like *Wilshire Boulevard, Los Angeles* (fig. 52), the entire image is contained – as the white border and Letraset caption suggest – within the format of a postcard, indicating that what is depicted is an image of the city composed of tourist clichés: palm-trees, cloudless skies and Modernist buildings. As David Thompson observed in the introduction to the catalogue of a mixed exhibition titled 'The New Generation: 1964' that was held at the Whitechapel Art Gallery, London, from March to May 1964: 'You are quickly aware that he is more likely to be watching you watching him being ingenuous, and finding it amusing. For this self-conscious art may be a kind of autobiography, but it is not self-revelation.'

Hockney returned to this compositional format, most notably for *Picture of Melrose Avenue in an Ornate Gold Frame* (fig. 49), the fourth of six lithographs in the suite *A Hollywood Collection* (1965).

Fig. 52 *Wilshire Boulevard, Los Angeles*, 1964.
Acrylic on canvas, 91 x 61 cm (36 x 24 in.).
Private collection

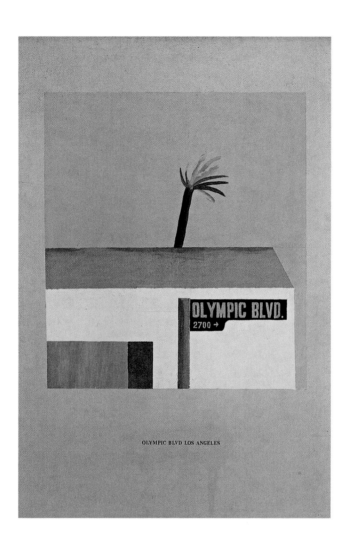

OLYMPIC BLVD LOS ANGELES

19 *California Art Collector* 1964
Acrylic on canvas, 153 x 183 cm
(60 x 72 in.)
Private collection

Soon after his arrival in Los Angeles, Hockney accompanied John Kasmin, his dealer, to a series of business meetings with Californian art collectors who, as he recollected in his autobiography, 'were mostly women – the husbands were out earning the money'. The relationship of the women to their collections intrigued him, and he decided to take it as a subject, thereby extending the series of works, begun in 1962, that explore human relationships.

When Hockney visited the homes of collectors, he was struck by the fact that they all had large windows and an open network of walls to let in light and air. They obviously reminded him of the manger in Piero della Francesca's *Nativity* in the National Gallery, London (fig. 53), although in the present painting, the manger has been repaired and brightly decorated. Since, typically, the collector's

husband was absent, Hockney decided to represent her as a virgin, thus enabling him to draw a parallel with images of the Annunciation to the Virgin Mary. A sculpture by William Turnbull was anthropomorphized (two schematic legs are visible) to imply the movement and flowing drapery of the angel. As the simple stone floor and white lily of Annunciation depictions (see fig. 54) would have been inappropriate in such an expensive house, he substituted a thick carpet and an extravagant arrangement of flowers. A smudge of white paint is all that remains of the holy dove, and Heaven is a swimming pool surrounded by palm-trees at the end of a Morris Louis-like rainbow.

In contrast to Mary's response to the Annunciation, the Californian collector is, as her proximity to the 'primitive' head suggests, too ignorant to understand the sculpture's meaning.

Fig. 53 Piero della Francesca, *Nativity, c.*
1470. Tempera on panel, 167.6 x 116.2 cm
(66 x 45 ³/₄ in.). National Gallery, London

Fig. 54 Fra Angelico, *Annunciation*, 1433/4.
Tempera on panel, 150 x 180 cm (59 x
70 ³/₄ in.). Museo Diocesano, Cortona

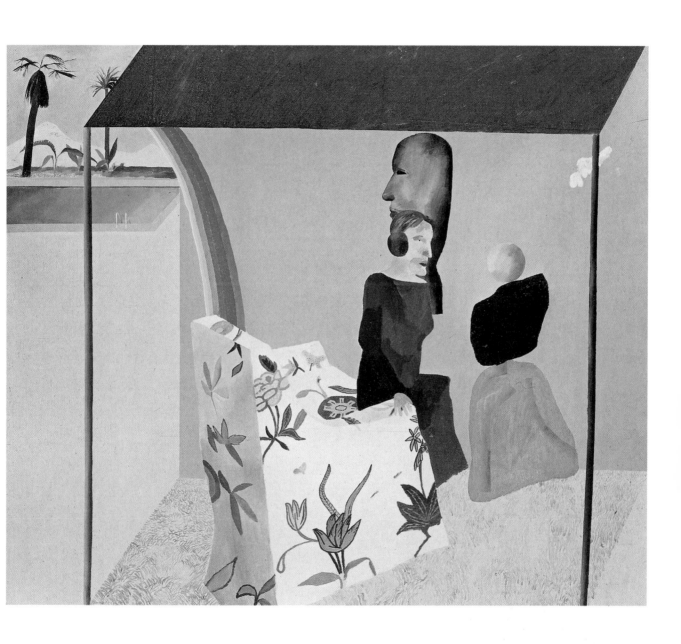

20 *The Actor* 1964

Acrylic on canvas, 167 x 167 cm
(65 $\frac{1}{2}$ x 65 $\frac{1}{2}$ in.)
Private collection, London

During the summer of 1964, Hockney taught at the University of Iowa and, in addition to completing *Man in Shower in Beverly Hills* (begun in Los Angeles), he painted *Iowa*, *Arizona*, *Cubist Boy with Colourful Tree* and *The Actor*.

In his autobiography, the artist wrote that all the homes of Californian collectors he visited had 'large comfortable chairs ... and pre-Columbian or primitive sculptures'. The figure here, whose head is based on an Ancient Egyptian sculpture of a princess, represents such a collector. The painting, which includes a stylized vase of lilies and part of a sculpture by William Turnbull, can even be conceived as a development of the theme of *California Art Collector* (plate 19). The identification of collectors with 'primitive' sculptures, hinted

at in the earlier work and used to suggest the collector's limited aesthetic appreciation, is now complete.

The figure has been positioned in front of two curtains in order to evoke a parallel with the standing woman on the right of Picasso's *Les Demoiselles d'Avignon* (fig. 55). Hockney would thus seem to be implying that Californian art collectors are little better than whores, that their marriages amount to little more than commercial agreements.

He also said of the collectors' homes: 'I'd never seen houses like that. And the way they liked to show them off!...They would show you the pictures, the garden, the house.' As the title and podium suggest, the collector is here depicted during such a performance.

Fig. 55 Pablo Picasso, *Les Demoiselles d'Avignon*, 1907. 244 x 244 cm (96 x 96 in.). The Museum of Modern Art, New York

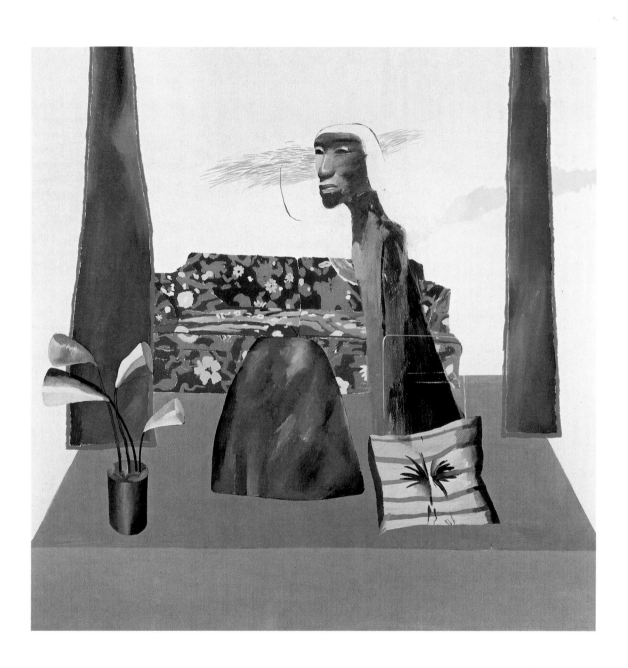

21 *Atlantic Crossing* 1965
Acrylic on canvas, 183 x 183 cm
(72 x 72 in.)
Ludwig Forum für Internationale Kunst,
Aachen

At the beginning of November 1965, Hockney travelled to England with Patrick Procktor and Robert Lee Earles III on board the SS *France*. En route he produced a drawing of Earles, *Bob, 'France'*, which the artist described in his autobiography as being 'of a marvellous beautiful pink bottom, and that's really all he [Earles] had in his favour, I suppose'.

Hockney was deeply impressed by the ocean and the winter sky on this crossing and, on his arrival in London, attempted to represent the seascape in the present painting. The dark-fringed clouds, whose forms derive from Jean Arp's 'Human Concretions' of the thirties, resemble old theatrical properties, as do the first two rows of waves.

A number of Hockney's other paintings from this period also make reference to the theatre. During 1963, he often identified the field of pictorial action as a stage (see plate 13, fig. 32) and, after completing *Atlantic Crossing*, he painted *A Theatrical Landscape*. In 1966, Hockney designed the sets for a revival of Alfred Jarry's 1896 satire *Ubu Roi* at the Royal Court Theatre, London. 'When I was doing that', he told Mark Glazebrook in 1970, 'I suddenly realised that a theatrical device in a painting is quite different to a theatrical device in the theatre. A theatrical device in the theatre is correct. In a painting it's something else.' *A Bigger Splash* (plate 27) represents the culmination of the artist's interest in using theatrical devices in paintings.

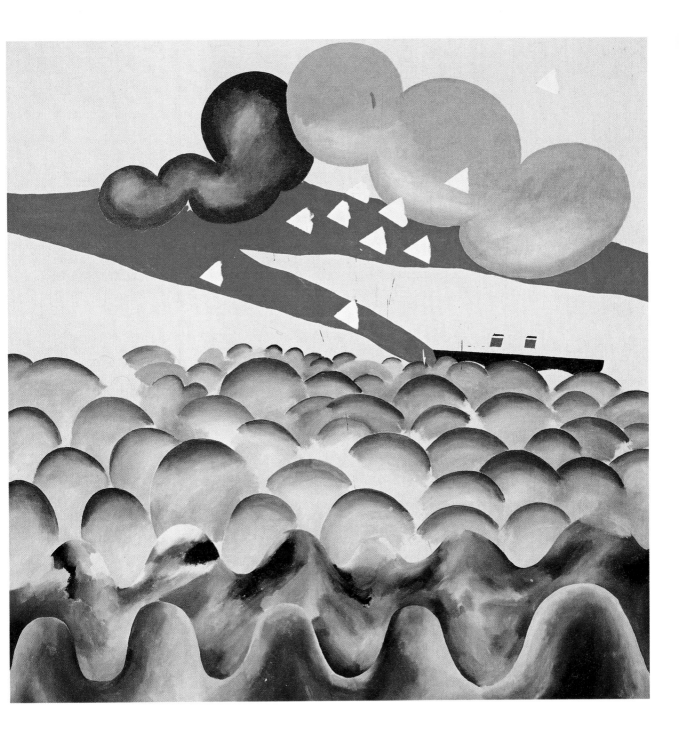

22 *Portrait Surrounded by Artistic Devices* 1965

Acrylic on canvas and paper,
153 x 183 cm (60 x 72 in.)
The Arts Council of Great Britain

On his return to London in December 1964, Hockney painted three still lifes: *Blue Interior and Two Still Lifes*, *Picture of a Still Life* and *Portrait Surrounded by Artistic Devices*. The series was continued over the summer in Boulder – where he taught at the University of Colorado – with *A Realistic Still Life*, *A More Realistic Still Life* and *A Less Realistic Still Life*. In these pictures, Hockney was concerned both to address Modernist abstraction and to signify the distinctness of his own work. It has remained a consistent feature of his practice since 1961 that such encounters and detachments are signified by the representation of styles.

Since the title of this painting tells us he has depicted a portrait, and not merely painted a figure, the other elements also have to be understood as bearing a likeness only to works of art. The shadow and the pink circular floor are appropriations from the work of Francis Bacon; the portrait is based on a drawing of the artist's father

(fig. 56); the collection of cylinders makes reference to Cézanne's dictum that everything in nature can be reduced to a cone, sphere or cylinder; and the abstract marks are 'quotations' from American abstraction, as is the technique of staining unprimed cotton duck with diluted acrylic.

Composed of ready-made images, the painting is a manifesto proclaiming – as *Invented Man Revealing Still Life* (plate 40) was to ten years later – Hockney's desire to resolve the schism between abstraction and figuration that had existed for a number of years within the professional world of modern art. In paintings produced from 1965 to 1967, the artist attempted to put into practice his own precepts: in *California* (plate 23), the figures are surrounded by excerpts from paintings by Jean Dubuffet and Colour Field Abstractionists, while in *Savings and Loan Building* (plate 25), six palm-trees are shown in front of a visual cliché for Minimalism.

Fig. 56 *Kenneth Hockney*, 1965. Ink on paper, 43 x 35.5 cm (17 x 14 in.). Private collection

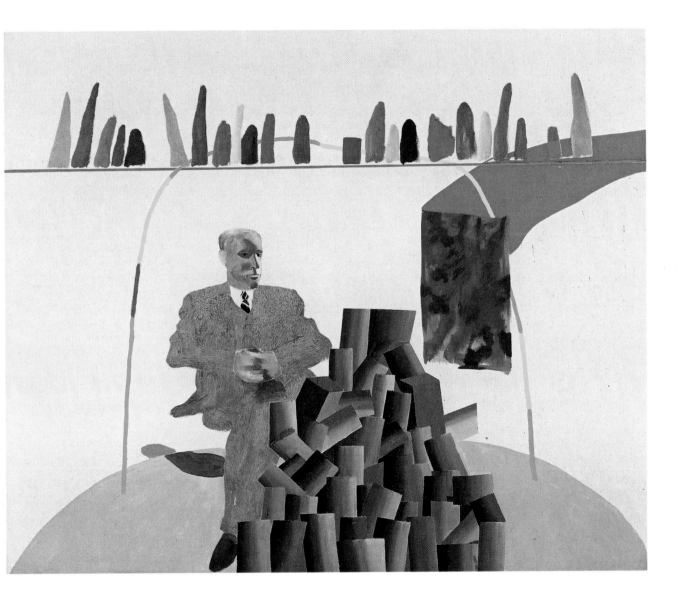

23 *California* 1965
Acrylic on canvas, 153 x 198 cm
(60 x 78 in.)
Private collection

Hockney has often spoken of the aesthetic pleasure he derives from abstract art. Here, forms fitting together like jig-saw pieces have been appropriated from Jean Dubuffet's *L'Hourloupe* series to represent the opacity and movement of water in a pool. The visual and intellectual delight thereby obtained augments the pleasure derived from the sight of two naked adolescents, for which *Physique Pictorial* once again provided the source of imagery (fig. 57).

From 1965 to 1967, nude adolescents in, or by, a swimming pool were a recurring motif in Hockney's work. These paintings have been seen by many as a reinterpretation of the myth of Arcadia, and also as positive affirmations of homosexual desire. It is important to recognize, however, that the boys are usually shown, as here, to be passive erotic objects for the spectator's gaze. There is an emphasis upon their buttocks, which have not only been positioned towards the centre of the composition, but also enlarged; and the boys' facial expression, unlike that of those in the *Physique Pictorial* photograph, is sullen. This painting implies a spectator whose gaze asserts control (to which the relatively high viewpoint contributes) in the manner familiar from the age-old tradition of the female nude in art. This suggests that such works by Hockney exist in an ambiguous relationship to traditional male power, neither fully within it nor fully outside it.

Reproduced here in colour for the first time, *California* was painted at the artist's London studio early in 1965 and is a variation on the theme of *Portrait Surrounded by Artistic Devices* (plate 22). Hockney considers it to be one of his most important pool paintings and, since it was unavailable for loan to the 1988 retrospective of his work, he made a copy from a black-and-white reproduction in 1987.

Fig. 57 Photograph published in *Physique Pictorial*, January 1963, p. 14

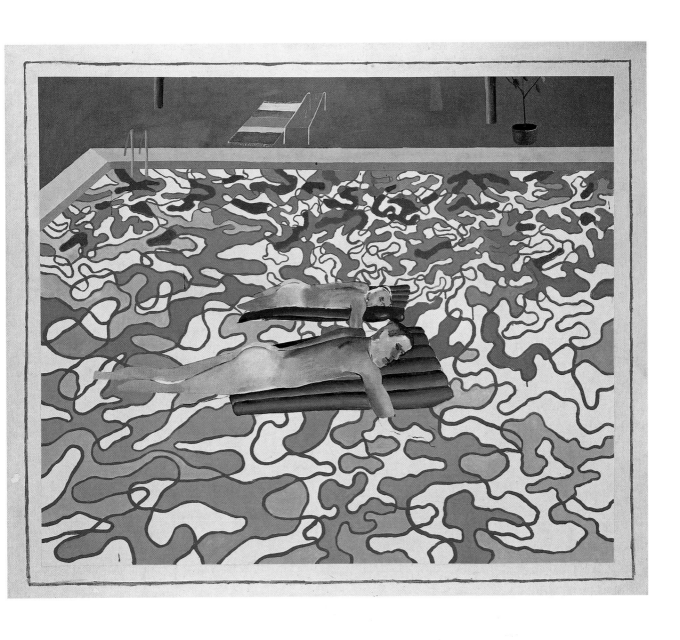

24 *A Hollywood Garden* 1966

Acrylic on canvas, 183 x 183 cm
(72 x 72 in.)
Hamburger Kunsthalle, Hamburg

Although Hockney produced his first landscape painting in 1961, it was only after his arrival in Los Angeles that he became interested in gardens as subjects. Traditionally viewed as symbols of paradise on earth (an association made explicit in *California Art Collector*; plate 19), they provided the natural setting for his images of naked adolescents in swimming pools. Yet the principal attraction of Californian gardens was that there was so little about them that was natural: they represented the triumph of artifice over nature. Hockney's first painting in Los Angeles was of a plastic tree in front of the City Hall, and, in subsequent works, trees were represented in a variety of styles, were shown to be dowdy and ill-designed when compared to garden umbrellas (as in the drawing *Hollywood Garden*; fig. 58) and could even be used, as in this painting, to suggest a drama in the manner of Joan Miró.

The apartment building featured here belonged to a condominium in which Hockney's friend Nicholas Wilder lived; it can be seen again in *Portrait of Nick Wilder* (plate 28). The leaves of the principal palm-tree, which bear a striking resemblance to those in *Beverly Hills Housewife* (1966), were painted last, a curious feature being the presence of a shadow cast by the leaf that Hockney chose not to complete.

It was not until the early nineties that Hockney's paintings show him to have become interested in the idea of nature as a symbol of the sublime.

Fig. 58 *Hollywood Garden*, 1965. Crayon and watercolour on paper, 49 x 60 cm (19 x 23 1/2 in.). Mr and Mrs Alan Bowness, London

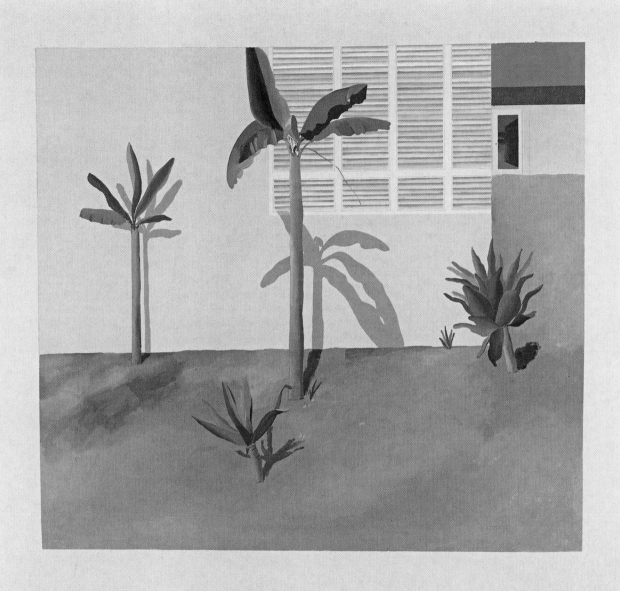

25 *Savings and Loan
 Building* 1967
 Acrylic on canvas, 122 x 122 cm
 (48 x 48 in.)
 Private collection

In the sixties, it was widely believed that, if a painting were to qualify as 'modern', it had to concentrate on its inherent flatness. Literal identification of colour with the surface of the canvas (by staining acrylic paints into unprimed cotton canvas, for example), together with the concomitant loss of reference to the physical world (the surface of the work was to be its only content), was understood by leading American artists, and critics, to serve as the foundation for the modern practice of painting.

Much of Hockney's work from the mid-sixties reflects his increasingly critical view of this conception. To establish his position, and to enable the spectator to consider it, he appropriated those very qualities that he aimed to deprecate. In this painting, for instance, he did so by representing a Modernist building in such a way, parallel to the plane of the canvas, as to create an optical ambiguity between its facade and the surface of the painting. Depicted flatness (the facade) becomes literal flatness (the surface of the picture plane) and then returns to its former state as we become aware of the palm-trees and the structure

on top of the building, at right. To achieve this kind of tension, the painting has to be large enough to occupy much of the spectator's field of vision.

The fact that the surface of this painting is emphasized as a substantial object in its own right suggests that Hockney did have a genuine interest in, and appreciation of, Modernist abstraction. His unwillingness to disallow the representational possibilities of the painted surface establishes a critical distance, however. A number of colour crayon drawings of Californian banks, related to this painting, were shown at Kasmin Limited, London, in September 1968. Reviewing the exhibition for *The Times*, Guy Brett noted that Hockney was chiding American Minimalism in the drawings.

Savings and Loan Building belongs to a series of representations of residential, public and commercial buildings in Southern California that includes *Plastic Tree Plus City Hall*, Hockney's first painting produced in Los Angeles; *Building, Pershing Square, Los Angeles* (1964); *California Bank* (1964); *An Apartment Block on Sunset Boulevard* (1965); and *Medical Building* (1966).

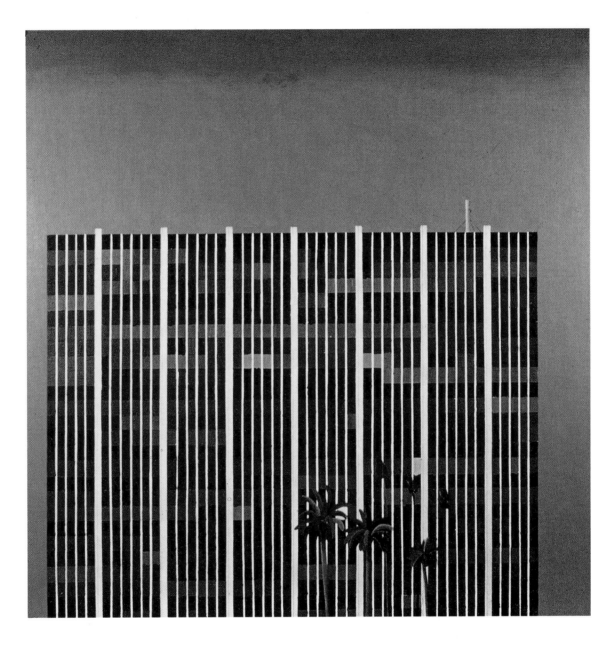

26 *A Lawn Being Sprinkled* 1967
Acrylic on canvas, 153 x 153 cm
(60 x 60 in.)
Private collection

Hockney's engagement with Modernist abstraction, raised in the discussion of *Savings and Loan Building* (plate 25), also informs this painting. The illusion of depth is countered by a number of means: for example, the lawn does not become appreciably lighter in tone as it moves into the middle distance; the lines formed by the tiles on the roof would never converge on a vanishing point; the sprays of water do not possess volume. Our attention thus constantly returns to the literal surface of the canvas, and our ability to fix the spatial positions of the two palm-trees and two plants is thereby weakened. This produces a sense of dislocation, augmented by the subject. This is not a candid commemoration of life in California, but an image composed from signs used by magazines to represent the life-style of the middle class (the lawn, for example, has the impersonal tidiness of a recently vacuumed carpet). Appearances imply deception when they are maintained too long.

Fig. 59 *Lawn Sprinkler*, 1966. Coloured pencils on paper, 43 x 35 cm (17 x 13 3/4 in.). Whereabouts unknown

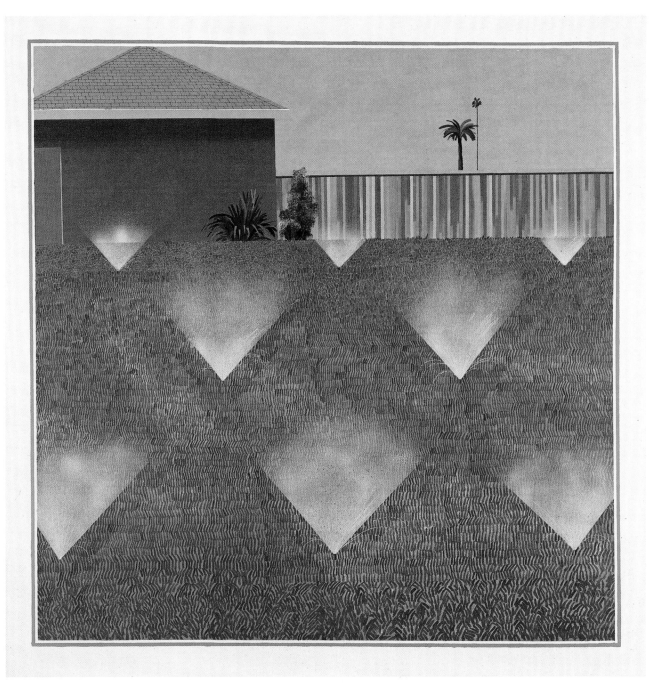

27 *A Bigger Splash* 1967
Acrylic on canvas, 243.8 x 243.8 cm
(96 x 96 in.)
Trustees of the Tate Gallery, London

Towards the end of 1966, Hockney painted *The Little Splash* (fig. 60) and *The Splash*, both of which contain a stylized reference to Jackson Pollock's 'drip' paintings. With these works he returned to a subject investigated in *Picture Emphasizing Stillness* (plate 10), in which the time taken to make the painting is forcefully contrasted with the instantaneousness of its subject, a 'still'.

Sometime between April and June of the following year, the artist produced *A Bigger Splash*. Why, we may ask, did Hockney return to this subject for a third time; what is signified by the size of this painting; why did he find the duration of both the splash and its representation so fascinating; and what meanings could the image of a splash be made to convey to other people in 1967?

The summer 1967 number of *Artforum* carried an essay, 'Art and Objecthood', in which Michael Fried attempted to clarify and resolve the deep schism that had existed for a number of years within the professional world of modern art. The essay constituted a defence of Modernist abstraction and a sustained attack on Minimal art, which presented a distinct challenge to the former's authority. To a large extent, Fried's argument is based on Minimalism's concern with the spectator: whereas a work of Modernist abstraction is 'absorbing' (and the spectator's sense of time and place is therefore suspended), a

Minimalist piece distances the spectator, so that the experience of it 'persists in time'. Fried held that the relationship of the spectator to a Minimalist piece can be invested with drama, can be made theatrical (he described Minimal objects as possessing 'a kind of *stage* presence'). For Fried, the survival of authentic modern art, characterized by an experience of 'absorption', had come to depend increasingly on its ability to defeat 'theatre'.

In the spring or summer of 1967, Hockney set out to re-work the explicit subject of two earlier paintings on a huge canvas (the largest of his whole California series), suggesting that this was to be a monumental painting in the 'modern tradition', as well as one that would somehow resolve his personal and technical concerns. Like *Savings and Loan Building* and *A Lawn Being Sprinkled* (plates 25, 26), each completed before March 1967, it draws both on Modernist abstraction and on ideas central to Minimalism (the preoccupation with the duration of experience, for instance, is nothing but 'theatrical'). The arguments and ideas to which Fried's essay serves as a useful index offer a framework within which to think about Hockney's practice prior to *A Bigger Splash*. At the very moment Fried sought to defend the crumbling authority of Modernism, however, Hockney felt free to pursue a more naturalistic approach.

Fig. 60 *The Little Splash*, 1966. Acrylic on canvas. 41 x 51 cm (16 x 20 in.). Private collection

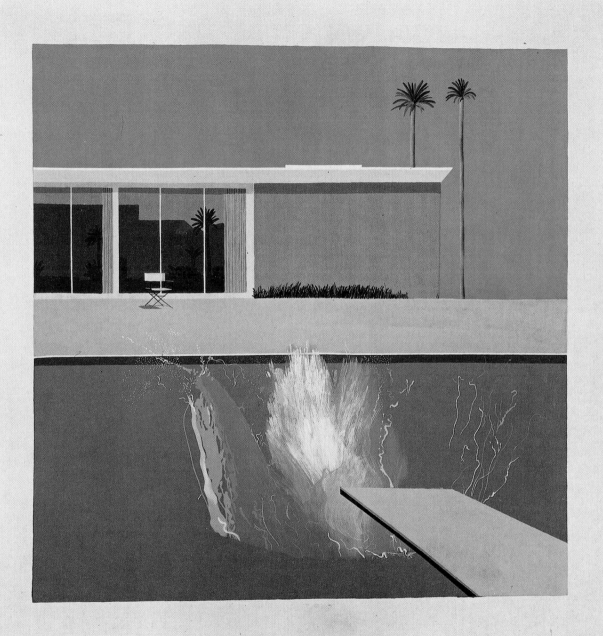

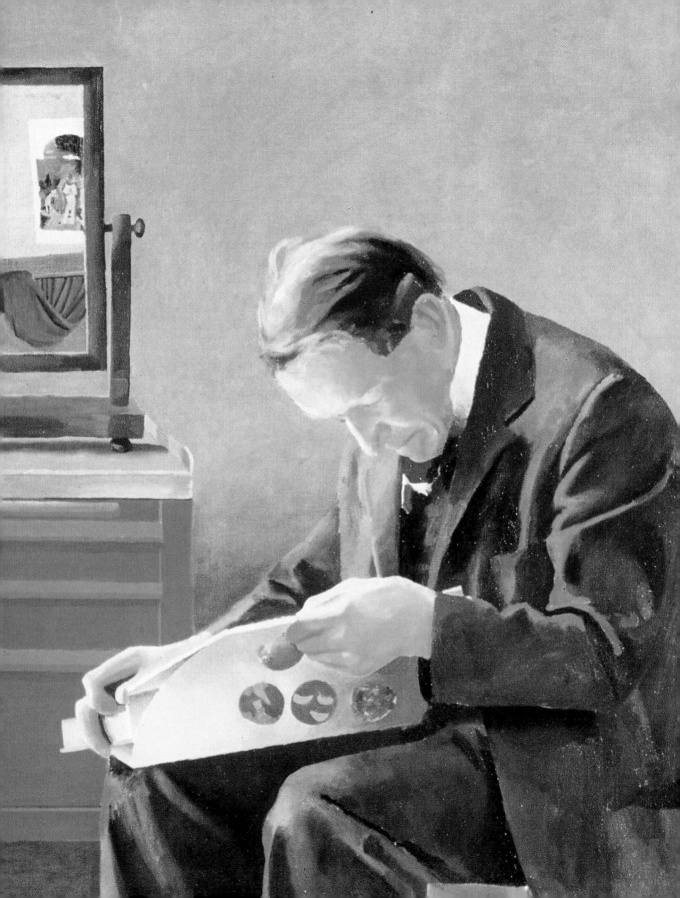

1967-1979

Portraits

Fig. 61 *The Room, Manchester Street*, 1967.
Acrylic on canvas, 244 x 244 cm (96 x
96 in.). Private collection

A comparison of *Portrait Surrounded by Artistic Devices* with *Portrait of Nick Wilder* (plates 22, 28) reveals that, by 1966, Hockney was beginning to intensify the degree of resemblance between the visual sign and the object it represents. The portrait of Wilder is surrounded by fewer 'artistic devices' and more naturalistic signs. Following *A Bigger Splash* (plate 27), a profound shift occurred in Hockney's practice: the naturalistic sign came to be used in association with the conventions of perspective. (*Portrait of Nick Wilder* had not depended on perspective – the stairwell, for instance, is shown parallel to the picture plane.) His September 1967 portrait of Peter Schlesinger, *The Room, Tarzana* (plate 29), represents Hockney's first use of perspective for many years. The illusion of space in his October 1967 portrait of Patrick Procktor, *The Room, Manchester Street* (fig. 61), also relies on perspective: all the receding lines have been organized so that, if extended, they would converge on one area – his friend's pelvis.

When, in his autobiography, Hockney discussed *The Room, Tarzana*, he recalled this change of approach: 'I realized the light in the room was a subject and for the first time it became an interesting thing for me, light. Consequently I had to arrange Peter so the light was coming from the direction of the window. Before, I wouldn't have bothered to think of things like that this is the first time I'm taking any notice of shadows and light. After that, it begins to get stronger in the picture And it all became a more and more traditional way of painting a picture. I think it was this, in a way, that led later on to almost excessive naturalism. And I found moving away from *that* harder than moving away from anything else.'

It may appear as though this shift in the means of representation was simply a consequence of Hockney's wish to produce portraits that described the sitters' appearance. From the beginning of 1968, he did indeed spend ten years making portraits, many of them featuring two people, friends or relations, just under life-size. This series includes such major canvases as *Henry Geldzahler and Christopher Scott, Mr and Mrs Clark and Percy, Portrait of an Artist (Pool with Two Figures)* and *My Parents* (plates 31-3, 35), and it is for these double portraits that the artist is probably best known – *Mr and Mrs Clark and Percy* is reputed to be the most popular item in the collection of the Tate Gallery, London. Yet Hockney need only have employed the naturalistic sign – and not perspective – if he had merely wanted to portray in greater detail two people in a relationship. Instead, the higher degree of naturalism is used in conjunction with perspective so that he could depict *his* relationship to the people portrayed; for the perspective system employed produces not only a point from which the spectator is to view the painting, but also indicates the artist's position within it. It is above all this triangular relationship that distinguishes these works from his previous depictions of relationships – for example, *We Two Boys Together Clinging, The First Marriage (A Marriage of Styles I)* and *California Art Collector* (plates 5, 11, 19).

The issues raised here are complex, and it is perhaps best to discuss them in relation to specific works. In both *Christopher Isherwood and Don*

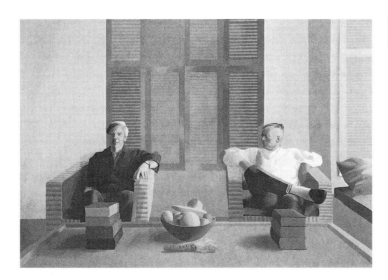

Fig. 62 *Christopher Isherwood and Don Bachardy*, 1968. Acrylic on canvas, 212 x 304 cm (83 $^1/_2$ x 119 $^1/_2$ in.). Private collection

Bachardy and *Henry Geldzahler and Christopher Scott* (fig. 62, plate 31), the figures are placed in a precisely triangulated space: the vanishing point in the former is created by the receding lines of the table's edges and lies just above a point mid-way along a line between the figures' eyes; in the latter, the point is a few centimetres above Geldzahler's head, and all the receding lines of the glass table and parquet floor, if extended, would meet there (see fig. 63). If an illusion of space is to be obtained without lateral distortion, the codes of perspective require that the viewer take up a position along an axis that passes through the vanishing point and is perpendicular to the picture plane. As the spectator moves into the viewing position offered, however, his or her own scale is diminished: in normal viewing experience, our eyes would only be level with Bachardy's or Geldzahler's if our body were lowered – that is, if we were seated. The spectator is addressed as a physical, bodily presence, a form of address underscored by the scale of the figures (consonant with that of the viewer's body) and by the implied continuity between the ground-plan of the room occupied by the figures and that occupied by the spectator. These factors address the viewer as though he or she were seated at a point in front of the table depicted in each painting, and because of this strong bond with the spectator's body, there is a tendency towards *trompe-l'œil*. The perspective system Hockney employs is an empirical one, used by early Renaissance artists – Piero della Francesca, for example.

As the viewer adopts the position that the paintings suggest, he or she becomes the focus of the entire scene. The figures are shown fully aware of the presence of a third person, towards whom their pose, their glances and their relationship to one another are directed. These portraits are not simply of relationships between two people; they are depictions of couples entering into a relationship with a third party – Hockney, since the viewpoint we are offered corresponds exactly to that adopted by him.

Despite his skills, Hockney is renowned for his reluctance to accept commissions for portraits. The reason is surely that his interest lies not so much in depicting couples or single figures as in portraying his relationship to them.

Both paintings also contain at least one other vanishing point, however. In the portrait of Geldzahler and Scott, this is created by the reflections on the glass table and by the windows of the skyscraper on the right and is situated below Scott's arm, shown rigid in order to direct the viewer's eye towards it. In the portrait of Isherwood and Bachardy, a separate vanishing point is created by each of the wicker chairs. These secondary vanishing points are, unlike the first, located in a zone that the body of the spectator cannot occupy and therefore entail a quite different conception of the viewing subject – as a disembodied point. This perspective system is a theoretical one, frequently used in post-Renaissance art.

These two paintings are thus divided into zones of empirical and theoretical perspective, a division that is acknowledged in specific areas of both works. In the portrait of Geldzahler and Scott, the lower storeys of the skyscraper on the left cohere around the empirical vanishing point, whereas its upper two storeys cohere around the theoretical vanishing point, a conflict that causes the building to appear warped. Despite the apparent naturalism of the painting, this building would be difficult to construct.

In the second portrait, Isherwood, Bachardy and the table cohere around the empirical vanishing point, the chairs around the separate theoretical vanishing points. The chairs are impossible to locate precisely since, like the skyscraper in the portrait of Geldzahler and Scott, they too are warped. As a consequence, one side of Bachardy's body appears to be placed in front of his chair.

This conflict between dimensional systems is not due to lack of skill on Hockney's part; rather, he uses it to comment on the relationships de-

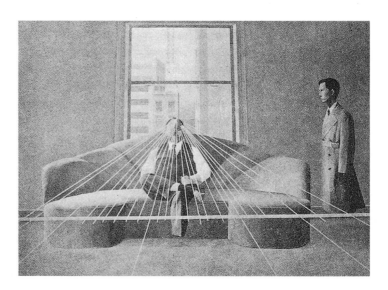

Fig. 63 Photograph of *Henry Geldzahler and Christopher Scott* in the artist's studio, 1969

picted. In the portrait of Isherwood and Bachardy, the figures are shown not to fit comfortably within the domestic interior. In the portrait of Geldzahler and Scott, the relationship of Geldzahler to Hockney – the primary relationship – is interrupted by Scott, just as the foreground space, organized around the empirical vanishing point, is interrupted by the reflections on the table, organized around the theoretical vanishing point.

These meanings, created by the means of representation, are reinforced by Hockney's decision to depict each couple as a sharply contrasted pair: Isherwood is in profile, his torso light, whereas Bachardy is shown frontally, his torso dark; Geldzahler is shown seated, frontally, and relaxed, whereas Scott is in profile, almost standing to attention. No absolute test of correctness exists to tell the viewer how to interpret these oppositions – their meaning depends on their context. In the first painting, of a homosexual 'marriage', it may be that the oppositions are used to represent the roles assumed by Isherwood and Bachardy, determined in part by the marked difference in their ages (in 1968, Isherwood was 63, Bachardy 33). When Stephen Spender raised the subject with Bachardy in 1990, he replied: 'Oh yes, we were father and son, teacher and pupil, *and* lovers. And that made it richer, I think, for both of us. And we could move back and forth in those roles almost imperceptibly.' That Isherwood is shown here directing a disapproving stare at Bachardy (the arrangement of the fruit in the bowl suggests that the disapprobation is of a sexual nature) while the latter, oblivious to this, enters into a relationship with Hockney, may constitute a comment on one consequence of this difference in age. In his autobiography, Hockney tells us that Isherwood discussed his 'marriage' while sitting for him: 'I do remember he said Oh David, don't ever get too possessive about your friends; let them feel free. Later I think he was a bit hurt that Don stayed away a long time.' Bachardy was absent for much of the time when Hockney was painting this double portrait.

In the portrait of Geldzahler and Scott, the two figures are also sharply contrasted in order to suggest the particular interaction that marks this homosexual relationship. Geldzahler himself has commented that Hockney 'sees Chris as coming and going'.

In order that the means of representation can be used to comment on the nature of the relationships depicted, mimetic and perspectival considerations are intentionally not quite synchronized. In *Mr and Mrs Clark and Percy* (plate 32), this becomes particularly clear. As in the two portraits discussed above, the picture includes a table, but it has not been articulated smoothly within the space occupied by the married couple. As a consequence, the husband and wife, and their domestic interior, seem to belong to a detail from a large painting or painted backcloth that is situated in a space behind the table. As with the garden in *Le Parc des sources, Vichy* (plate 38), the main object of the spectator's attention appears as an illusion when seen in conjunction with the objects in the foreground. Hockney is suggesting, it would seem, that the marriage depicted is only virtual.

How much weight one wishes to accord such interpretations in an analysis of these portraits is, of course, a matter of individual taste. Avoid-

ance of detailed discussion of content does have much in its favour, particularly since spurious meanings can so easily be ascribed to the paintings. In his autobiography, Hockney recollects an interpretation of his portrait of Isherwood and Bachardy: 'I remember somebody asked why there were four books in front of Don and only three books in front of Christopher. Was this because Don wasn't as well-read and needed more? Amazing what people can read into pictures.'

That Hockney, even *in absentia*, is to be considered an integral part of such works is suggested by objects depicted in them and not only by the viewpoint offered to the spectator. For example, although the portrait of Geldzahler and Scott is set in their New York apartment, the glass table and vase of tulips belonged in Hockney's London studio. That they are to be understood as signs of the artist's presence, and are not just the result of a fortuitous decision, can be illustrated by reference to another portrait of Geldzahler, *Panama Hat* (fig. 64).

In 1972, Geldzahler asked Hockney to produce an etching for a charity and later recalled the ensuing dialogue: 'David said, "Let me do a portrait of you" and I said "You really can't because I am fund-raising for them. It would look a little funny." So he said, "Well", and just sat down with an etching plate and in about an hour, he did my jacket, my hat, my pipe and my iced coffee. I like that print because it's a portrait of a subject with the subject missing.' Thus, since an explicit portrait was not permissible, Hockney composed one drawn from Geldzahler's accoutrements. Because *Panama Hat* is structured metonymically, by relations of contiguity, rather than metaphorically, by relations of similarity, it could only be recognized as a portrait by people who knew Geldzahler well. Metonymy accorded this image the necessary degree of privacy to enable Geldzahler to use it without being censured.

Fig. 64 *Panama Hat*, 1972. Etching and aquatint, 42 x 34 cm (16 1/$_2$ x 13 3/$_8$ in.). Edition of 125

Fig. 65 *Still Life on a Glass Table*, 1971-2. Acrylic on canvas, 183 x 274.5 cm (72 x 108 in.). Collection of Mr and Mrs Ahmet Ertegun

Fig. 66 *Chair and Shirt*, 1972. Acrylic on canvas, 183 x 183 cm (72 x 72 in.). Private collection, UK

With the mechanism of metonymy in mind, one can interpret *Henry Geldzahler and Christopher Scott* as being primarily concerned with Geldzahler's relationship to Hockney – not to Scott or the spectator of the painting. The principal difference between the finished work and its study is that a table belonging to Hockney was substituted for the circular one – it is a metonym for the artist, as is the vase of tulips (cf. plate 31 and fig. 72). The table and vase of tulips were used again in *Still Life on a Glass Table* (fig. 65).

One can also understand a number of other works as portraits or self-portraits, even though no figure is shown in them. *Chair and Shirt* (fig. 66), for instance, appears to be about more than its literal subject; it seems to convey a vivid emotional content while, as it were, pretending not to do so. It is enigmatic, as are other paintings by Hockney from 1972 – *Still Life on a Glass Table* and *Portrait of an Artist (Pool with Two Figures)* (plate 33), for example. If one assumes that its vivid subject is autobiographical in nature, then, in order to establish what that subject might be, one needs to undertake a causal enquiry, to reconstruct the metonymic chain by which the shirt becomes expressive of, or refers to, some specific event or feeling. It should be acknowledged, however, that this can be difficult, if not impossible, for someone outside Hockney's circle: as *Panama Hat* illustrated, metonyms accord a degree of privacy.

At the beginning of 1968, the artist decided to return to Los Angeles to live with Peter Schlesinger; they rented a small apartment on 3rd Street in Santa Monica and Hockney found a studio nearby. In his autobiography, he notes: 'They were very happy times; once we were in the house, I didn't care if I went out to see anybody or not, whereas before that, when I lived in California, I was a roamer, I had to go out. It was because of Peter.' *Peter, Santa Monica* (fig. 67) and *Peter Running, Santa Monica* are drawings that date from those few happy months. Following the trau-

Fig. 67 *Peter, Santa Monica*, 1968. Crayon on paper, 43 x 35.5 cm (17 x 14 in.). Collection of the artist

matic ending of their relationship in September 1971, Hockney decided to ask Mark Lancaster to accompany him on a trip to Japan in the hope that it would help him to take his mind off what had happened. Hockney awoke one morning and saw a shirt lying on a stool. Half-awake, he thought it was the shirt that Schlesinger had worn when he drew him three and a half years earlier. Although he soon realized that it must belong to Lancaster, he decided to produce a drawing of the scene, *Suginoi Hotel, Beppu* (fig. 68) – this served as a study for a painting produced early in 1972, which the artist subsequently destroyed – and arranged the shirt on a chair for a photograph that he used as a study for the large painting *Chair and Shirt*.

It would seem that the sight of this shirt in 1971 evoked, or referred to, a specific period in Hockney's relationship with Schlesinger and, by showing it as though cast aside in both the destroyed painting and *Chair and Shirt*, he was able to use it in 1972 to represent or express his own feelings about that relationship some months after its end. One assumes that those who knew Hockney well were potentially able to respond to the 'language' of *Chair and Shirt* and to transfer that response to other works. In 1976, for example, Geldzahler wrote that *Still Life on a Glass Table* 'is as autobiographical as the late paintings are permitted to get'. What may appear to the public to be quite 'neutral' images seem to be invested with intense significance to those within Hockney's circle. What is of interest is that such meanings are not so much exclusive as publicly kept at bay.

The metonymical process enables many works to be easily recognized as self-portraits by people outside the artist's circle – for instance, *Mirror, Casa Santini* (fig. 69). What such images represent, however, is Hockney's

Fig. 68 *Suginoi Hotel, Beppu*, 1971. Crayon on paper, 35.5 x 43 cm (14 x 17 in). Private collection, London

public identity, his *persona*, not his private self, his *person*. In *Mirror, Casa Santini*, for example, it is his ties we are shown and not his reflection. The process by which personae are manufactured is complex, but we may note that the leitmotivs of the artist's persona during this period are the striped rugby shirt and the vase of tulips (one wonders if he appreciated that tulips are traditionally used to symbolize a 'showy' person). Signs of his persona are depicted in numerous works from this time and serve not only to authenticate his work, by functioning as a kind of signature, but also as promotional devices. When the Royal Opera House in London commissioned a portrait to mark the retirement of its General Administrator, Sir David Webster, they received a painting that contained a portrait on the right and an advertisement for Hockney, the vase of tulips, on the left. The picture is usually hung on the staircase to the Royal Box.

Works of this kind exemplify Hockney's unwillingness to offer psychological insights into his own character; he simply plays a role for the public, in order to satisfy its expectations of who he is. Since he had achieved celebrity status by the early seventies (*A Bigger Splash*, a feature-length film about him, was released in 1974), it is perhaps understandable that he withdrew from the dangers – real or imagined – of self-exposure by using oblique metonyms to deal with feelings of loss, negation or rejection in, for example, *Chair and Shirt*, *Still Life on a Glass Table* and *Portrait of an Artist (Pool with Two Figures)*. Even the photographic portrait used on the cover of his autobiography, published in 1976, is of Hockney's persona and not his person (fig.70). The portrait shows another persona behind the first, as though to emphasize the fact that the book makes few appeals to psychological or biographical notions of 'depth'. This *is* a book that can be judged by its cover.

A persona, or front, is inappropriate to subjects that do require an insight into Hockney's own character. In 1975, he attempted to represent his relationship to his parents – referred to literally by means of the triangle in the background (fig.73). However, while he depicts himself both metonymically (by the paint trolley and tulips) and literally (by his reflection in the mirror), it is his persona, not his person, that he shows. It would seem not only that Hockney was unwilling to represent his feelings explicitly during the seventies, but also that he was unable to do so. It may come as no surprise, therefore, to learn that he abandoned this painting after two years and that the second version, *My Parents* (plate 35), primarily concerns the relationship of his mother and father to one another: although the paint trolley and tulips are still present, his face has been replaced by the reflection of two works of art. Apparently, Hockney could find no way to include himself in a painting that demanded he portray his person, and thus omitted himself. In 1970, he produced a study for a self-portrait with Peter Schlesinger. The double portrait never materialized, and perhaps this, too, was due to Hockney's inability to depict his person. Even *Self-Portrait with Blue Guitar* and *Model with Unfinished Self-Portrait* (fig.74, plate 36) present only his artistic persona – the rugby shirt and vase of tulips.

Fig. 69 *Mirror, Casa Santini*, 1973. Crayon on paper, 43 x 35.5 cm (17 x 14 in.). Private collection

Fig. 70 Photograph of the artist by Peter Schlesinger, a detail of which was used for the cover of *David Hockney by David Hockney* (1976).

Fig. 71 *Self-Portrait on the Terrace*, 1984.
Oil on two canvases, 213 x 305 cm (84 x
120 in.). Rita and Morris Pynoos

During a conversation with the artist in 1980, Marco Livingstone
suggested that Hockney's reluctance to draw himself might indicate that
he refused to examine himself closely. 'There's something of that in it, I
think, that I do stop short,' the artist replied. 'I admit I avoid some
things about myself, as I avoid some things about life. Partly I'm aware
that in the past there was an innocence of vision and is there still at
times, but I'm also aware that perhaps it can't go on, might not go on
.... I think if I looked at myself carefully, it would probably be the end of
that innocent vision. Maybe therefore I should do it.'

That Hockney did come to draw himself, in 1983 (see fig. 92), sug-
gests that his 'innocence of vision' had finally come to an end. His prac-
tice certainly underwent a distinct change, foreshadowed by *Divine* of
1979 (plate 37), during the eighties and this entailed a shift to an emo-
tionally open and expressive approach. *Self-Portrait on the Terrace* (fig. 71),
for example, is explicitly concerned with the artist's feelings of remoteness
from a loved one, perhaps even with his inability to form genuine relation-
ships in general. One can only speculate on the causal conditions of this
shift.

Although Hockney's practice as a portrait painter represented a com-
plete rejection of the ideas associated with American Modernism, whose
critical force had so preoccupied him from 1965 to 1967, it also demon-
strates that he had assumed that the questions concerning the nature of
representation that had been posed by the pre-war European tradition of
modern painting could be ignored. In retrospect, he realized that it had
been a mistake for him to have done so, and in a series of drawings, prints
and less ambitious paintings in the seventies, he began to investigate early
modern art, particularly Cubism. This interest in mimesis, perspective *and*
early Modernism, which is often unnaturalistic, appears to have caused
that severe painting 'block' in the years 1974 to 1976 which he discusses

in his autobiography. Even as late as 1977, he was still unable to establish a critical distance from that form of academic naturalism which had characterized much of his work since 1973 (see figs. 75, 76): his 1977 portrait of Geldzahler, *Looking at Pictures on a Screen* (plate 34), for example, turned out to be more naturalistic than he had intended. As already mentioned, the 1979 portrait of Divine foreshadows a new beginning in Hockney's practice, one that is less dependent on the naturalistic sign and the conventions of perspective and more openly expressive.

28 *Portrait of Nick Wilder* 1966
Acrylic on canvas, 183 x 183 cm
(72 x 72 in.)
Fukuoka Sogo Bank, Japan

From June 1966 to July 1967, Hockney had a studio on Pico Boulevard in Los Angeles and for some of the time lived in Nicholas Wilder's apartment in West Hollywood. The apartment belonged to a condominium, which formed the setting for this portrait of Wilder and which is featured in *Peter Getting Out of Nick's Pool* and *A Hollywood Garden* (plate 24), both also from 1966.

We may note that Wilder is an identifiable individual (the title records his full name) and that much of the painting is given over to a description of the apartment and pool, which serve as signs for his affluence. One of the principal pleasures Wilder will have derived from this portrait is that of seeing himself depicted as wealthy – a man of property.

The curve of the pool, the horizontal line formed by the intersection of the building and ground, the vertical line of the edge of the building and the diagonal one created by the staircase all meet at Wilder's head. This has been depicted so as to resemble a Classical bust; the portrait thus documents not only Wilder's appearance and social status, but also conveys something of his personality.

Wilder owned a well-known art gallery on La Cienega Boulevard and was later to represent Hockney in Southern California. This was one of the artist's first painted portraits since *Play within a Play* (plate 13).

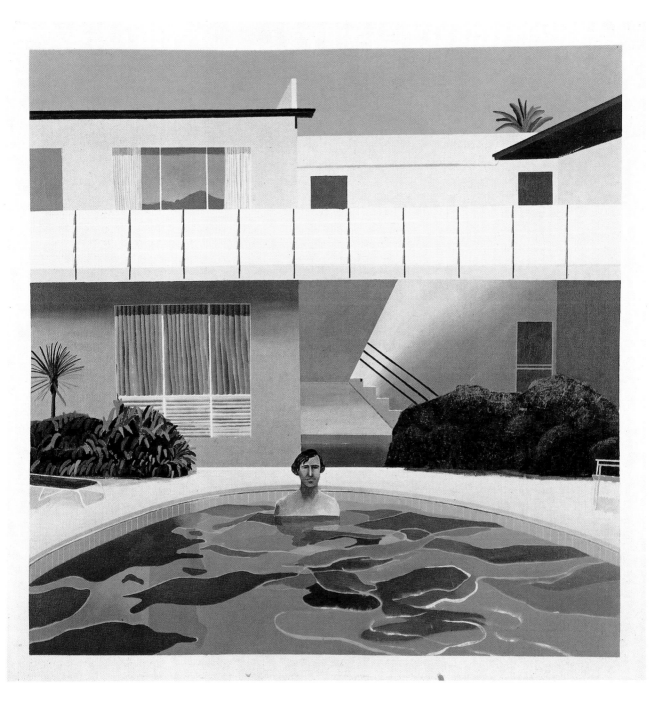

29 *The Room, Tarzana* 1967
Acrylic on canvas, 244 x 244 cm
(96 x 96 in.)
Private collection

In the spring of 1967, Hockney taught for ten weeks at the University of California at Berkeley, where he began *The Room, Tarzana*, completing it during the summer, after his return to London.

Unlike the paintings he produced from 1965 to 1967, this work suggests that Hockney no longer believed that it was necessary for him to emphasize the picture plane, since, for the first time for almost a decade, he introduced an illusion of three dimensions by organizing the receding lines around one of two vanishing points. His use of perspective is linked with the naturalistic sign, evident in *Portrait of Nick Wilder* (plate 28), and is used here to create a portrait of Peter Schlesinger, a former student of Hockney's, with whom he had developed a relationship.

Although this painting marked a new beginning for Hockney – the following year, he started a series of double portraits in which the use of perspective and naturalistic sign is more sophisticated (see plates 30-2) – it also represents the conclusion of the series of paintings, begun in 1965, in which Californian youths were reduced to stereotypes (indicated here by the white socks and shirt), the subjects of a voyeur's gaze.

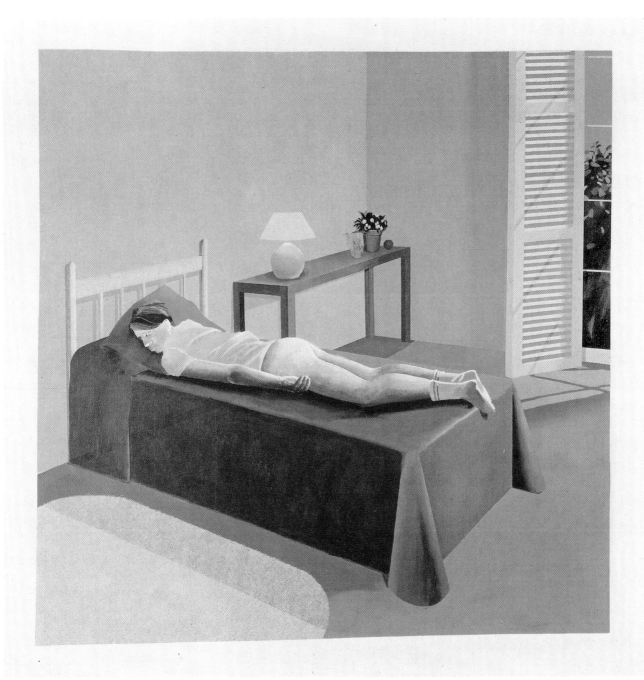

30 *American Collectors (Fred and Marcia Weisman)* 1968
Acrylic on canvas, 214 x 305 cm
(84 x 120 in.)
The Art Institute of Chicago, restricted
gift of Mrs Frederic Pick

The Weismans were leading figures in the Los Angeles art world and had amassed an impressive collection of contemporary art by 1968. Hockney refused Marcia's invitation to paint her husband's portrait, but did offer to paint them as a couple. He shows them with two items of British sculpture, a William Turnbull and a Henry Moore. The artist equates Marcia with a piece of 'primitive' sculpture – her mouth echoes those of the totem depicted on the right – as he had done the collectors in *California Art Collector* and *The Actor* (plates 19, 20).

Although, or perhaps because, they realized that the portrait is disparaging, the Weismans bought it. However, as Henry Geldzahler has noted, 'it was soon stored away, on loan to the Pasadena Museum of Art'.

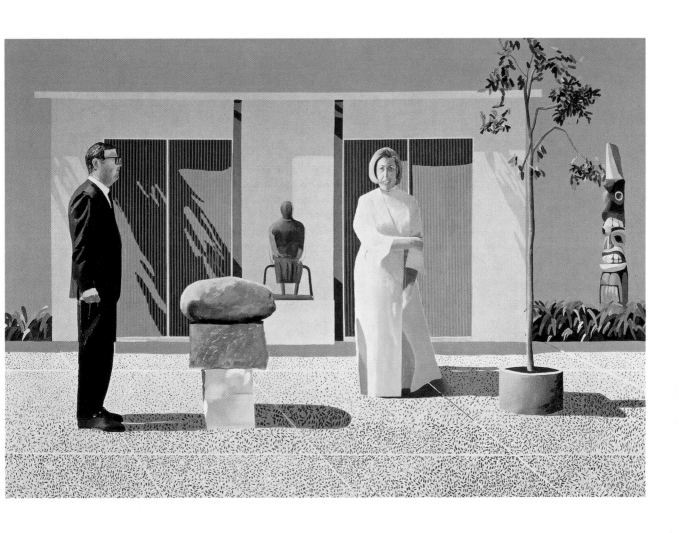

31 *Henry Geldzahler*
 and Christopher Scott 1969
 Acrylic on canvas, 214 x 305 cm
 (84 x 120 in.)
 Private collection

In the spring of 1967, Hockney produced
a lithograph of Geldzahler and Scott, each
of the fifteen prints having different hand-
executed additions. In December 1968, he
began taking photographs of Geldzahler's
and Scott's apartment to use as studies for
this painting, another version of their 'mar-
riage', which he had completed by the fol-
lowing February.

 In an interview with Mark Glazebrook
in 1970, the artist commented: 'Chris-
topher looks rather as if he's going to leave
or he's just arrived. He's got his coat on.
That is how I felt the situation was. It's a
bit like that.' Despite Hockney's impres-
sions, Geldzahler and Scott remained to-
gether for another ten years.

Fig. 72 *Henry Geldzahler and Christopher
Scott*, 1968. Ink on paper, 28 x 35.5 cm
(11 x 14 in.). Private collection

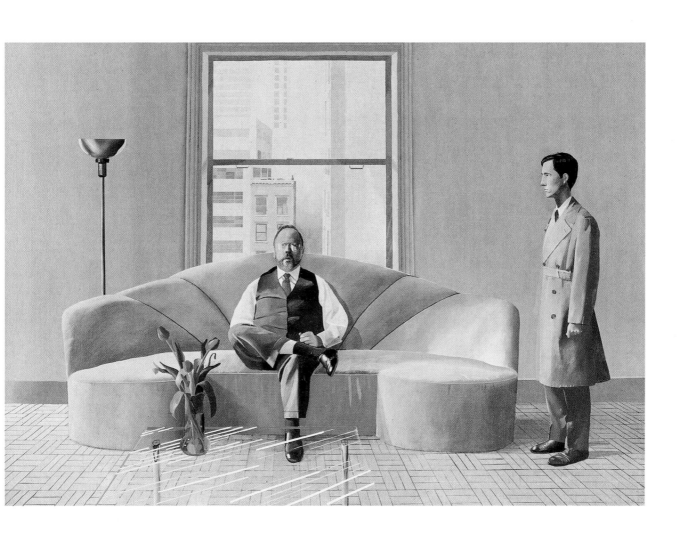

32 *Mr and Mrs Clark
 and Percy* 1970-1
Acrylic on canvas, 214 x 305 cm
(84 x 120 in.)
Trustees of the Tate Gallery, London

This painting draws on established models for representing married couples, although Hockney introduces a number of significant deviations in order to comment on the marriage. For example, it is the husband, not the wife, who is seated and, instead of being shown in an intimate pose, the couple are depicted as occupying separate halves of the drawing-room in their Bayswater house (a vertical line formed by the left shutter effectively divides the picture in two).

Many of the objects in the room have quite specific meanings within the tradition of European painting. White lilies, here associated with Mrs Clark, signify purity, and their aroma incorruptibility. The cat is a symbol of licentiousness, a meaning reinforced by Hockney's decision to position Percy, a colloquialism for penis, on Mr Clark's groin and show the cat looking into the world outside.

Ossie Clark was introduced to Celia Birtwell in Manchester in 1961, by Mo McDermott, who was later also to become a close friend of Hockney. They met again in London the following year and entered into a relationship that led, in 1969, to their marriage, which lasted five years. Celia, a fabric designer, and Ossie, a fashion designer, were both celebrated figures in London's fashion world during the sixties.

In conversation with Peter Fuller in 1977, Hockney made reference to Mr and Mrs Clark: 'They are no longer together. They've split up. The picture, *Mr and Mrs Clark and Percy*, probably caused it.' When recently asked by a journalist to explain why she ended the marriage, Celia replied: 'I always say "I have enormous admiration for Ossie's talent", and leave it at that.'

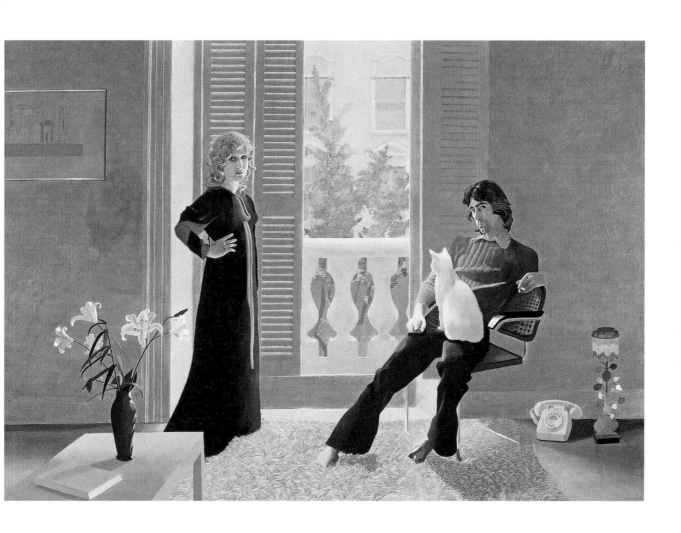

33 *Portrait of an Artist*
 (Pool with Two Figures) 1972

Acrylic on canvas, 214 x 305 cm
(84 x 120 in.)
Private collection

This painting was produced during a two-week period in April 1972, after the artist had abandoned his first attempt at the subject, *Pool with Two Figures*, begun in October 1971 only a few weeks after the traumatic conclusion of his long-standing relationship with Peter Schlesinger. His decision to use Schlesinger as the standing figure and to prefix the title of the second version with 'Portrait of an Artist' suggests that this work relates directly to Hockney's personal circumstances.

Although Schlesinger had successfully completed his training as an artist by this time, no signs have been included to indicate that he is the artist referred to in the title. It is possible, therefore, that the artist is Hockney himself, represented metonymically by the image of the pool, which, as Christopher Knight has written, resembles a picture within the picture: 'In contrast to the evident naturalism of the surrounding landscape the rendering of the pool and swimmer is carefully patterned, highly artificial, contextually abstracted. It is as if the standing boy is staring deep into a perfect picture, thoroughly seduced yet fully aware of its utter inaccessibility.' The 'perfect picture', a pool containing a distorted figure, is surely a metonym for Hockney himself, implying that the painting is to be understood as a metaphor either for his relationship with Schlesinger or for the ending of that relationship.

The work contains a number of perplexing features. For example, Schlesinger's head is too large in relation to the remainder of his body, even when the high viewpoint, which 'tips' the pool up to suggest a picture, is taken into account. Furthermore, the landscape – a valley and, on the horizon, two breast-shaped hills – has feminine connotations. There is also something mysterious about the two phallus-like trees, each of which is associated with one of the figures in the foreground.

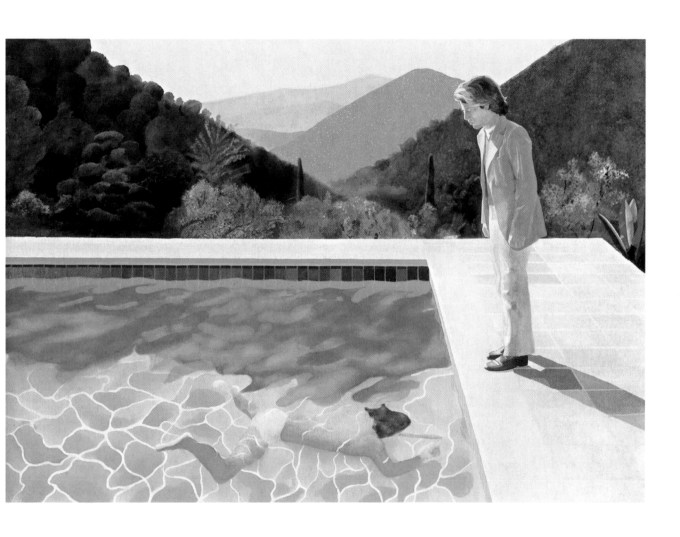

34 *Looking at Pictures on a Screen* 1977

Oil on canvas, 188 x 188 cm
(74 x 74 in.)
On permanent loan to Walker Art
Center, Minneapolis, from the collection
of Mr and Mrs Miles Q. Fiterman

Hockney was introduced to Henry Geldzahler in December 1963, and they established a close friendship soon afterwards. Geldzahler was Curator of Twentieth Century Art at the Metropolitan Museum of Art, New York, and later became Commissioner of Cultural Affairs, New York City. In this painting, Geldzahler is shown in his professional role as a connoisseur, rather than in private, as in the artist's other portraits of him. The painting belongs to a particular genre, that of images of renowned authors or critics. Manet's *Portrait of Zola* (1867) may have been the model.

During the late seventies, Hockney became an influential member of a lobby calling for a return to figurative themes in modern painting, and *Looking at Pictures on a Screen* may be understood in terms of this standpoint. Unlike the figure in *Portrait Surrounded by Artistic Devices* (plate 22), Geldzahler is shown looking at Hockney's reproductions of works by past 'masters': Vermeer's *A Young Woman standing at a Virginal*, Piero della Francesca's *The Baptism of Christ*, Van Gogh's *Sunflowers* and Degas' *After the Bath*. The painting serves as evidence of Hockney's apparent need to recover a sense of contact with the European tradition, to which, it is implied, this work belongs.

Hockney's attitude towards this tradition, and his reaction to the dismissive opinions of his own work expressed by many of his peers, became clear during a conversation with R. B. Kitaj, later printed in *The New Review* (January 1977). At one moment, Hockney exclaimed: 'What I don't understand is this: why is it that Seurat could study a painter of 300 hundred years before – Piero della Francesca – and produce in 1880 a version of Piero's ideas, updated or progressed or whatever word you want to say, and if that was valid in 1880 why is it not valid in 1977? Nothing has happened between then and now to stop somebody carefully analysing and studying the pictures of Piero della Francesca and making something from the ideas in them.'

Looking at Pictures on a Screen, together with the actual paintings, reproductions, screen and chair, constituted a small exhibition that Hockney organized for the National Gallery, London, in 1981. The exhibition, 'Looking at Pictures in a Room', was accompanied by a catalogue, *Looking at Pictures in a Book*, in which the artist discussed the role of reproductions – as the differences between the three titles may already suggest – and the uses of photography. These two topics had intrigued Hockney for many years and became central to his practice during the mid-eighties.

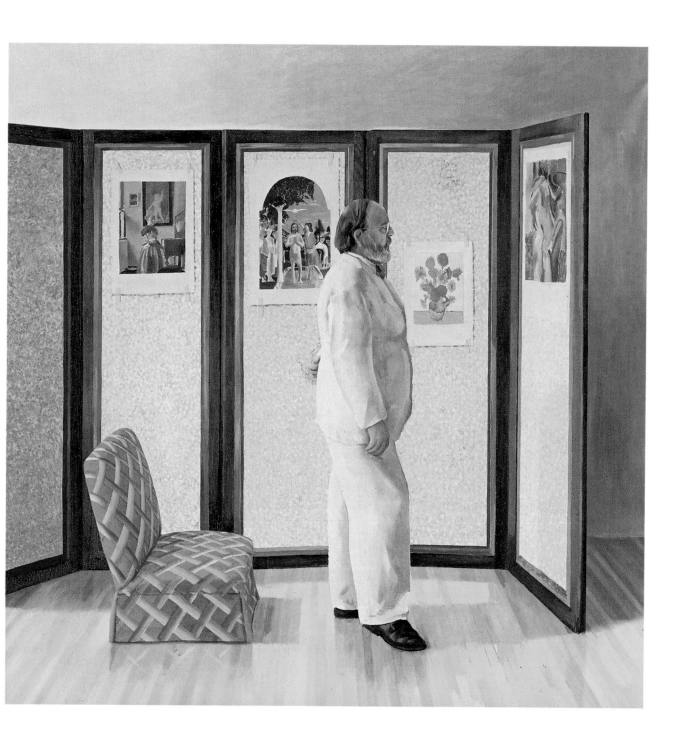

35 *My Parents* 1977
Oil on canvas, 183 x 183 cm
(72 x 72 in.)
Trustees of the Tate Gallery, London

Hockney began *My Parents and Myself*
(fig. 73) during the spring of 1975 and,
even though it was not complete, he de-
cided to reproduce it in his autobiography.
He continued working on it until February
1976, painting two curtains looped over a
rail – as in *Invented Man Revealing Still Life*
(plate 40) – before abandoning it for
reasons discussed on page 95. Hockney re-
turned to the subject in February 1977
with *My Parents*, which he finished within
six months. In this second painting, he sub-
stituted details from two works of art –
Piero della Francesca's *The Baptism of
Christ* and his own *My Parents and My-
self* – for his reflection in the mirror. In
addition to the pictures within the picture,
a number of books have also been included,
among them six prominently displayed
volumes of Marcel Proust's twelve-volume
A la Recherche du temps perdu (*Remembrance
of Things Past*).

Fig. 73 *My Parents and Myself*, 1975;
unfinished. Oil on canvas, 183 x 183 cm
(72 x 72 in.). Collection of the artist

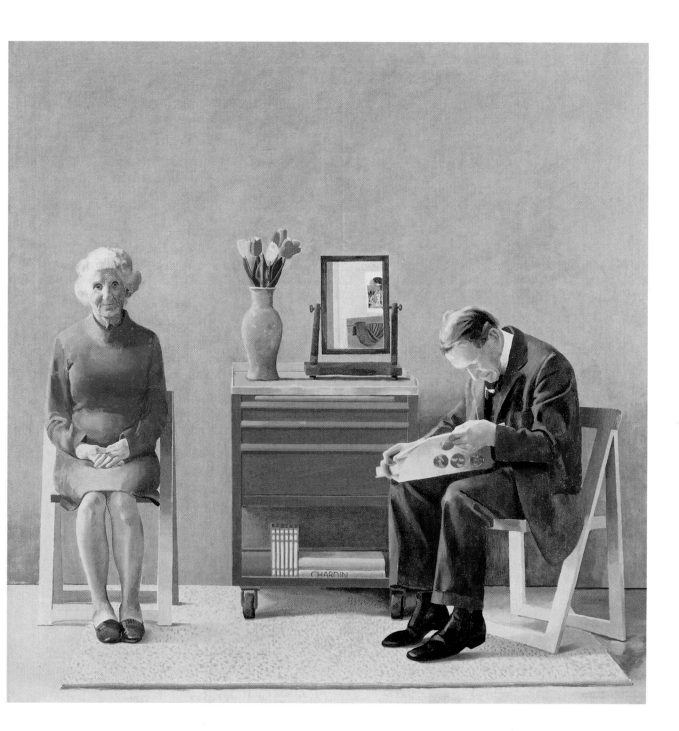

36 *Model with Unfinished
 Self-Portrait* 1977
Oil on canvas, 152 x 152 cm
(60 x 60 in.)
Private collection, Paris

In January 1977, Hockney began work on *Self-Portrait with Blue Guitar* (fig. 74). It was to represent the culmination of a series of drawings, small paintings and etchings, begun in the summer of 1976, in which he had offered an interpretation of Wallace Stevens's poem 'The Man with the Blue Guitar' (1936). His decision to 'illustrate' this poem, a prolonged meditation on the practice of Picasso, provided him with a means of extending his interest in, and understanding of, the Spaniard's work.

While still incomplete, *Self-Portrait with Blue Guitar* became the subject of another painting, *Model with Unfinished Self-Portrait*. This is an extremely complex image, since the boundary between the illusory room occupied by the sleeping model and the even more illusory room occupied by Hockney is ambiguous. This was achieved by making the precisely calculated ground-plan of the former continuous with that of the latter, and by making the naturalistic curtain appear to belong to both worlds. Furthermore, an effect of *trompe-l'œil* – explored by the artist in a series of photographs taken during 1977 – is engendered by the implied continuity between the illusory room inhabited by the model and the real space inhabited by the spectator.

When one looks at *Model with Unfinished Self-Portrait*, the urge to constantly veer between it, the other painting and the photographs, in an attempt to re-establish the boundaries between the representational levels that this painting destabilizes, is almost irresistible. Such a process is, of course, distracting, and this may be what Hockney, at one level, intended.

In an essay on Hockney's portraits, the art historian Nannette Aldred suggests that many of the details added by Hockney in order to complete *Self-Portrait with Blue Guitar* are the result of objects in the space occupied by the sleeping figure in *Model with Unfinished Self-Portrait* having been displaced: the pane of glass resting on top of the table reappears in the upper-left corner of the former painting; the bed-cover becomes the pattern of diagonal lines in the upper left-hand corner; and the model becomes Dora Maar, who also has her hand by her cheek.

This series of visual displacements is surely used to indicate that a psychological identification has taken place: Maar – Picasso's mistress and model in the mid-thirties – is substituted for Hockney's lover and model, Gregory Evans. Hockney has even rendered Picasso's 1937 portrait of Maar as a sculpture, matching the three-dimensionality of Evans's face, in order to aid this process of displacement and identification. That Hockney felt it necessary to ask his earlier lover, Peter Schlesinger, to act as a substitute when Evans was unavailable to pose for *Model with Unfinished Self-Portrait*, suggests that the artist knew in advance what the final subject of *Self-Portrait with Blue Guitar* would be. Whereas three years earlier Hockney had depicted himself merely as Picasso's model (fig. 79), in *Self-Portrait with Blue Guitar* he now, by implication, identifies himself with the Spaniard. His decision to represent himself, in the final self-portrait, in the act of drawing 'the blue guitar' establishes a further point of identification with the subject of Stevens's poem.

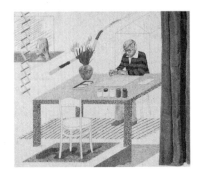

Fig. 74 *Self-Portrait with Blue Guitar*, 1977.
Oil on canvas, 152 x 183 cm (60 x 72 in.).
Ludwig Collection, Aachen

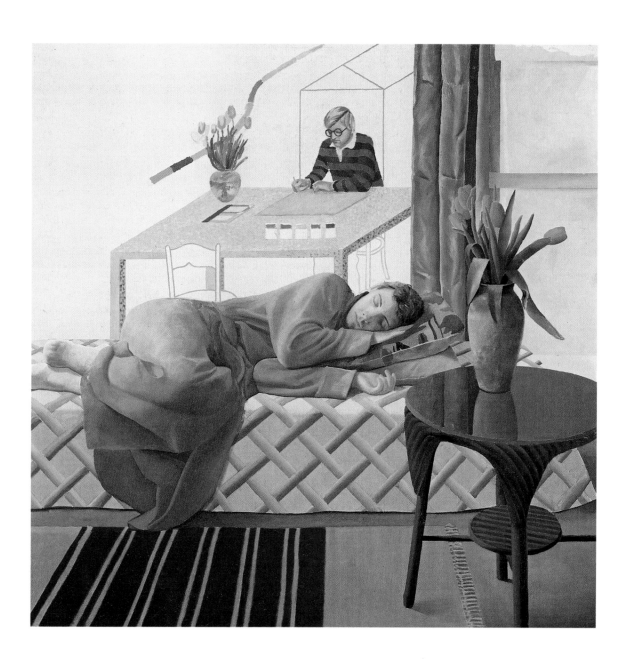

37 *Divine* 1979

Acrylic on canvas, 152 x 152 cm
(60 x 60 in.)
The Carnegie Museum of Art, Pitts-
burgh, gift of Richard M. Scaife, 1982

Divine (Harris Glenn Milstead) was an
accomplished female impersonator who
achieved cult status after starring as 'Bab
Johnson' and appearing as himself in John
Walters's 1972 underground film, *Pink Fla-
mingos*. Hockney produced two paintings of
the actor, to whom he had been introduced
in the summer of 1979. Milstead died in
March 1989.

The present painting belongs to a
series of works from the late seventies in
which the artist adopted a certain informal-
ity of technique and introduced new styl-
istic characteristics (the juxtaposition of
stronger colours, for instance) to suggest
directness of observation, spontaneity of ex-
pression and freedom from the conventions
of naturalism, to which he had felt himself
bound prior to 1978. This series culmin-
ated in *Mulholland Drive: The Road to the
Studio* (plate 43), a painting over six metres
long that was completed in the space of
three weeks towards the end of 1980.

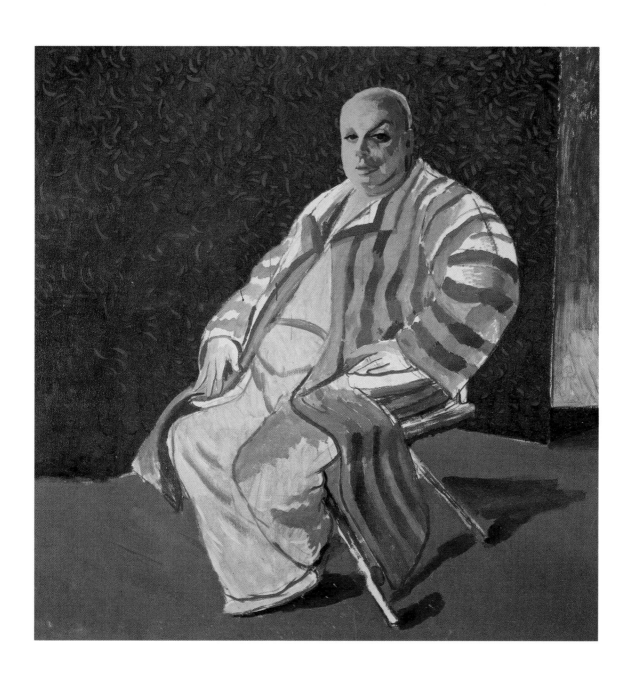

1970-1986

Conversations in the Studio

Fig. 75 *Celia Smoking*, 1973. Lithograph, 98 x 71 cm (38 x 28 in.). Edition of 70

Fig. 76 *Portrait of Jean Léger*, 1973. Pencil on paper, 65 x 50 cm (25 $^1/_2$ x 19 $^3/_4$ in.). Private collection

Dissatisfied with his work since *Mr and Mrs Clark and Percy* (plate 32), Hockney decided that, in order to focus his attention, he needed to leave London. In 1973, he moved to Paris and produced relatively few paintings, electing to concentrate instead on a series of drawings and prints executed in a naturalistic, even academic, style, each drawing often taking two or three days to complete (see figs. 75, 76). As the artist recollected: 'At that time I felt almost as though I should go back to drawing skeletons, as I did when I was a student at the Royal College of Art, thinking, what shall I do?: I'll make a study of the skeleton; what should I do?: I'll make some drawings of my friends; I'll make them slowly, accurately, have them sit down and pose for hours, and so on. I tend to do that at times when I feel a little lost, searching around.'

That his Parisian sojourn had not resolved his professional difficulties became apparent on his return to London in 1975. He was unable to complete either the ambitious double portrait of George Lawson and Wayne Sleep, which he had begun in 1972, or the painting showing his relationship to his parents (fig. 73).

Despite his difficulties, the mid- to late seventies saw Hockney become an influential member of an informal group of artists and critics who sought to reinstate the human figure as a subject fit for modern painting at a time when the authority of both Modernist art and theory had declined. *Looking at Pictures on a Screen* (plate 34) suggests that Hockney thought it necessary to establish a sense of continuity with the tradition of European art (as, indeed, did his decision to live in Paris). That, as Hockney admitted, the painting turned out more naturalistically than he had intended, seems to indicate, along with his inability to complete other major figurative paintings, that his problem was how a return to figuration was to be practically achieved. Ever since *Mr and Mrs Clark and Percy*, his practice had depended on understanding painting as involving a faithful copying of reality – as though a canvas were a window on to, or a reflection of, the world. The fallacy of naturalism – namely, that unmediated access to the real world is possible outside systems of representation – was recognized by artists of the early twentieth-century European avant-garde, and their work had bequeathed serious problems to their successors concerning the nature of meaning and representation. Could Hockney's approach, which professed ignorance of these problems, escape cliché? The fact that he abandoned several major canvases and experienced a painting 'block' suggests that he thought it could not.

Hockney realized that he needed to take into account the early modern movement in art. As he told Peter Fuller in 1977: 'You cannot ignore it. The painters who do must be making a mistake.' Yet, as is indicated by many of his ambitious paintings of the seventies, Hockney could not actually abandon naturalism. He acknowledged this in his conversation with Fuller: 'It might be the severe weakness of all my ideas, my real weakness as an artist, that I keep falling back on it.' At over six metres long and two metres high, *Santa Monica Blvd.* (fig. 77), begun in 1978, was surely intended as a monumental painting in the figurative tradition – five fig-

Fig. 77 *Santa Monica Blvd.*, 1978-80; unfinished. Oil on canvas, 218 x 609.5 cm (86 x 240 in.). Collection of the artist

ures are shown, the largest number he had ever included in a single canvas – and one that would end his confusion of the preceding years. Yet Hockney abandoned the work in 1980, admitting he felt 'lost' with it. One assumes he was able neither to resolve his professional problems nor to address a difficult and, for him, unprecedented subject: the social realities of Los Angeles.

Although his break with naturalism was not to occur until the early eighties, the foundations for this development were laid in works from the seventies. In a series of drawings, prints and less ambitious paintings, Hockney began to investigate the non-naturalistic sign, principally through an examination of Picasso's work; examples are *Three Chairs with a Section of a Picasso Mural, Japanese Rain on Canvas* and *Showing Maurice the Sugar Lift* (plate 39, fig. 87). In 1975, he produced a small painting, *Invented Man Revealing Still Life* (plate 40), that brings together some of his studies of Picasso – the 'invented man', for instance, derives from *Showing Maurice the Sugar Lift* – with 'quotations' from other works of art. That Hockney here uses a collection of styles suggests that the painting was intended as an index of his own practice, in the way that *Portrait Surrounded by Artistic Devices* (plate 22) had been ten years earlier. As with *Chair with Photograph* (fig. 78), also from 1975, *Invented Man Revealing Still Life* is an early realization of Hockney's belief that naturalism and Modernism could somehow be combined. The artist commented: 'I think up to now very few people have used this idea, that you can take from the great diversity there's been and put it all in your work. The way I say it, it sounds like a polemic for eclecticism, but I'm not meaning it in just an eclectic way. Eclecticism can be a *synthesis* in the end It seems to me that it's worth doing, it's worth attempting.' It was this reasoning that had led to a revival of his interest in Picasso (see fig. 79). According to Marco Livingstone, Hockney recalled that 'it was only with Picasso's death that one

Fig. 78 *Chair with Photograph*, 1975. Oil on canvas, 91.5 x 61 cm (36 x 24 in.). Private collection

could begin to see the consistency of his life's work, making sense of the apparent stylistic breaks as the result of a unified attitude towards style and content'.

During the summer of 1976, Hockney read Wallace Stevens's poem 'The Man with the Blue Guitar'. This takes Picasso's painting *The Old Guitarist* of 1903 as its point of departure and amounts to a meditation on his practice. Hockney decided to illustrate the poem and, inspired by his reading of it, soon produced a series of drawings and small paintings, a portfolio of etchings and two major canvases (see plate 36). In addition to depicting pictures within pictures and juxtaposing different styles – as in *Invented Man Revealing Still Life* and *Chair with Photograph* – the series makes numerous references to specific works by Picasso. In a painting that forms the culmination of the series, *Self-Portrait with Blue Guitar* (fig. 74), Hockney identified not only artistically with the Spaniard, but also psychologically.

From 1978 to 1980, Hockney spent a considerable amount of time either working on *Santa Monica Blvd.* or designing stage sets, the latter also enabling him to pursue his interest in Picasso (see page 134). *Mulholland Drive: The Road to the Studio* (plate 43), begun immediately after the artist had abandoned *Santa Monica Blvd.* in 1980, represents both a new beginning in Hockney's œuvre and the culmination of several landscape paintings based on the drive from his house in the Hollywood Hills to his studio on Santa Monica Boulevard (see plate 42, fig. 88). A comparison with his naturalistic paintings of 1977 – *Looking at Pictures on a Screen*, for example – reveals a number of significant differences. Apart from the features mentioned in the commentary on *Divine* (plate 37), perhaps the most striking change is in the treatment of space: no longer homogeneous – a 'box' into which objects are placed – it is here represented as it was experienced. Hockney has commented that the term 'drive' in the work's title was intended not simply to refer to the name of the road, but also to the act of driving.

Although *Mulholland Drive* was undoubtedly a significant painting for the artist – through it, he appears to have gone some way towards establishing an approach that was not dependent on naturalism – it can hardly be viewed as the major painting that its size suggests it was meant to be. By referring to diagrams employed by geographers to describe the layout of streets, Hockney represents the Los Angeles suburbs of Burbank and Studio City in the upper register as a two-dimensional plane. It is by showing this as parallel to the picture surface – an apt way to depict the view from the Hollywood Hills – that he gave the painting its most compelling feature, one that emphasizes the surface of the painting as an object in its own right.

Hockney produced few paintings in 1980 and 1981, as he was working on a commission to design sets for an opera production, but his decision, in *Mulholland Drive*, to articulate the surface, rather than to erase its presence in the interests of suggesting depth, also informs his paintings from early 1982 – for example, *Terrace Hollywood Hills House with*

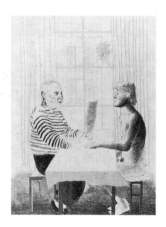

Fig. 79 *Artist and Model*, 1974.
Etching and aquatint, 57.4 x 44.3 cm
(22 $^{1}/_{2}$ x 17 $^{1}/_{2}$ in.). Edition of 100

Banana Tree (fig. 90). In this, the wooden floor of the artist's lounge and terrace have been depicted as parallel to the picture plane. It would be interesting to speculate on how subsequent paintings might have been developed; yet, after spending a week in February 1982 making experimental collages from Polaroid photographs, Hockney decided to abandon painting temporarily and, over the next three months, produced some 150 Polaroid collages. From September 1982 to May 1983, he created over 200 collages using prints from 35 mm film. In 1984, 117 of them were reproduced in the form of a book, entitled *Cameraworks*. In these photocollages, which constitute one of the most important sections of Hockney's entire *œuvre*, he extended the exploration of the means of representation evident in his paintings of 1980 and early 1982.

In *Nicholas Wilder Studying Picasso* (fig. 80), for instance, Hockney chose to return to the theme of his 1977 naturalistic painting *Looking at Pictures on a Screen*, though here it is treated in a technically radical manner. When making the lower part of the collage, Hockney positioned his camera parallel to the paving stones, which has resulted in the depicted surfaces appearing to fuse with the literal surface of the photograph. Wilder's right foot has not been shown foreshortened, but from above, so that it, too, lies parallel to the picture plane. Similarly, not only his left foot, but his whole left leg has been photographed in order to show it lying parallel to, and – in places – fusing with, the surface of the collage. Hockney's use of composite views and his depiction of receding planes as though parallel to the picture surface can be compared not only to *Terrace Hollywood Hills House with Banana Tree*, but also to Cubist art. Indeed, just as Wilder is shown to be studying works by Picasso, so Hockney makes an allusion to his own study of Cubism. For one of the Polaroids along the lowest register, he has photographed a piece of paper – which casts a shadow – between a paving stone and the camera. This detail is surely a reference to the naturalistically rendered dog-eared piece of paper in Georges Braque's *Violin and Pitcher* (1910). In April 1982, as if to acknowledge explicitly his debt to Cubism, Hockney produced two Polaroid collages that constitute pastiches of typical still-life paintings, and in his lecture 'On Photography', delivered at the Victoria and Albert Museum in London the following year, he spoke of his collages in terms of Cubism's 'destruction of a fixed way of viewing'.

In subsequent collages, Hockney became increasingly concerned, on the one hand, to emphasize the surface of the work, thereby drawing attention to the material aspect of the visual sign and not just to what it signifies, and, on the other, to intensify the viewer's awareness of the activity that is required to make images signify. In so doing, he offered a critique of the naturalistic paradigm that both conceptualizes the picture surface as a pane of transparent glass through which one views whatever is depicted and expects the spectator to be a relatively passive consumer of the meanings conveyed. (Since naturalistic images reduce the viewer's awareness of the surface, it appears as though meaning is simply 'there', and not produced.) *You Make the Picture* (fig. 81), for example, is divided into two sec-

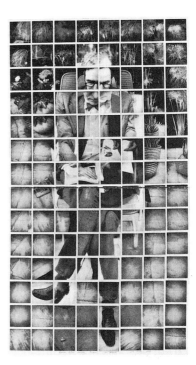

Fig. 80 *Nicholas Wilder Studying Picasso*, 1982. Polaroid collage, 117 x 67.5 cm (46 x 26 1/2 in.). Collection of the artist

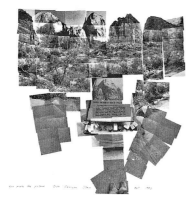

Fig. 81 *You Make the Picture*, 1982. Photographic collage, 133.5 x 123 cm (52 $\frac{1}{2}$ x 48 $\frac{1}{2}$ in.). Collection of the artist

tions – upper and lower – which meet in only two places, towards the centre and on the right. The upper part, which represents a view of the Great White Throne in the Zion Canyon, conforms to the conventional conceptualization of the picture surface – the individual photographs have been arranged into a rectangle so that the viewer is presented with 'a window on the world'. In the lower part, by contrast, Hockney breaks with his conception to show himself, the rolls of film and their packaging, from which the image of the Great White Throne has been produced. By placing the two sections together, he suggests that naturalistic images do not reflect, or correspond to, a pre-discursive reality, but one that is already interpreted and conceptualized, and that it is through familiarity with a set of conventions, the visual 'language' invented during the Renaissance, that the spectator constructs meaning for images. The 'you' in the title of this collage does not refer only to the photographer – that is, Hockney himself.

Later, in his images and notes for *Vogue* (see plates 50-2), in a series of public lectures and in the second part of his autobiography, the artist was to suggest not only that the meaning of an image is constructed by the spectator, but also that the spectator's subjectivity is constituted by images. Unwittingly, during the eighties, Hockney thus became a structuralist.

In collages produced in 1984 and 1985, after the publication of *Cameraworks*, he introduced other means of emphasizing the picture surface: for instance, the glue used to secure the individual photographs to their support is left visible and some prints are intentionally not firmly attached, so that they exist in relief, casting shadows across the surface (see plate 47). As with the scratches made by avant-garde film-makers on the celluloid of their films, these devices draw attention to the surface of the work, to the material nature of the visual sign and, therefore, to the processes by which meaning is constructed.

In *Walking in the Zen Garden at the Ryoanji Temple, Kyoto, Feb. 21st 1983* (plate 46), Hockney established the means by which he could represent large spaces as parallel to the picture plane, and with *The Desk, July 1st, 1984* (fig. 82), he determined how to show objects 'in' a space depicted in this way. Yet his work with the camera led him to deal not only with spatiality. In September 1985, during a conversation with Paul Joyce, the artist noted: 'In order to give the feeling of objects in space, they [conventional images] take away your body, and you become a theoretical point. It must be doing damage to us. Perspective, it dawned on me, makes narrative difficult. Narrative must be a flow in time and one-point perspective freezes time and space.'

Hockney came to realize that the Western tradition of representation is predicated on disavowing both temporality and the bodies of the artist and spectator as integral parts of an image. During the mid-eighties, he attempted to deal with these absences. *Paint Trolley, L. A. 1985* (plate 47), like *The Desk, July 1st, 1984*, shows not only the front of a piece of his studio furniture, but also both its sides. It therefore depicts a walk

along a line parallel to the wall shown in the background: it is an image that encompasses the artist's, and the spectator's, whole body in a temporal sequence and not simply as a static eye.

Yet *Paint Trolley* is also a record of the artist's body in another way: like the photographs of his feet in the early collages, the glue visible on the surface is evidence of the physical labour involved in producing the work. Reinstating both the artist's and the spectator's body as integral parts of the image was pursued in subsequent paintings (see plate 62) and seems to have been suggested to Hockney by the late work of Picasso – in which the Spaniard's labour is constantly displayed, as though painting were, to borrow a phrase from Norman Bryson's *Vision and Painting*, a *performing* art – and also by Chinese scrolls. In 1987, Hockney and Philip Haas made a documentary film on an eighteenth-century Chinese scroll painting that the artist had seen a few years earlier: 'When I first saw that scroll, in about 1984, I got incredibly excited: it was one of the most memorable days of my life. I loved it and I wanted to pass on the excitement of what I saw in it to other people.' Indeed, Hockney saw a technical similarity between Chinese art and the late work of Picasso: 'Most of them, the connoisseurs in that field [of Chinese scrolls], talk about the exquisite brushwork and the hand. Perfectly good things to talk about – in fact, I saw a direct connection in that regard to the late Picasso, in which all the activity of painting is made visible, not hidden in layers as in a [Raoul] Dufy, but all very clear and transparent.' Appropriately, Hockney included literal references to Chinese scrolls and to Picasso's work in *Paint Trolley.*

In the space of a few years, Hockney had conducted a critique of the naturalistic paradigm using a medium that is widely regarded as its cul-

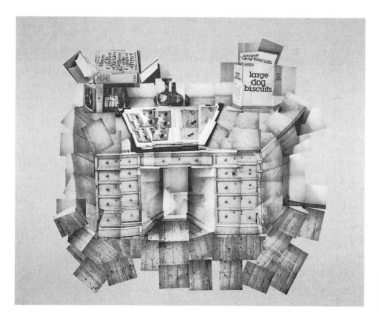

Fig. 82 *The Desk, July 1st, 1984*, 1984.
Photographic collage, 123 x 118 cm
(48 $^1/_2$ x 46 $^1/_2$ in.). Edition of 17

mination – photography – and, in both theory and practice, had resolved the confusion that had beset his work during the seventies. At various moments between 1982 and 1985, he became interested in seeing how his new understanding of representation would translate into the media of drawing, printing and painting (see plate 53). Indeed, there is a strong case to be made for viewing all Hockney's work of the mid-eighties as facets of a single unified activity; he himself suggests as much by juxtaposing reproductions of works made in a variety of media in the forty-one pages he designed for the December 1985/January 1986 issue of French *Vogue* (see plates 47, 50-2).

The Perspective Lesson (plate 50), reproduced in *Vogue*, was one of a number of lithographs made in 1984 and 1985 using a new technique that Ken Tyler had devised. The erasure mark over the chair depicted in the upper part of the work is employed by Hockney to illustrate the inadequacy, and his rejection, of the kind of naturalistic practice he had pursued in the seventies. The lower part of the image is organized by reference to *The Desk, July 1st, 1984*: the floor-boards have been depicted as parallel to the picture plane and three sides of the chair are shown. The chair is Vincent van Gogh's – Hockney appropriated it from the Dutchman's *The Chair and the Pipe* of 1888/9 – and both the erasure mark and the cross-hatchings, the latter used to represent the floor-boards, are derived from the work of Jasper Johns, who employed them in numerous paintings during the seventies and eighties. Indeed, for *The Perspective Lesson*, Hockney re-worked the right-hand panels of Johns's *Corpse and Mirror* (fig. 83) and *Between the Clock and the Bed* (1981).

These references to Johns's work are remarkable, for, although Hockney has repeatedly stressed his admiration of Van Gogh, he has not mentioned Johns in any of his lectures, essays or interviews of the last two dec-

Fig. 83 Jasper Johns, *Corpse and Mirror*, 1974. Oil, encaustic and collage on two canvases, 127 x 174 cm (50 x 68 $^1/_2$ in.). Collection of Mrs Victor Ganz

ades. Perhaps he simply found Johns's cross-hatched paintings amusing, given his own concern in the mid-eighties to render floor-boards from a variety of viewpoints and as parallel to the picture plane. However, Hockney is widely read and, in view of his interest in Picasso, one wonders whether he knew that Johns's hatchings made reference to the work of the Spaniard; in other words, whether he realized that, by appropriating this motif, he could both allude to Johns – by this time established as the pre-eminent living artist – and extend his references to Picasso.

The 'logic' of *The Perspective Lesson* is that of *Portrait Surrounded by Artistic Devices* of 1965 and *Invented Man Revealing Still Life* of 1975 (plates 22, 40). It suggests that, in 1984/5, Hockney saw his future work as a painter as involving an attempt to create a synthesis of Van Gogh's, Picasso's and Johns's work. In *Two Pembroke Studio Chairs* (fig. 84), as in *Conversation in the Studio* (fig. 85), Hockney depicts a dialogue taking place in his London studio between two chairs – metonyms for figures – a dialogue that, in *Two Pembroke Studio Chairs*, occurs on, or in front of, an obvious reference to Johns's work.

It is tempting to see the chair on the left as representing Hockney: it is the type that had featured in his work since *Chair with Photograph*. If such an interpretation is valid, then the lithograph suggests that he was well-aware of the difficulty of the task he had set himself – the subject of *The Perspective Lesson*. In contrast to the expansive and seemingly confident 'figure' on the right, Hockney has chosen to represent himself by a chair that easily collapses.

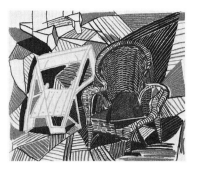

Fig. 84 *Two Pembroke Studio Chairs*, 1985. Lithograph, 39.2 x 49 cm (15 1/$_2$ x 19 1/$_2$ in.). Edition of 98

Fig. 85 *Conversation in the Studio*, 1984. Lithograph with hand-painted frame, 61 x 73.7 cm (24 x 29 in.). Edition of 45

38 *Le Parc des sources, Vichy* 1970
Acrylic on canvas, 214 x 305 cm
(84 x 120 in.)
Marquis of Hartington, London

This painting appears to show Ossie Clark (left) and Peter Schlesinger looking at a formal garden in Vichy. If we ignore the diagonal towards the lower-left corner, we can understand the garden as a detail from a two-dimensional representation – a painting, tapestry or poster – within the world occupied by the figures. For a series of photographs produced in April 1970 (see fig. 86), Hockney posed himself, Clark and Schlesinger in front of the painting, which leads us to view the garden as being a representation embedded within a painting that is itself embedded within a photograph. This recursive structure is, of course, capable of infinite regress. It is used to draw attention to the boundary between the real-world object (the present reproduction of a photograph of the painting, for example, belongs to the world of the reader of this book) and the 'fictional' figures and scene (projected by the painting projected by a photograph projected by this reproduction). Was the painting, produced in London, based on a photograph, one wonders!

If we recognize the chair as having been vacated by Hockney – as, in his autobiography, he tells us it had been – it then reminds the viewer that what he or she is looking at is a scene that has been recounted. Since *Le Parc des sources, Vichy* includes a reference to its creator, the status of the painting inevitably changes: it becomes more a visibly made artefact. As a corollary, then, to the artist's self-representation, the art work itself comes to be presented as an art work – and the colour reproduction opposite has to be seen as a reproduction.

Issues of 'authorship', raised by this painting and by the 1970 photographs, were also being explored by Conceptual artists at this time. Of particular interest is Tom Phillips's series of works entitled *Benches* (begun in 1970), which used a postcard of people sitting in a park as their point of origin. The people caught up in Hockney's 'play' are not only Clark and Schlesinger, but also Hockney and the spectator.

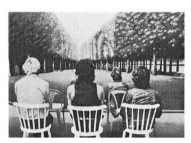

Fig. 86 Photographs of *Le Parc des sources, Vichy*, April 1970: with the artist, Ossie Clark and Peter Schlesinger (upper left); with empty chair, Clark and Schlesinger (upper right); with empty chairs (lower left); the painting (lower right)

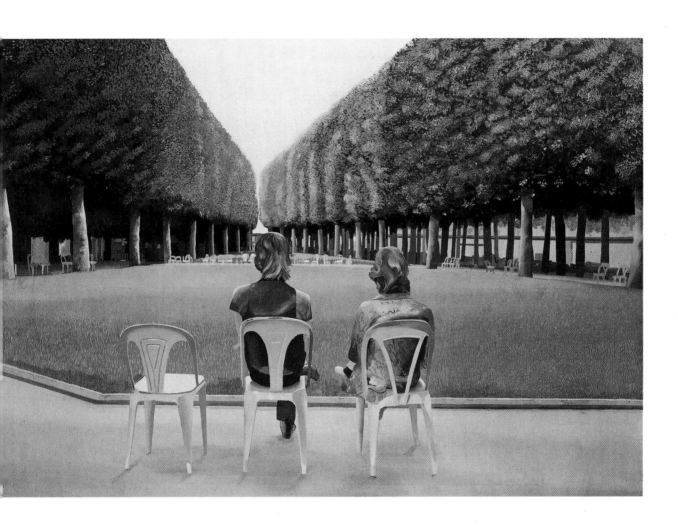

39 *Japanese Rain on Canvas* 1972
Acrylic on canvas, 122 x 122 cm
(48 x 48 in.)
Private collection

Ever since his first visit to Los Angeles in 1964, Hockney has been interested in the variety of ways in which water can be represented. In this painting, he decided to stain acrylic paint, diluted with detergent and water, into the unprimed canvas and then to allow water to trickle over the surface. The idea of using the thin bars also to represent falling rain occurred to Hockney after he had looked at some Japanese art – hence the painting's title. The work provides evidence of the artist's continuing interest in the non-naturalistic sign.

In his twenty-nine 'Paper Pools' of 1978, Hockney also tried to establish an equivalence between the subject and the means of representation by mixing water with coloured paper-pulp before the whole was sandwiched between felts in a hydraulic press. In some of these pieces, he was so concerned to emphasize the inherent wetness of water in a swimming pool (rather than, say, its transparency) that he used over a thousand gallons; 'in a watercolour you only use a cupful', he wryly remarked.

40 *Invented Man Revealing Still Life* 1975

Oil on canvas, 91.5 x 72.5 cm
(36 x 28 1/2 in.)
Nelson-Atkins Museum of Art, Kansas City, Missouri, gift of Mr and Mrs William L. Evan, Jr.

The curtain, copied from Fra Angelico's *The Dream of the Deacon Justinian* (*c*. 1440), suggests an illusion of three-dimensional space, which is then undermined by the flatness of the figure's torso, by the lines of smeared paint (a reference to Modernist abstraction) and by areas of what appear to be unprimed canvas (they are actually coated with rabbit-skin glue). Hockney's use of opposing styles to portray the man and his surroundings brings to mind *Portrait Surrounded by Artistic Devices* (plate 22). Unlike in that earlier painting, however, it is now the figure, not the setting, that is composed of non-naturalistic signs. This reversal, and the inclusion of the curtain – a reference also to his own early work – is indicative of Hockney's dissatisfaction with the naturalistically based practice he had been pursuing since the late sixties.

That Hockney later recognized that this painting marked a new beginning in his *œuvre*, is shown by the fact that many works from 1976 and 1977, including *Self-Portrait with Blue Guitar* (fig. 74), make reference to it.

Fig. 87 *Showing Maurice the Sugar Lift*, 1974. Etching and aquatint, 68.5 x 54.5 cm (27 x 21 1/2 in.). Edition of 75

41 *Harlequin* 1980
Oil on canvas, 122 x 91.5 cm
(48 x 36 in.)
Collection of the artist

Based on an engraving from Jacques Cal-
lot's *Balli di Sfessania* (1622), this painting
was one of sixteen canvases produced in
London during July and August 1980,
after Hockney had seen the retrospective ex-
hibition of Picasso's work at the Museum
of Modern Art, New York. '[Picasso] didn't
spend months on one picture,' Hockney
told Peter Webb in July 1980, 'he was con-
stantly open to new ideas and inspiration
which he put into his painting immedi-
ately. I came to London feeling that I must
just work and work, paint and paint. I
must catch his spontaneity. I'm painting a
new picture every few days, plundering
Picasso and Matisse, and loving every
moment.' Hockney's emulation of Picasso
and Matisse culminated in a series of paint-
ings of the Hollywood Hills, produced on
the artist's return to Los Angeles in the
autumn (see plates 42, 43).

Like the other fifteen canvases, *Harle-
quin* was painted while Hockney was de-
signing Erik Satie's ballet *Parade* and two
operas, *L'Enfant et les sortilèges* by Maurice
Ravel and *Les Mamelles de Tirésias* by
Francis Poulenc, for a triple bill that
opened at the Metropolitan Opera House,
New York, in February 1981. Since design-
ing the sets and costumes for Igor Stravin-
sky's *The Rake's Progress* in 1975, the artist
had become increasingly interested in
working for the theatre and spent much of
his time during the eighties and early nine-
ties creating designs for a variety of opera
productions. Many critics regard Hockney's
work for the theatre as having distracted
him from the more 'serious' activity of
painting. However, he himself told Wil-
liam Hardie in 1993: 'I've never treated
the theatre as just another sideline, noth-
ing I do is a sideline.'

42 *Nichols Canyon* 1980
 Acrylic on canvas, 214 x 153 cm
 (84 x 60 in.)
 Private collection

In the summer of 1978, Hockney decided
to settle in Los Angeles and, in the au-
tumn, established a studio on Santa Mon-
ica Boulevard, West Hollywood. At first,
he rented a house at the foot of the
Hollywood Hills, but in August 1979, he
moved into one in the Hills, which he pur-
chased in the spring of 1981.

The drive from his house in the Hills
to the studio on Santa Monica Boulevard
took Hockney along Mulholland Drive and
Nichols Canyon Road, the latter winding
for miles inside the canyon. This journey
became the subject of two paintings in
1980: *Nichols Canyon* (September) and *Mul-
holland Drive: The Road to the Studio* (Oc-
tober; plate 43). Both return to the theme
of *Canyon Painting* (fig. 88), begun as an ex-
periment with a new acrylic paint and the
first painting of Los Angeles that Hockney
had produced since the late sixties.

Fig. 88 *Canyon Painting*, 1978. Acrylic on
canvas, 153 x 153 cm (60 x 60 in.). Private
collection

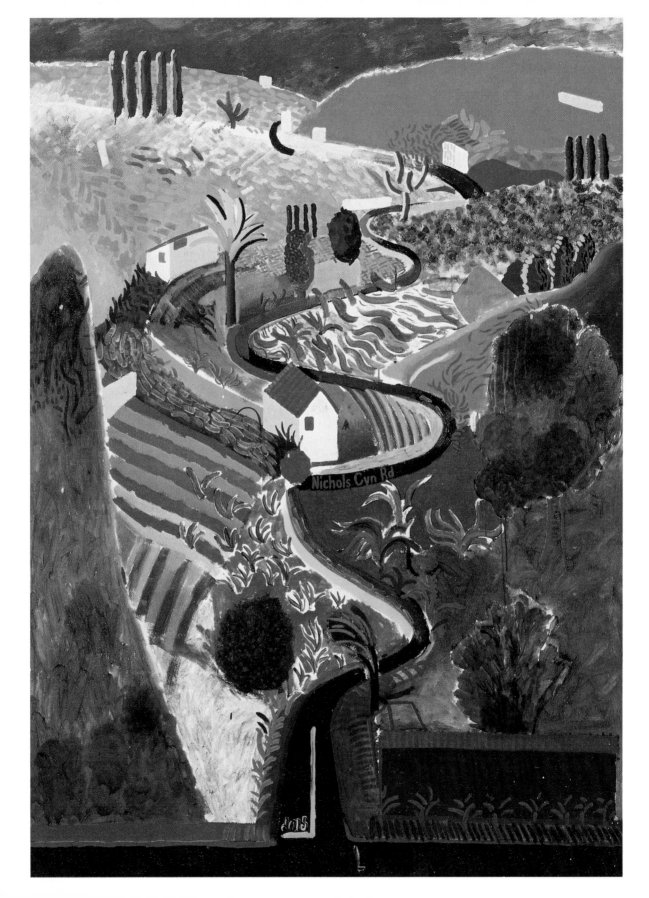

43 *Mulholland Drive: The Road to the Studio* 1980

Acrylic on canvas, 218 x 617 cm
(86 x 243 in.)
Los Angeles County Museum of Art,
purchased with funds provided by the
F. Patrick Burns bequest

Mulholland Drive is a scenic road that runs through the Santa Monica Mountains and the Hollywood Hills, an area whose inhabitants live the 'fat life of the delectable mountains', as Rayner Banham put it in his book *Los Angeles: The Architecture of Four Ecologies*. In contrast to most Los Angeles suburbs, which are organized according to strict geometric patterns, the homes in this area can be approached only via narrow, tortuous roads through a wilderness that, thanks to costly irrigation schemes, supports a variety of lush vegetation. Thickets provide the necessary privacy: the passer-by can catch but a glimpse of the split-level homes with their tennis courts and swimming pools.

The area through which Mulholland Drive winds offers a breathtaking panorama of downtown Los Angeles to the south and of the suburbs that stretch to the San Gabriel Mountains in the north. The physical isolation of Los Angeles's wealthiest class – matched only by their personal aloofness – can be seen to signify their socio-economic power. As Marchand wrote in *The Emergence of Los Angeles*: 'The owner has spent enormous sums of money to separate himself and his home from the city only in order to relate to it again from a superior or dominating position.'

Hockney's painting of Mulholland Drive is an image of the 'fat life of the delectable mountains', of its residents' physical separation from the masses and their socio-economic domination of them. It is appropriate that the painting was bought by the Los Angeles County Museum of Art, since it provides an image of the city in keeping with that held by Los Angeles's cultural élite. During the seventies and eighties, their notion of the city was actively promoted by local corporate patrons who, as Mike Davis observed in *City of Quartz*, had a promotion budget so large that they could 'afford to buy the international celebrity architects, painters and designers – [Richard] Meier, [Michael] Graves, Hockney, and so on – capable of giving cultural prestige and a happy "Pop" veneer to the emergence of a "world city".'

Hockney's decision to produce this picture immediately after *Santa Monica Blvd.* (fig. 77), in which he had begun to depict the disadvantaged – Hispanic American women and male prostitutes by a used-car lot – raises some disturbing issues. A representation of those with little socio-economic power was abandoned in favour of a painting that celebrates a bourgeois utopia.

Detail ▷
Complete painting overleaf

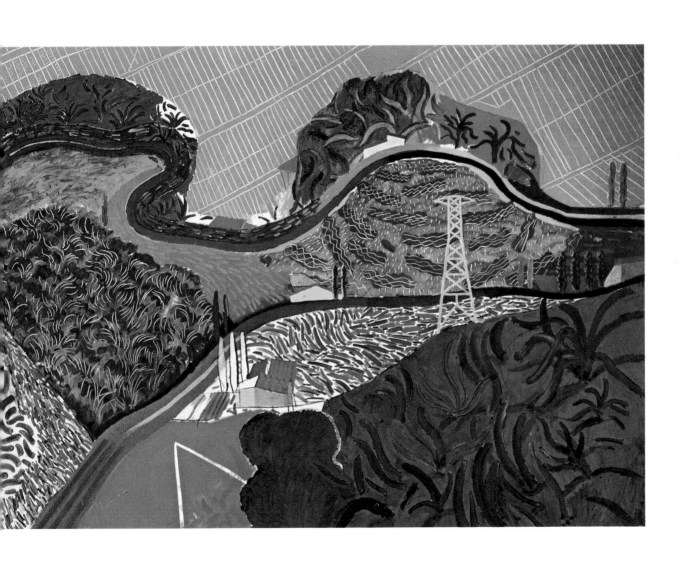

44 *Ian with Self Portrait
March 2nd 1982 L.A.* 1982
Polaroid collage, 35.6 x 26.7 cm
(14 x 10 $^1/_2$ in.)
Collection of the artist

Hockney continued to be preoccupied with the means of representation during the eighties, and it became the central theme of many of his photo-collages. In the present collage, for example, the act of representation literally becomes the subject.

Yet the means of representation is also the subject-matter of this early collage in another sense. The twelve Polaroids have been arranged into three columns of four, each of which presents Ian Falconer, Hockney's pupil and friend, to the viewer in a different way: by a photograph of his reflection in the mirror, by a photograph of his self-portrait on canvas and by a photograph of Falconer himself.

The central column is particularly complex since, in addition to the self-portrait drawn on canvas, Hockney has constructed a representation of Falconer by photographing materials associated with the craft of painting. The canvas shown in the uppermost register clearly signifies the head but, in the middle, it is also employed to represent his torso, white shirt and even his left knee. The base of the easel is obviously used to depict Falconer's legs and feet. This central column is an image of an artist, Falconer, that depends on metaphor and recalls an early self-portrait by Hockney, *Figure in a Flat Style* (fig. 12).

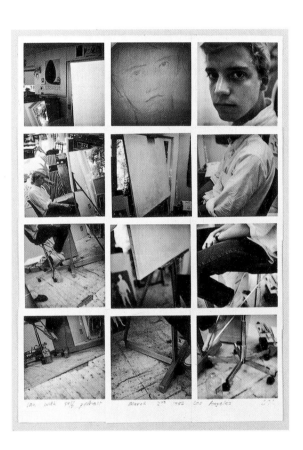

Ian with self portrait March 2nd 1982 Los Angeles

45 *Don and Christopher Los Angeles*
 6th March 1982 1982

Polaroid collage, 79.4 x 58.2 cm
(31 $^1/_4$ x 23 in.)
Collection of the artist

During the eighties, Hockney delivered a number of public lectures on his photo-collages. In 'On Photography' – a talk given at the Victoria and Albert Museum, London, that was later transcribed and published by the André Emmerich Gallery – he made reference to the present collage: 'These photographs took a long time to make. Some of them took about four or five hours. As I progressed, they got bigger and more complex and more difficult to make, which kept me interested. Just to describe how one was taken, for instance, I portrayed Christopher Isherwood and Don Bachardy; I got them to pose against a wall in the studio, and began as I do in a drawing, with the eyes, then the head, then the figures. At first they were both looking at me, but as the picture took such a long time, they relaxed into a more natural pose. I realized after a while Don kept looking down rather protectively at Chris-topher, so I altered the picture to include this, re-photographing parts of Don when he thought I'd done that bit. In this way I got a more interesting picture, altering it as I went along. I thought, you're half way through the picture, and you can still alter it! This is not like an ordinary photograph. It's really about drawing – about the hand, and what the hand is doing.' 'Drawing with a Camera' was, in fact, the title of the exhibition of Hockney's Polaroid collages that took place in the summer of 1982.

Later in the talk, the artist noted that, when arranging the photographs, 'the shapes of people's bodies and their overall countenance must be preserved. Otherwise you lose the sense of character. Even though someone may appear elongated, or compressed, this was not a distortion; this was a record of my experience, watching them.'

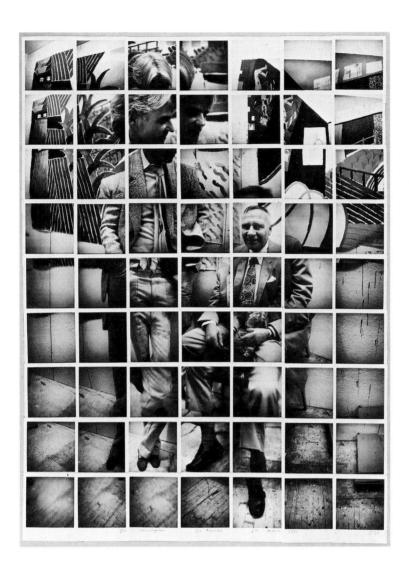

46 *Walking in the Zen Garden at the Ryoanji Temple, Kyoto, Feb. 21st 1983* 1983

Photographic collage, 101.5 x 158.5 cm (40 x 62$\frac{1}{2}$ in.)
Edition of 20

During a trip to Japan early in 1983, Hockney produced a number of photo-collages of tourist sites, including two of the Zen Garden at the Ryoanji Temple, Kyoto. The first (fig. 89) bears similarities to his earlier collages made with 35 mm film – he photographed the scene from a fixed position, using the camera to record the vertical and horizontal motion of his head. The resulting photographs were then collaged to describe the selectivity of his vision. As the artist told Charles Ingham in 1979: 'Vision is like hearing, it is selective, *you* decide what's important.'

In a lecture given in New York in November 1993 and later printed in *Engineering and Science*, Hockney recounted how, after finishing the collage, he soon became dissatisfied with the way he had depicted the garden and 'wondered how it would be possible to make it a rectangle in a picture, even in a photograph. Of course, the most obvious way would be to rent a helicopter and go above it and point your camera down, and the garden would be a rectangle as it is in nature. And you could do that. But then, while I was walking around Kyoto, it occurred to me that to make it a rectangle you have to see it as a rectangle, which means you have to move.'

The second collage, reproduced opposite, is a result of Hockney walking along the border of the garden. Every couple of steps, he would stop, face the garden and take a column of photographs extending from the border in the foreground to the yellow wall in the distance. To underline his movement, Hockney included a row of shots along the bottom that detail his feet advancing forward, one step at a time. 'I calculated how many photographs I needed to take (I should take more photographs at the top than at the bottom because of what happens) I used four rolls of film, each with 24 exposures – that's the lot; I used them all – and a half-frame camera, a tiny Pentax that I carried around in my pocket. All the pebbles actually are in the right place; there's no repetition (you'd recognize the repetition of the pattern if you just took one picture and filled it in) which meant that I had to look at all the pebbles and connect each photograph. I had to fix points – fix little patterns that I could then link with the next photograph and so on. And I was counting all the time So, if you suggest that there's movement in the viewer, the shape of things alters, and I was fascinated by this; I'm still fascinated by it.'

Fig. 89 *Sitting in the Zen Garden at the Ryoanji Temple Kyoto Feb. 19 1983*, 1983. Photographic collage, 145 x 117 cm (57 x 46 in.). Edition of 4

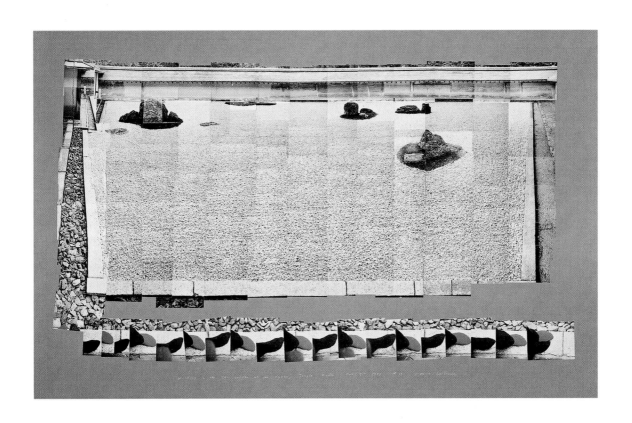

47 *Paint Trolley, L. A. 1985* 1985
Photographic collage, 101.5 x 153 cm
(40 x 60 in.)
Edition of 2

Like *Self-Portrait with Blue Guitar* (fig. 74),
this photo-collage amounts to an index of
Hockney's practice. In addition to paint,
brushes, canvases, glue and a camera, sev-
eral books are also represented: eight vol-
umes of Christian Zervos's *catalogue raisonné*
of Picasso's work; two volumes of Matisse's
graphic works; a copy of Hockney's own
Cameraworks; and, contained within a rect-
angular box, a reproduction of a Chinese
scroll painting. The artist shows his work
trolley as containing all the physical and in-
tellectual resources needed to produce not
only the portrait of Celia Birtwell – visible
on the lower shelf – but also *Paint Trolley*
itself.

 This collage concluded the forty-one-
page feature that Hockney designed for the
December 1985/January 1986 issue of
French *Vogue*; the portrait of Birtwell was
reproduced on the cover (plate 49).

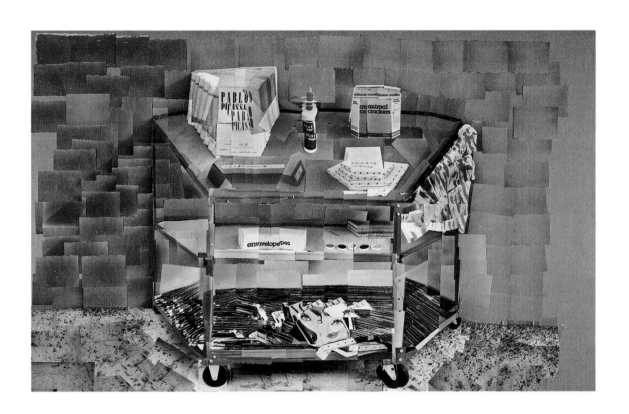

48 *Pearblossom Hwy.,*
 11-18th April 1986 no. 2 1986

Photographic collage, 198 x 282 cm
(78 x 111 in.)
Collection of the artist

Following his work for *Vogue* in 1985, Hockney was commissioned by *Vanity Fair* to produce a series of photo-collages to illustrate an article on the final chapters of Vladimir Nabokov's 1955 novel *Lolita*. Hockney intended that his illustrations, of petrol stations and motels, would culminate in *Pearblossom Hwy., 11-18th April 1986 no. 1*, which depicts a crossroads in the Mojave Desert, California. The artist spent nine days photographing the scene, electing to assemble the photo-collage at the crossroads in order to decide how it was to develop. Unfortunately, *Vanity Fair* chose not to use Hockney's illustrations; the magazine believed they were too expensive to print – *Pearblossom Hwy.*, for example, was to fold out like a road map.

In July, Hockney had another set of prints produced from the negatives in order to make a second, larger version of the collage, *Pearblossom Hwy., 11-18th April 1986 no. 2*, for an exhibition the following spring at the International Center of Photography in New York. Like *Mulholland Drive: The Road to the Studio* (plate 43), this is an image not of nature experienced directly, but as seen from a moving car.

This collage also represents the culmination of Hockney's interest in depicting space as a two-dimensional plane parallel to the surface of his photo-collages. In order to accomplish this with such a vast space as the Mojave Desert, the artist employed a variety of devices. He had the prints processed in such a way as to enhance the colour and reduce the contrasts of tone to a minimum — the sky becomes an almost monochrome surface, for example. The photographs that represent the yellow road markings have been carefully arranged to form a strong line perpendicular to the horizon. Hockney has chosen to show only two telegraph poles, at the centre of the composition; those in the foreground have been omitted, which effectively prevents the sides of the road from creating a perspectival illusion. A lateral reading of the image is reinforced by the inclusion of so many road signs, and to encourage this reading, Hockney climbed up a ladder to position his camera parallel to the signs. The road markings were photographed from above; the illusion of recession that would have resulted if he had photographed them conventionally was thereby prevented. Perhaps the most striking device is the use of the 'stop' sign, featured once in red against the deep blue sky, slightly above centre, and twice towards the lower right. It would seem that the artist has used this sign as a metaphor: 'STOP' orders the spectator to halt his or her gaze at the surface of the work.

By such means, Hockney conflates the surface of the depicted objects with that of the collage. Although the space represented is immense, little distance is shown to exist between the viewer and the objects represented, and he or she is even able to read the small print on the road signs – 'Property State of California'.

Although this image of a crossroads, with its emphasis upon 'stop' signs, was originally intended to illustrate the end of Humbert Humbert's search for Lolita, it can also be understood as referring to Hockney's decision to abandon photo-collage once this work had been completed and to return to painting and theatre work.

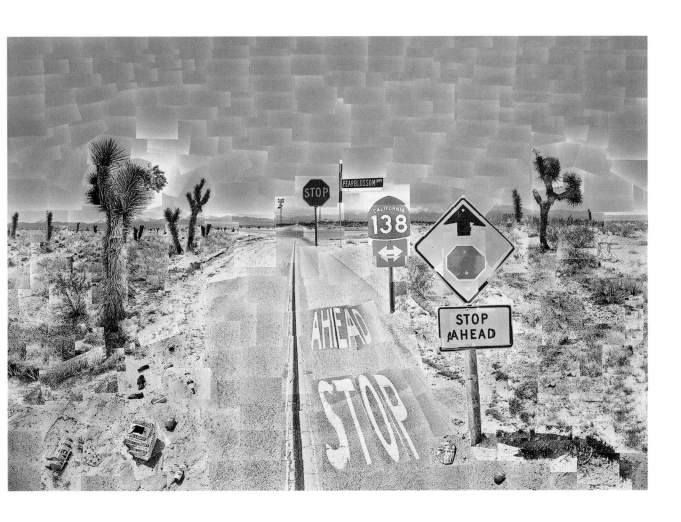

49-52 Cover and three double-page
spreads from 'Vogue par David
Hockney', *Vogue* (Paris), no. 662
(December 1985/January 1986),
pp. 219-59

Plate 49
Cover: *Tableau de David Hockney*

Plate 50
Page 228: *'The Perspective Lesson.* The idea
of the moving viewer is, of course, old. It
only came under attack with the introduc-
tion of one-point perspective, that pictorial
artifice of the Renaissance. This may have
been due to the problems of depicting the
Crucifixion.

'When Giotto depicts the Crucifixion
he does it in the medieval way, as an action
through time, from one picture to the
next, Christ carrying the Cross up the hill,
and so on.

'Yet the actual execution contains no
action (your head is not chopped off, an
arrow does not pierce your heart).

'With the invention of one-point per-
spective time stops and space is fixed, giv-
ing objects in space a feeling of weight and
volume. For the depiction of Christ's suf-
fering this is an expressive gain, but the
problem is: "what does it do to us?"

'We are not close to what is seen or
connected visually with it (emotionally, of
course, we can be).

'This invention must have led to the
camera obscura and hence the camera of to-
day, always seeing the world in the same
way. It makes for a static world and seems
to deprive us of our bodies, for to make
perspective work, we have to stand still,
close one eye and look at the world
through a hole (the photographer's prob-
lem today).'

Page 229: Reproduction of *The Perspective
Lesson*, 1985; lithograph, 76 x 56.4 cm
($29^7/_8$ x $22^3/_{16}$ in.); edition of 50

Plate 51
Page 230: 'Now let us begin a journey to
a more complex perspective that puts us in
the world. What happens if we reverse per-
spective?'

Page 231: Reproduction of *The Chair*,
1985; oil on canvas, 122 x 91.5 cm
(48 x 36 in.)

Plate 52
Page 232: 'In the theory of one-point per-
spective the vanishing point is infinity and
the viewer is an immobile point outside
the picture. If the infinite is God, we never
connect, but if perspective is reversed then
infinity is everywhere, infinity is every-
where, infinity is everywhere, infinity is
everywhere and the viewer is now mobile
(is this better theologically?).'

Page 233: Reproduction of *Chair, Jardin du
Luxemburg, Paris, 10th August 1985*, 1985;
photographic collage, 110.5 x 80 cm
($43^1/_2$ x $31^1/_2$ in.); edition of 3

The final double-page spread consisted of a
reproduction of *Paint Trolley, L.A. 1985*
(plate 47).

VOGUE

PARIS

DÉC
JAN

F 40

I.S.S.N. 0750-3628

P A R D A V I D H O C K N E Y

La leçon de perspective

C'est, bien sûr, une vieille idée que de considérer le spectateur en mouvement. Elle fut détruite par l'invention de la perspective, l'unique point de fuite, l'artifice pictural de la Renaissance. Cela fût peut-être dû aux difficultés de peindre la crucifixion.

Lorsque Giotto peint la crucifixion, il le fait d'une manière medievale : c'est-à-dire une suite d'événements traversants le temps, d'un tableau à l'autre, le Christ portant la croix jusqu'en haut du mont.

Mais cette exécution n'est pas une action, (votre tête n'est pas coupée, aucune flèche ne transperce votre coeur.)

Le temps s'arrête, et l'espace devient fixe lorsqu'on utilise le procédé de la perspective, donnant ainsi une impression de poids et de volume aux objets dans l'espace. La souffrance du Christ est rendue plus appréciable par la perspective et gagne en expression, mais le problème est toujours ; "qu'est-ce-que cela peut bien nous faire ?."

Nous ne sommes ni près ni attachés visuellement parce que nous voyons, (en revanche, on peut l'être emotivement.)

Cette invention précéda celle de la chambre obscure, et par la suite l'appareil de photo tel que nous le connaissons aujourd'hui, voyant le monde de la même façon. C'est donc un monde statique, un monde qui supprime notre matérialité. Pour que cette perspective puisse fonctionner, nous sommes obligés de ne pas bouger, de fermer un oeil pour regarder ce monde avec l'autre, à travers un petit trou : (et voilà l'angoisse du photo: aujourd'hui.)
graphe

Commençons un voyage dans

un pays où la perspective est

plus complexe et qui nous place

dans ce monde-là.

Qu'est-ce-qui se passe si

nous inversions la perspective?

dans la theorie de la perspective

∞

le point de fuite

est l'infini

et le spectateur est
un point immobile en
dehors du tableau

Si l'infini est Dieu, nous ne nous rejoindrons
jamais, mais si la perspective est
inversé alors

l'infini est partout
l'infini est partout
l'infini est partout
l'infini est partout

et le spectateur est
maintenant en
mouvement

[est-ce mieux théologiquement?]

1982-1993

Wider Perspectives

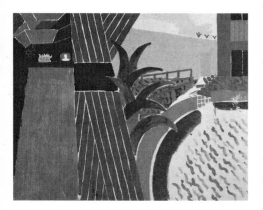

Fig. 90 *Terrace Hollywood Hills House with Banana Tree*, 1982. Gouache on paper, 129.5 x 167.5 cm (51 x 66 in.). Private collection

Fig. 91 *Waking Up VII*, 1983. Pencil on paper, 56 x 76 cm (22 x 30 in.). Collection of the artist

As a result of Hockney's preoccupation with photography, and with the possibilities offered by photo-collage as a means of altering his treatment of pictorial space, the artist's painting, too, inevitably underwent a fundamental change. As always when his interest focused on photography and collage, he produced relatively few paintings. After the works he had shown in London in the exhibition 'A New Spirit in Painting' (1981), which included the first of his large-scale compositions, *Mulholland Drive: The Road to the Studio* (plate 43), there followed a phase of reorientation. The insights that photo-collage in particular had afforded into both perception and representation were now applied to painting and adapted accordingly. This process took many years and, to begin with, it was apparent only in pictures painted in 1982 (see plate 53). It was from 1984 (after painting had again begun to claim more of Hockney's attention) that this development led him to fundamentally new ways of using pictorial space in his paintings.

Preparations for the touring exhibition 'Hockney Paints the Stage', which opened in 1983 in Minneapolis, took up much of the artist's time because he was engaged in reconstructing several stage sets as three-dimensional installations. During this period Hockney again did no painting, producing only photo-collages. At the end of his work for the exhibition, he turned to a genre that, previously, he had treated only in some drawings and a few paintings: the self-portrait. In a series of chalk drawings, he mostly appears as a half-figure placed frontally in relation to the viewer, and captured in the act of drawing (see fig. 92). In these self-portraits, he was concerned to achieve a naturalistic record in which both his appearance and his activity were equally important as subjects. Quite distinct from these drawings is the series of seven sheets, from the same year, showing Hockney and his friend Ian Falconer waking up in the morning: here the sequence of images forms a narrative (see fig. 91). Neither Hockney's work on the stage set installations nor his photo-collages appear to have had any influence on these drawings.

By 1984 Hockney was able to translate into painterly terms the insights gained from his work with photo-collage. In several pictures made in 1982 – above all, in portrait heads – he had already tried using the multiple viewpoints of Cubism, as well as the Futurist-derived means of showing limbs in movement in terms of their phased displacement (see plate 53). It was harder to organize space in a picture in such a way that it did not take on an inflexible character (as in the gouaches of 1982) through a use of perspective that prevented the spectator from arriving at his or her own, autonomous experience of space. When trying to resolve this problem, Hockney found an answer in a book by George Rowley, *Principles of Chinese Painting*, that he had come across while preparing the Minneapolis exhibition. Rowley explained the varying perspectives employed in the depiction of landscape in Chinese scroll paintings. In contrast to the conception of a single central perspective, familiar in the West since the Renaissance, Chinese landscape painting assumes the viewer to be located not in front of the picture, but within it. There, he or she is able

to 'walk' through, and take part in, the landscape composition, be this narrative or descriptive. Such notions naturally presuppose a quite different conception of space, in particular one informed by the sense of ambiguity lacking in the system of central perspective. It was above all in the large paintings produced, or conceived, in 1984, *A Visit with Christopher and Don, Santa Monica Canyon 1984* (plate 54) and *A Walk Around the Hotel Courtyard, Acatlán*, that Hockney was determined to address the problem of perspective, and the question of the role played by the spectator as someone 'entering' depicted space.

Hockney also applied this newly won experience of spatial representation to his work on a series of large-scale, sometimes bi-partite lithographs that were printed in up to twenty-eight colours, among them various views of the hotel courtyard in Acatlán. In the interiors, it is notable that individual objects, such as chairs, and the space surrounding them do not share a common perspective. The objects, 'correctly' shown according to their own, reverse perspective, thus become sculptural. At the same time, Hockney explored this phenomenon in a series of paintings simply showing a chair – variations on a subject of Van Gogh's (see plate 51).

The complexity of the new processes used to produce Hockney's multicoloured lithographs meant that the artist had to rely more than ever on the help of an experienced lithographer, and this allowed for only a small degree of spontaneity. In 1986, partly in response to this situation, the artist started to explore radically different ways of producing prints: he discovered that a colour photocopier would allow him to work both spontaneously and without the need for assistants. However, this printing process, devised to reproduce the lines on a surface rather than nuances of tone, imposed its own limitations. This disadvantage spurred Hockney to experiment, in turn, with possible textures and printing materials (including city maps). He partly cut out the 'graphic' structures produced by the copying process and put them together as a collage with other textured planes, shapes, line drawings and paintings in gouache or watercolour, so creating new compositions. In this process, every new printing colour required its own printing material, on each occasion produced as a new collage or drawing, and this had to be individually prepared. The final result, after many separate printings, was a composition for which there had been no single original image, only individual colour prints of the different parts. It was through the combined printing of these that a complete composition emerged.

Hockney gave the name 'Home Made Prints' to the results of this process, which he employed to produce limited editions of each motif. He was fascinated, above all, by the new possibilities in the technical manipulation of planes, the alteration of the intensity of the resulting print, from gradations of grey to black, and the scope for playing with colour (he had one of the toner powders specially mixed for him by the manufacturer).

Hockney's 'Home Made Prints', conditioned by what was technically possible, present planar, abstracted compositions, still lifes (see fig. 93),

Fig. 92 *Self-Portrait 28th Sept. 1983*, 1983. Charcoal on paper, 76 x 57 cm (30 x 22 $\frac{1}{2}$ in.). Collection of the artist

Fig. 93 *Dancing Flowers, May 1986*, 1986. 'Home Made Print': xerographic print, 56 x 64.5 cm (22 x 25 $\frac{1}{2}$ in.) (six panels). Edition of 60

Fig. 94 *Tristan Looking for Shade*, 1987.
Acrylic on canvas, 61 x 61 cm (24 x 24 in.).
Private collection

landscape motifs (for example, the image of a tree spread across several individual prints) or subjects taken from the artist's immediate surroundings, such as his dachshund Stanley, a recent arrival in the house. The complicated perspectives and spatial compositions that were of such immediate interest to Hockney only a year previously have scarcely any significance in relation to these flat and cheerful images. The world of his pictorial imagination appears to have altered – from the open, narrative picture form that was the determining factor in *A Visit with Christopher and Don* to the small and the intimate.

In October 1986, after a gap of six years, Hockney returned to working for the theatre: he was commissioned by the Los Angeles Music Center Opera to design the sets for Richard Wagner's *Tristan und Isolde*. This work occupied him for almost a year and, from the start, he was aware of how important the new types of perspective that he had discovered in the photo-collages and landscape panoramas would become in this new context. Looking back, he wrote: 'I started using my ideas about perspective, which I had developed in photography, from the complexity of *Pearblossom Hwy.* [plate 48], which although it has actually got hundreds of perspectives, looks as though it's got a normal one as well. I realized one could maybe do this in space. I couldn't make hundreds of perspectives in the sets, on the stage, but I could make quite a few that still looked as if they were one. The effect, I thought, would be to pull the viewer closer into it.'

Alongside the silhouette-like shapes that dominate the stage in Hockney's designs for *Tristan und Isolde*, it was now above all the drama of lighting, synchronized with the music, that altered the appearance of the shapes themselves and of the sets as a whole in such a way that new types of space seemed to come into being, even though no change had been made in the physical arrangement of the stage. One thus had the impression of a complete transformation. In these 'tableaux vivants', the power of the coloured stage lighting was the decisive new element. This was later to be further developed in the artist's set designs for Giacomo Puccini's *Turandot* (1990/1) and Richard Strauss's *Die Frau ohne Schatten* (1992), and it was also to prove a determining factor in his subsequent work as a painter. To begin with, Hockney produced only a few paintings, including a small group of pictures in which he captured the individual characters from *Tristan und Isolde*, in the manner of stills, at particular points in the story, or showed them in interaction (see fig. 94). These pictures are not designs for costumes, nor do they show the figures on the stage. They are, rather, studies in which the artist sought to examine the characters and their actions with a concentration not possible in the small-scale models of the stage that he used in designing his sets.

After finishing work on *Tristan und Isolde*, Hockney produced several paintings, above all still lifes, in which he inserted flat 'silhouettes' like those found in his set designs – *The Golden Still Life* (1987), for example. This was a form of abstraction that he went on to employ in filling the seemingly chaotic, and yet not unarticulated, space of *Big Landscape*

Fig. 95 *Henry*, 1988. Oil on canvas,
61 x 61 cm (24 x 24 in.). Private collection

(Medium Size) (plate 58), painted in 1988. In this year — one that was to prove fruitful for Hockney's work as a painter — the artist also produced a series of interiors, in which he again addressed the question of the representation of space and perspective (see plate 56). In contrast to his earlier attempts in this direction — for example, in *A Visit with Christopher and Don* — Hockney selected only a single, fixed point of view for the presentation of space, such as had to be assumed in designing for the stage. Investigation of imaginary movement and spatial continuity was here no longer his principal concern.

Retreating to the seclusion of his small studio at Malibu Beach in the same year, Hockney turned to a subject that had last occupied him in 1984/5, albeit then in his attempt to deal with the problem of showing solid volumes from multiple viewpoints: the portrait. In a short time, he produced an extensive series of small-scale portraits of the friends and relatives who visited him at Malibu, recording them swiftly and spontaneously (see plate 59). Many of these portrait heads are posed against a neutral white or blue background, as in a passport photograph; only in a few of them is there any suggestion of space in the background (see figs. 95, 101). In his concentration on heads, and in particular on facial features, Hockney was aiming at the sort of directness that is not to be found in his earlier portraits, which mostly show the whole figure.

In late 1988, while Hockney was living at Malibu, he discovered the technical possibilities offered by the fax machine. Over the following months, he experimented with these with an intensity comparable to that with which he had worked with the photocopier two years earlier, subsequently showing the results internationally in a series of exhibitions. As with the 'Home Made Prints', he first devised various graphic structures

Fig. 96 *Tennis*, 1989. Fax print, 144 panels, each 21.5 x 35.5 cm (8 ¹/₂ x 14 in.). Unlimited edition

Fig. 97 *What About the Caves?*, 1991. Oil on canvas, 91.5 x 122 cm (36 x 48 in.). Collection of the artist

using the photocopier; he then created collages by combining these with drawings and gouaches in different tones of grey, and sent the completed work as a fax. In order not to be limited to the sheet size that it was possible to transmit by fax, he produced large compositions that could be faxed as a series of sheets, which the recipient would then piece together (see fig. 96).

Hockney was interested, above all, in the new graphic structures made possible by the copying process and in their reproduction in the form of fax; and these had an influence on his painting. In several landscapes painted in 1989 and 1990, he experimented with a number of styles – even within a single composition, as in *Pacific Coast Highway and Santa Monica* (plate 60).

This new interest in landscape was not only the result of the long periods Hockney was now spending at his beach house; it also had to do with a 'choreographed' car journey that he called the 'Wagner Drive'. Starting out from his house on Pacific Coast Highway, Hockney would listen to popular American music, usually beginning with musicals; he would then mark his exit from the coastal road and the ascent, at breakneck speed, into the Santa Monica Mountains with music by Wagner, which he felt to be dramatically attuned to the experience of the landscape.

In 1991, after the 'Home Made Prints' and the fax works, Hockney turned to yet another form of new technology: he explored the possibilities of using a computer to create drawings. Again, as with the 'Home Made Prints', it was a form of photocopier (now a Colour Laser Printer) that produced the drawings in printed form. The 'original' was created on the computer screen and stored on disc. The almost endless range of possibilities offered by the computer's drawing programme – from a simple arrangement of lines to the complex dissolution of planes, from black-and-white to a perpetually changeable mixture of colours – opened up totally new directions in the creation of drawings. Hockney was especially fascinated by the brilliance of synthetic colours and the luminosity of the potentially endless layers of colour when these were printed (having been overlaid but not mixed).

Fig. 98 *John Fitzherbert, Dec. 31 1993,* 1993. Crayon on paper, 77 x 57 cm (30 $^1/_4$ x 22 $^1/_2$ in.). Private collection

Hockney was also able to use the computer to perfect the complex graphic structures of his fax works and to develop these through the addition of colour. Compositions and motifs evolved in this context then became the basis for a series of abstract constructions, resembling still lifes, but nevertheless intended to represent landscapes (see fig. 97, plate 58). These, in turn, anticipated Hockney's 'Some Very New Paintings', produced in 1992. Here, the focus was on a three-dimensional object at the centre of a picture surface, itself divided only ambiguously into foreground and background. The composition in each of 'Some Very New Paintings' is derived in some measure from Hockney's experience of designing stage sets, in that it allows pictorial space to resemble that of a stage through the use of largely abstract shapes and colours, and of perspective and dramatic light (see plate 62). Hockney writes in his autobiography: 'In *Some Very New Paintings* I think the viewer is moving in them,

so to put a figure there did not seem right. In fact, depicted images or ob-
ject-like things are included only to give a sense of scale; without those,
the pictures would be something different. You may not be sure what
those little things are, but they give an illusion and a scale so that the eye
roams about, roams and mentally makes space.' The spaces described here
are those of inner vision, or imagination, rather than those encountered in
everyday experience.

Hockney went on to apply what he had learned about space in
'Some Very New Paintings' to a series of gouaches that he made in the
spring of 1994. At about this time, he returned to 'traditional' drawing, a
medium he had barely employed in the previous years because of his preoc-
cupation with painting, set design and the possibilities offered by the new
technology. Starting in December 1993, Hockney produced a great many
large-scale portraits of relatives and friends. While the painted portraits
of 1988 had concentrated on the facial features, the new works showed
seated, three-quarter figures filling out the surface and drawn in variously
coloured chalks, though mostly in grey and black. In addition to record-
ing faces, Hockney paid particular attention to the hands, these becoming
exceptionally characterful bearers of expression (see figs. 98, 99).

Fig. 99 *Mum, 10 March 94*, 1994. Crayon
on paper, 77 x 57 cm (30 $^1/_4$ x 22 $^1/_2$ in.).
Private collection

53 *David, Celia, Stephen and Ian, London 1982* (also called *Four Friends*) 1982

Oil on eight canvases, 183 x 203 cm (72 x 80 in.)
Private collection, USA

In the summer of 1982, after Hockney's period of intensive work on his composite Polaroid pictures, he produced a few paintings in London and Paris. As he himself writes, he was 'trying to take and use the ideas from the Polaroids. The first efforts were simple, quite simple, but I could begin to see what to do in painting and it was exciting. But I wasn't sure.' For *David, Celia, Stephen and Ian*, Hockney used eight canvases of equal shape and size – one for the upper and lower halves of the figure of each of the four friends. The figures are seen against different backgrounds and floors, and all four portraits have their own painterly character. The interconnection of each pair of related canvases is established through the individual it depicts. A number of devices that Hockney first explored in some of the Polaroid works – the multiple viewpoints of Cubism (above all, in the faces) and the movement of the limbs as a representation of the passage of time – recur here, rendered with the means available to a painter. The fluent, partially 'unfinished', application of paint indicates that these portraits were made relatively quickly.

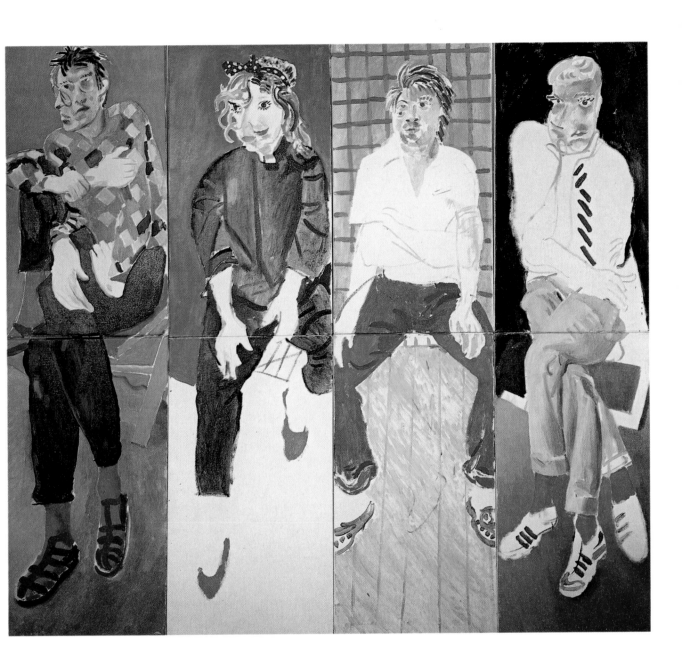

54 *A Visit with Christopher and Don, Santa Monica Canyon 1984* 1984
Oil on two canvases, 183 x 610 cm
(72 x 240 in.)
Collection of the artist

In the spring of 1984, taking his point of departure in the discovery, made during his work with photo-collage, that a motif in a picture need not necessarily be represented from only one point of view, Hockney evolved the painting *A Visit with Christopher and Don, Santa Monica Canyon 1984*, a complex composition for which he made a series of preparatory studies. He again worked on the large scale he had used for *Mulholland Drive: The Road to the Studio* (plate 43), produced four years earlier, yet the two paintings are fundamentally distinct in terms of composition. *Mulholland Drive*, with largely frontal views from a single point and vistas that appear, in part, as if presented as collage, is a panorama that generates hardly any sense of depth. In *A Visit with Christopher and Don*, on the other hand, one can make out numerous points from which Hockney has constructed his composition, which includes both interior and exterior views.

Hockney's motif here – two people in an interior – was not new in his work: it is also to be found in his 'Domestic Scenes' of 1963 (see plates 12, 16). In the painting of 1984, however, the two figures (the painter Don Bachardy on the left, the author Christopher Isherwood on the right) are rendered in the form of line drawings and so appear to retreat into the picture. They thus seem as if absent from the space that they in reality inhabit. At the centre of the picture, there is a round table; beyond it, we look through two arched openings out on to the view of a yellow house on a cliff. This view is repeated a further six times in the composition: it is seen, separately, by the painter and by the writer, but it can also be seen from the living room and the bedroom and from elsewhere in the house and garden.

A Visit with Christopher and Don is not a double portrait of the two friends such as Hockney had painted in 1968 (fig. 62). It is, rather, a work in which the artist analyses the presentation of space, of proximity and distance, and of different types of proportion and perspective. Here, space can be 'read' from every possible point of view and – as with an image reflected in a multi-facetted glass – imaginatively pursued in every possible direction.

Detail ▷
Complete painting overleaf

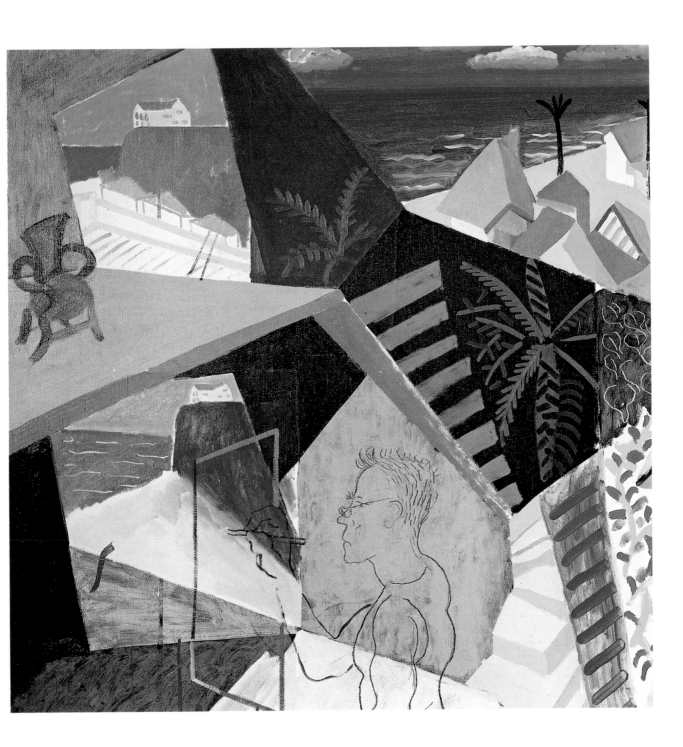

55 *Still Life with Book
 on Table* 1988
Acrylic on canvas, dia. 124 cm (47 $^3/_4$ in.)
Private collection, New York

Still Life with Book on Table – an excep-
tional work in Hockney's *œuvre* on account
of its circular format – takes as its subject
the representation of space. The table-top
is viewed almost completely from above,
with the circular form slightly fore-
shortened and cropped to an oval. Two of
the table-legs are visible within the cres-
cent forming the lower edge of the picture.

This play with a traditional picture
format and the *trompe-l'œil* painting of the
table is itself interrupted by the treatment
of the still life. While the book and other
objects are arranged on the table in such a
way that we can interpret them in terms of
conventional perspective, the blue vase
with flowers in the centre of the composi-
tion, added to the surface like a cut-out,
seems to obey a new sort of perspective.

56 *Large Interior, Los Angeles* 1988

Oil, paper and ink on canvas,
183 x 305 cm (72 x 120 in.)
The Metropolitan Museum of Art, New
York, purchase, Natasha Gelman gift, in
honour of William F. Lieberman, 1989

Large Interior, Los Angeles is a view of the
living room of Hockney's house in the
Hollywood Hills. Space here has a logic
that is not easily understood, the walls,
windows and furniture combining to form
a coloured mosaic in which perspective is
not employed as an organizing element. In
order to strengthen the element of con-
trast, the floor is differentiated from the
other planes by means of irregular patterns
scratched in the paint while it was still
wet. In this composition (for which several
small preparatory studies were produced),
Hockney focuses on the spatial possibilities
of the interior and the three-dimensional
pieces of furniture to be found there. The
view beyond – to the blue sky and into the
garden with its tall plants – is conceived of
in terms of contrasting planes of colour.

Detail ▷

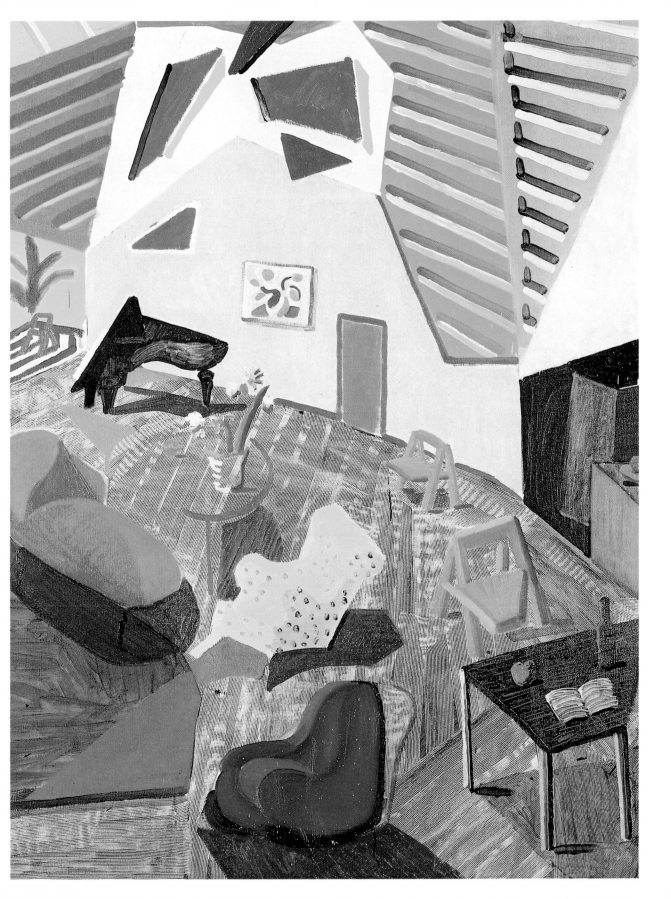

57 *The Sea at Malibu* 1988

Oil on canvas, 91 x 122 cm
(36 x 48 in.)
Collection of Mr and Mrs Miles Q.
Fiterman, Minneapolis

Of the compositions produced after the
completion of work on the set designs for
Wagner's *Tristan und Isolde* and the opening
of the retrospective exhibition in 1988, *The
Sea at Malibu* makes especially clear the
formal changes not emerging in Hock-
ney's work. Even though the motif of the
coastal landscape remains recognizable, one
cannot fail to detect a rearrangement of pic-
torial space and an increasing abstraction
in the presentation of the scene. The com-
position is organized so as to suggest three
different levels. In the foreground we find
a stage-like construction on which there
stand three objects – two cylindrical, one a
tapering funnel – which resist more spe-
cific identification. The middle ground is
an undulating form made up of curved
lines and planes, and repeatedly suggestive
of space. It opens at two points to reveal a
view of the background, where we find the
Pacific with two distinct horizon lines.
This composition is striking because it is
only in the foreground that light (falling
from the left) is introduced as a further
source of visual drama.

Fig. 100 *Beach House with Waves I*, 1988.
Oil on canvas, 61 x 91 cm (24 x 36 in.).
Collection of the artist

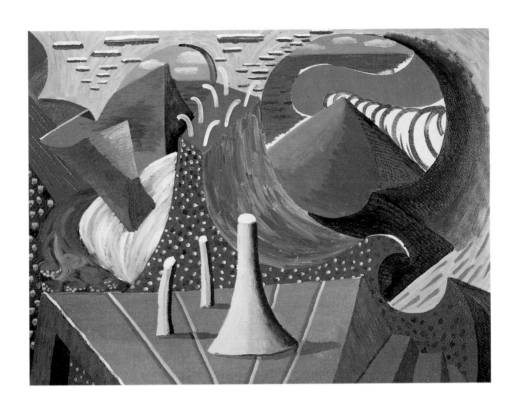

58 *Big Landscape (Medium Size)* 1988

Acrylic on two canvases, 122 x 91 cm (48 x 36 in.)
Private collection

Describing the evolution of this unusual picture, Hockney writes in his autobiography: 'The painting is made with two canvases; it began as one and I then made it bigger. I could see I was beginning here to play with spatial ideas. I worked on it off and on for a few months. I kept it in a corner and it looked a bit odd because it is a painting in which I'm exploring ideas.'

The surface of the painting is completely covered with a seemingly disorganized mosaic of individual areas of colour. Some of the coloured shapes, whether alone or in groups, are shaded and positioned in such a way that they suggest solid bodies; but only a few rounded, 'organic' forms seem to justify the reference to landscape in the picture's title. A landscape is, none the less, conveyed by the clear sense of space and of a succession of planes and bodies, even though there is no indication of relative size and distance. We can detect architectural forms in the 'foreground', a swimming pool at the centre and pyramidal hill forms above.

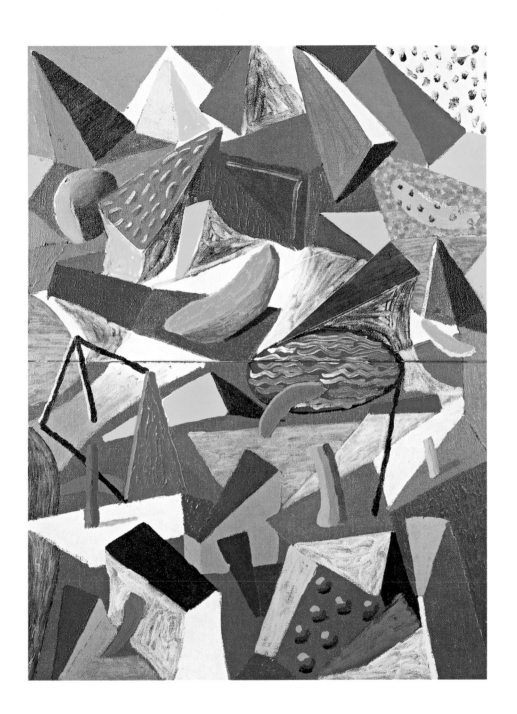

59 *Mum* 1988/9
Oil on canvas, 42 x 26.5 cm
(16 1/$_2$ x 10 1/$_2$ in.)
Collection of the artist

In 1988 and 1989, in the seclusion of his studio at Malibu Beach, Hockney painted an extensive series of portraits (see fig. 101). In each of these, he showed only the head and the facial features; details of dress and background remain subordinate. As in every phase of Hockney's career in which he has painted or drawn portraits, his mother was among those who sat for him.

Of these portraits, the artist writes in the second volume of his autobiography: 'I felt I wanted to look at my friends' faces again and I painted them rather quickly and crudely, but, as the painting accumulated, they seemed quite interesting. Most of the people I had painted didn't like them – I don't think I'm that much of a flatterer. Nevertheless, it was useful to me to look at people again – they were all people I knew. If the best ones are my mother, it is perhaps because I know her best.'

The insistent frontality of Hockney's portrait of his aged mother allows a high degree of directness in the confrontation between the painter (and viewer) and the sitter. In the subtle modelling with which the artist records her wrinkled skin, and in the trusting character of the eyes as they seem to respond to our gaze, he creates an image of old age marked by dignity and self-assurance.

Fig. 101 *Ian*, 1988. Oil on canvas, 52.5 x 33 cm (20 3/$_4$ x 13 in.). Collection of the artist

60 *Pacific Coast Highway and Santa Monica* 1990

Oil on canvas, 198 x 305 cm
(78 x 120 in.)
Private collection

Ten years after painting *Mulholland Drive: The Road to the Studio* (plate 43), Hockney again tackled a landscape panorama in *Pacific Coast Highway and Santa Monica*. It was produced at a time when, alongside his preoccupation with the artistic possibilities of the fax machine, he was experimenting with distinct styles of landscape painting.

The composition is divided into four distinct planes that illusionistically generate the picture space in the manner of stage flats. A foreground area shows the mountains, broken up into coloured planes, with two pale blue highways snaking between them. While both the serpentine lines and the colour gradations give rise to a deceptive impression of perspective recession, it remains clear that the landscape here still consists only of two-dimensional planes. Beyond this segment of coloured 'stage scenery', there is another, forming the middle ground: here, Hockney uses blue and pink in a painterly fashion to model the forms of the hills. The background shows the view from the hills down on to Santa Monica and the bay. At first glance, conventional perspective seems to apply here, but it is called into question through the presentation of a sequence of high-rise buildings, the 'nearest' one shown smaller than the 'furthest'. To the various levels of illusionism presented in this painting (for which the starting point was a frozen frame from a video), Hockney adds a fourth in the shape of two dark triangular areas overlapping both left and right lower corners of the image; these recall the curtains at either side of a stage.

61 *Esplanade* 1992
 Oil on canvas, 198 x 305 cm
 (78 x 120 in.)
 Collection of the artist

Esplanade, painted directly before and during Hockney's work on 'Some Very New Paintings' (see plate 62), is one of his largest pictures from this period. In it, the overall abstract composition – a three-dimensional object (impossible to identify precisely) surrounded by a white-and-grey plane – absorbs, without negating, the seemingly figurative elements contained within it, notably the pier projecting into the water. Hockney is here also experimenting with the possibilities of combining diverse types of line and form in the organization of a composition.

62 *The Eleventh V. N. Painting* 1992

Oil on canvas, 61 x 91 cm (24 x 36 in.)
Collection of the artist

The Eleventh V. N. Painting is one of a series of twenty-six pictures in which Hockney translated into the two-dimensionality of paint on canvas what he had learned about light and space during his work on the stage sets for productions of Giacomo Puccini's *Turandot* and Richard Strauss's *Die Frau ohne Schatten*.

Although the entire picture surface is formed of abstract shapes, planes and textures, we can detect a spatial composition, albeit not one that offers an unambiguous definition of space. While some of the shapes appear to swell as a result of their modelling in colour, and so to hint at volume, other planes and patterns tend to act as the perspective indication of a background or to form a surface for other, smaller entities. The small blue vertical forms placed centrally in the lower part of the composition, and standing on one of these surfaces, serve as an indication of scale, enabling us to derive an idea of relative size within the picture space. These forms and the small sphere at the lower right corner are the only elements that, by means of a dramatic play of light and shade, appear as clearly defined volumes.

Fig. 102 *Doodle*, 1992. Ball-point pen on paper, 21.5 x 14 cm (8 $^1/_2$ x 5 $^1/_2$ in.). Collection of the artist

63 *Still Life in Landscape* 1993
Oil on canvas, 61 x 91 cm (24 x 36 in.)
Collection of the artist

Since completing 'Some Very New Paint-ings' (see plate 62), Hockney has painted only sporadically. As so often in his career, he has turned to other projects, embraced other challenges, supervising revivals of *Turandot* in Houston and *The Rake's Progress* in the new opera house at Glyndebourne, as well as producing a large number of gouaches and drawings.

Still Life in Landscape is among the few paintings that the artist has created since 'Some Very New Paintings'. Not directly related to the latter – its spatial organization, for example, is clearer – it takes up the style of a work such as

Esplanade (plate 61). Probably deriving from the doodles that Hockney produces 'in passing' at every possible opportunity (see fig. 102), the yellow lines in *Still Life in Landscape* form a framework that seems to inhabit a stage space. The blue still-life items – a many-sided object reminiscent of a human torso and two upright hook shapes – are presented at the front of this stage like frozen figures in a drama; the green and red 'backdrop' areas are articu-lated by a mosaic of pointillist dots. In its hieratic theatricality, the image recalls the artist's 'curtain paintings' of the sixties (see plates 13, 14; fig. 38).

Chronology

1937-1947

David Hockney is born on 9 July 1937 in Bradford, Yorkshire. He is the fourth of Laura and Kenneth Hockney's five children. The family lives at 61 Steadman Terrace.

He is evacuated to Nelson in Lancashire for six months during the Second World War; otherwise, he spends his entire childhood and adolescence in Bradford.

1948-1953

Attends Bradford Grammar School on a scholarship. Caricatures by him are published in the school magazine.

Hockney at Bradford Grammar School, 1955

In autumn 1953, enrolls at Bradford School of Art, where he initially studies anatomical drawing. He subsequently produces numerous drawings of Bradford and its environs, as well as portraits and figure subjects.

1954

Creates his first oil paintings and some colour lithographs and, later, painted ceramic pieces.

1957-1959

His painting *Mount Street, Bradford* is shown at the Royal Academy of Arts Summer Exhibition of 1957. That year, at the 'Yorkshire Artists' exhibition at Leeds Art Gallery, he sells a painting for the first time: *Portrait of my Father* (1955), one of two pictures by him included in the show. Receives his diploma from Bradford School of Art in the summer.

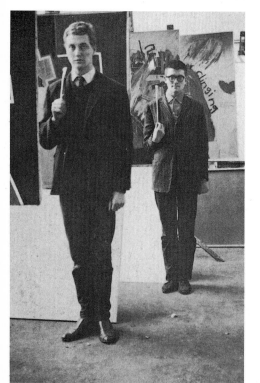

'Artists on Guard': Derek Boshier and Hockney at the Royal College of Art, London, in 1961. *K is for King* (plate 7) and *We Two Boys Together Clinging* (plate 5) can be seen at the back.

A conscientious objector, he works in hospitals in Bradford and in Hastings, Sussex, to fulfil his National Service obligations.

In September 1959, begins studying at the Royal College of Art in London; gets to know R. B. Kitaj during his first days there. Lives in Kempsford Gardens, Earls Court.

1960

Shows two paintings at the 'London Group 1960' exhibition and is included for the first time in the annual Young Contemporaries exhibition (R. B. A. Galleries, London).

1961

Meets John Kasmin, who is to become his dealer.

Commissioned to execute murals in the Teenagers' Room on the ocean liner SS *Canberra*.

Leaves for a two-month visit to New York at the beginning of July. The Museum of Modern Art purchases two of his etchings.

After returning to London, starts work on *A Rake's Progress*, a suite of etchings not published until 1963.

1962

Receives his diploma from the Royal College of Art and, at the same time, the college's Life Drawing Prize.

Travels to Italy in the summer, visiting Munich and Berlin on the return journey.

Moves to 17 Powis Terrace, Notting Hill, in the autumn.

Teaches at the art school in Maidstone, Kent.

1963

Travels to Egypt in the autumn to produce drawings for *The Sunday Times*, which never publishes them.

Sells all paintings included in 'Pictures with People In', his first solo exhibition, held at Kasmin's new gallery in London in

December. *A Rake's Progress* is published by Editions Alecto and shown by them at the Print Centre concurrently with the Kasmin exhibition.
Travels to the USA at the end of the year. First stop is New York, where he meets Andy Warhol and the art historian Henry Geldzahler.

Hockney in Berlin, 1962

1964

Flies to Los Angeles at the beginning of January; rents a small studio in Santa Monica.
Begins painting in acrylic.
During the summer, teaches at the University of Iowa, Iowa City.
Travels through New Mexico, Oklahoma and Kansas to Chicago and, later, via the Grand Canyon and New Orleans to New York, where he attends the opening of his successful first solo exhibition in the USA. Returns to London in December.

1965

Teaches at the University of Colorado in Boulder during the summer, subsequently travelling to Los Angeles and New York. Produces the well-known suite of six lithographs *A Hollywood Collection*.
Returns to London on the SS *France* in October.
Solo exhibition at Kasmin's gallery in London.

1966

In January, travels to Beirut, where he does drawings for the series of etchings *Illustrations for Fourteen Poems from C. P. Cavafy*, published later in the year.
Designs sets and costumes for Alfred Jarry's *Ubu Roi* at the Royal Court Theatre, London.
During the summer, teaches at the University of California at Los Angeles, where he meets Peter Schlesinger.
Rents a studio on Pico Boulevard.

1967

Teaches at the University of California at Berkeley in the spring.
Starts relying on his own photographs as studies for paintings.
Returns to London in the summer.
Visits France and Italy in August.

Hockney contemplating *Portrait of Nick Wilder* (plate 28) in his Los Angeles studio, 1966. *Sunbather* (fig. 44), also as yet unfinished, can be seen at the rear.

1968

Travels to New York in January, then journeys across country to Los Angeles. Rents a studio in 3rd Street, Santa Monica.
Returns to London in the summer.

1969

Works on the suite of etchings *Six Fairy Tales from the Brothers Grimm*.
Visiting Professor at the Hochschule für bildende Künste in Hamburg.
Solo exhibition at the André Emmerich Gallery, New York, in November.

1970

Retrospective exhibition of his work opens at the Whitechapel Gallery, London, at the beginning of April; subsequently shown in Hanover, Rotterdam and Belgrade.

1971

Travels to Morocco in March, later in the USA and France. In the autumn, visits Japan and South-east Asia. Travels widely during the next years.

Jack Hazan starts preparing his film on the artist, *A Bigger Splash*.
Peter Schlesinger ends his relationship with Hockney.

1973

Moves to Paris, where he lives in the Cour de Rohan.
Focus of interest shifts from painting to drawing and print-making.

1974

Returns to painting in oils.
Retrospective exhibition held at the Musée des Arts Décoratifs, Paris.
Enters into a relationship with Gregory Evans.

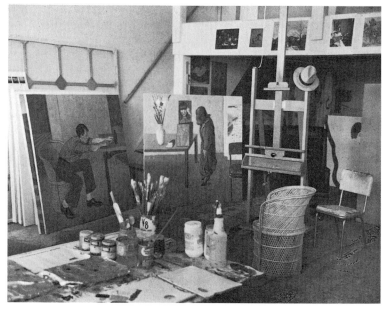

Hockney's Los Angeles studio, 1979. The painting in the centre is *Ann Upton Combing her Hair*, which was later cut into three parts.

1975

Designs sets and costumes for a production of Igor Stravinsky's *The Rake's Progress* at the Glyndebourne Festival Opera; first performance in June.

Hockney in the exhibition 'Looking at Pictures in a Room', organized by him for the National Gallery, London, in 1981

1976

Travels in the USA. Later visits Australia and the South Sea Islands.
Publication of the first part of his autobiography, *David Hockney by David Hockney*.
Works on *The Blue Guitar*, a series of etchings (published the following year) based on Wallace Stevens's poem 'The Man with the Blue Guitar'.

1977

Moves his London studio to Pembroke Studios, Kensington, initially intending to keep it for only a few months.
Visits India.
In New York, works on sets and costumes for a production of Mozart's *The Magic Flute*, which opens at Glyndebourne in May of the following year.

1978

Travels to Egypt early in the year.
Decides to settle in Los Angeles.
Produces the series of twenty-nine 'Paper Pools' in the workshop of the printer Ken Tyler at Bedford Village, near New York.
In October, rents a studio on Santa Monica Boulevard in Los Angeles.
'Travels with Pen, Pencil and Ink', a major exhibition of his drawings, begins its tour throughout the USA; final showing is in London in 1980.

1979

An article by him in the *Observer* on 4 March triggers off a public controversy over the acquisitions policy of the Tate Gallery, London.
Moves into a house in the Hollywood Hills, on the tennis court of which he has a studio built in 1983.
Teaches at the San Francisco Art Institute.

1980

For the Metropolitan Opera, New York, he designs sets and costumes for the triple bill of Eric Satie's *Parade*, Francis Poulenc's *Les Marmelles de Tirésias* and Maurice Ravel's *L'Enfant et les sortilèges*; first night is 20 March the following year.

1981

Four paintings by him – *Canyon Painting*, *Nichols Canyon*, *Divine* and *Mulholland Drive: The Road to the Studio* – are shown in the exhibition 'A New Spirit in Painting' at the Royal Academy of Arts, London.
In May, travels to China with Stephen Spender.
Publication of the first monograph on Hockney, by Marco Livingstone.

Hockney presenting his book *Cameraworks* at the Limelight club, New York, in 1984

1982

Preoccupied with photography. Produces his first Polaroid montages, which are exhibited in Paris together with some earlier photographs. Afterwards, he works on photo-collages, producing a great many between now and May of the following year.
Lives with Ian Falconer.

1983

The Walker Art Center in Minneapolis organizes a major exhibition, 'Hockney Paints the Stage', which is shown there and at other venues in North America, in Mexico and in London, where it closes in 1985.

Ian Falconer and Hockney, Los Angeles, c. 1982

1984

After a break of almost four years, begins painting intensively again.
In the summer, starts work on a series of lithographs in Ken Tyler's workshop.

1985

Produces more lithographs, some in very large formats, that are shown in the exhibition 'Wider Perspectives are Needed Now' at Kasmin's gallery, London, in the summer.
Designs the cover and forty-one pages of the December 1985/January 1986 issue of French *Vogue*.

1986

Using a colour photocopying machine, he produces the 'Home Made Prints'.
In the autumn, begins work on sets and costumes for a production of Richard Wagner's *Tristan und Isolde* at the Los Angeles Music Center Opera, which has its first performance in December of the following year.

1987

In addition to his work on *Tristan und Isolde*, he designs the Waltz Pavilion for André Heller's Luna-Luna Park in Hamburg.

1988

Major retrospective of his work opens in February at the Los Angeles County Museum of Art; it is subsequently shown at the Metropolitan Museum of Art, New York, and the Tate Gallery, London, where

paintings produced since the Los Angeles showing are included.
Publication of *Hockney on Photography*.
Acquires a house next to the sea at Malibu, in which he sets up a small studio. Produces a series of small-format portraits and, in October, his first works using a fax machine.

1989

Shows fax works at the Biennale in São Paulo and at various other venues the world over, including Mexico City (1990).
Visits Alaska with Henry Geldzahler.
Produces his first computer drawings.

1990

In the autumn, begins work on sets for Giacomo Puccini's *Turandot*; the costumes are designed by Ian Falconer. First performance takes place at the Chicago Lyric Opera in January 1992.

Hockney painting a portrait of Billy Wilder (subsequently destroyed by the artist) at his Malibu studio, 1989

1991

Paints intensively.
In the autumn, starts designing sets for a production of Richard Strauss's *Die Frau ohne Schatten* at the Royal Opera House, Covent Garden, in London; Falconer is again responsible for the costumes. First performance takes place in November of the following year.

1992

In May, begins the series 'Some Very New Paintings', initially produced in his Malibu studio, later in the larger one in the Hollywood Hills.

1993

Publication of a second autobiographical volume, *That's the way I see it*.
A period of intense drawing activity – especially portraits and collages, developed from doodles – begins at the end of the year.

1994

Adapts his *Die Frau ohne Schatten* sets for a production of the opera at Houston, Texas, and oversees the revival of *The Rake's Progress* at Glyndebourne.
Produces an extensive series of gouaches and portrait drawings, which are shown at the 1853 Gallery, Saltaire, in the summer.

Hockney working in his Los Angeles studio on the scale model of his set for the final scene of Puccini's *Turandot*, 1990

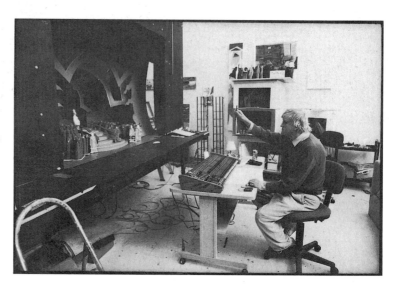

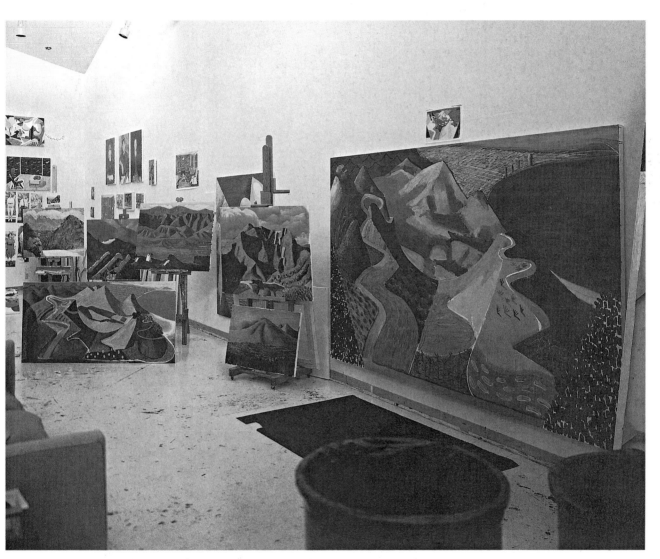

Hockney's Los Angeles studio, 1990. *Pacific Coast Highway and Santa Monica* (plate 60) is on the right.

Selected Bibliography

David Hockney: A Retrospective, published in 1988 by the Los Angeles County Museum of Art (see below), contains an extensive bibliography on the artist. The present bibliography is limited to providing references for passages quoted in the text and to a selection of works written since 1988.

Publications by the Artist

David Hockney by David Hockney: My Early Years. Ed. Nikos Stangos, intro. Henry Geldzahler. London, 1976; New York, 1977. First part of the artist's autobiography.

The Blue Guitar [etchings]: *The Man with the Blue Guitar* [poem by] *Wallace Stevens*. London and New York: Petersberg Press, 1977. Limited edn. portfolio of the etchings also publ. October 1977.

David Hockney: Paper Pools. Ed. Nikos Stangos. London and New York, 1980.

On Photography: A Lecture at the Victoria and Albert Museum, November 1983. New York, 1983; repr. Bradford, 1985.

'Vogue par David Hockney'. *Vogue* (Paris), no. 662 (December 1985 / January 1986), cover and pp. 219-59.

Hockney on Photography: Conversations with Paul Joyce. London, 1988.

Picasso. Madras and New York, 1990.

That's the way I see it. Ed. Nikos Stangos. London, 1993. Second part of the artist's autobiography.

'Which Way is Reverse?' *Engineering and Science* 57, no. 2 (Winter 1994), pp. 23-30. Transcript of the Second Annual James Michelin Distinguished Visitor Lecture.

Books and Articles

Benecke, Clarissa-Diana. 'Schrift und Sprache in David Hockneys Frühwerk 1960-1963'. Unpubl. MA thesis, Ludwig-Maximilians-Universität, Munich, 1989.

Brett, Guy. 'David Hockney: A Note in Progress'. *London Magazine* 3 (April 1963), pp. 73-5.

Fuller, Peter. 'An Interview with David Hockney'. *Art Monthly*, no. 12 (November 1977), pp. 4-6, 8 f.; no. 13 (December 1977 / January 1978), pp. 5-8, 10. Repr. in *idem, Beyond the Crisis in Art* (London, 1980), pp. 168-89.

Fuss, Daniela. 'David Hockney: Reflexionen über Kunst und Realität'. Unpubl. MA thesis, Ludwig-Maximilians-Universität, Munich, 1989.

Geldzahler, Henry. 'Hockney Abroad: A Slide Show'. *Art in America* 69 (February 1981), pp. 126-41.

Ingham, Charles. 'Words and Pictures'. Unpubl. M. Phil. thesis, University of Essex, 1986.

'R. B. Kitaj and David Hockney in Conversation'. *New Review* 3 (January / February 1977), pp. 75-7.

Luz, Kathrin. 'David Hockney in der Tradition des Dandytums'. Unpubl. MA thesis, Cologne University, 1989.

Livingstone, Marco. *David Hockney*. London and New York, 1981; rev. edn., 1988.

Melia, Paul (ed.). *Critical Introductions to Art: David Hockney*. Essays by Nannette Aldred, Andrew Causey, Simon Faulkner, William Hardie, Paul Melia and Alan Woods. Manchester. [Forthcoming.]

Spalding, Julian. [Review of the artist's retrospective exhibition at the Tate Gallery, London.] *Burlington Magazine* (January 1989), pp. 51-3.

Webb, Peter. *A Portrait of David Hockney*. London and New York, 1988.

Weschler, Lawrence. *Cameraworks: David Hockney*. London and New York, 1984.

Exhibition Catalogues

Bradford, Cartwright Hall, organized by the South Bank Centre, London. *David Hockney: We Two Boys Together Clinging*. March / April 1993. Toured to Birmingham, Hull and Truro. Essay by Paul Melia.

Brussels, Palais des Beaux-Arts. *David Hockney*. June / July 1992. Toured to Barcelona and Madrid. Essay by Marco Livingstone.

Chicago, Richard Gray Gallery. *David Hockney: Recent Pictures*. January / February 1992.

Frankfurt am Main, Galerie Neuendorf. *David Hockney: Neue Bilder / Recent Paintings*. May / June 1989. Interview with, and text by, the artist.

Glasgow, William Hardie Gallery. *David Hockney: Some Very New Paintings*. June - August 1993. Intro. William Hardie, interview with the artist.

Hamburg, Hamburger Kunsthalle. *'Doll Boy' von David Hockney*. November 1991 - January 1992. Essay by Ulrich Luckhardt.

London, National Gallery. *David Hockney: Looking at Pictures in a Book*. July / August 1981. Essay by the artist.

London, Whitechapel Art Gallery. *The New Generation: 1964*. March - May 1964. Intro. David Thompson.

London, Whitechapel Gallery. *David Hockney: Paintings, Prints and Drawings 1960-1970*. April / May 1970. Toured to Hanover, Rotterdam and Belgrade. Intro. Mark Glazebrook, interview with the artist. Rev. edn., London, 1970.

Los Angeles County Museum of Art. *David Hockney: A Retrospective*. February - April 1988. Toured to New York and London. Preface by R. B. Kitaj, essays by Henry Geldzahler, Anne Hoy, Christopher Knight, Gert Schiff, Kenneth E. Silver and Lawrence Weschler.

Los Angeles, Layband Art Gallery. *David Hockney: Faces 1966-1984*. January - March 1987. Cat. designed by the artist, essay and commentaries by Marco Livingstone.

Mexico City, Centro Cultural Arte Contemporaneo, A. C. *David Hockney: Fax Dibujos*. October 1990 - January 1991. Intro. the artist.

Minneapolis, Walker Art Center. *Hockney Paints the Stage.* November 1983 - January 1984. Toured to Mexico City, Toronto, Chicago, Fort Worth, San Francisco and London. Intro. Martin Friedman, contributions by the artist, John Cox, John Dexter and Stephen Spender.

Rotterdam, Museum Boymans-van Beuningen. *David Hockney Prints.* July - October 1993. Intro. and cat. notes by Manfred Sellink.

Saltaire, Salts Mill, 1853 Gallery. *David Hockney: Some Drawings of Family, Friends and Best Friends 1993-1994.* July - September 1994. Intro. the artist and Jonathan Silver.

Tokyo, Bunkamura Museum of Art. *Hockney's Opera.* June / July 1992. Toured to Sapporo, Nagoya, Kobe, Hiroshima and Mito. Essays by Shin'ichiro Osakai, Stephen Spender, Hideo Takahashi and Kazuo Yamawaki.

Tokyo, Nishimura Gallery. *David Hockney: Paintings.* October / November 1989.

Tokyo, Nishimura Gallery. *David Hockney: New Paintings & Still Video Portraits.* June / July 1992.

Tokyo, Odakyu Grand Gallery. *David Hockney.* April / May 1989. Toured to Gunma, Chiba and Osaka. Essay by Marco Livingstone.

Tokyo, Takashimaya Art Gallery. *Hockney in California.* April / May 1994. Toured to Kagawa, Fukushima and Chiba. Intro. and cat. notes by Marco Livingstone, essay by Masao Kobayasha.

Venice, California, L. A. Louver Gallery. *David Hockney: Home Made Prints.* December 1986 / January 1987. Shown concurrently at André Emmerich Gallery, New York; Knoedler Gallery, London; and Nishimura Gallery, Tokyo. Note on technique by the artist.

Venice, California, L. A. Louver Gallery. *David Hockney: Some New Pictures.* December 1989 / January 1990. Toured to Honolulu. Foreword by Peter Goulds.

Index of Works by Hockney

Numerals in **bold type** refer to pages with illustrations

Photographic Acknowledgments

Photographs were provided by the David Hockney Studio, Los Angeles, by the individuals and institutions named in the captions or by the authors. Additional credits are as follows:

Courtesy Marisa del Re Gallery, New York: p. 31 · Courtesy André Emmerich Gallery, New York: p. 194 (top) · Gregory Evans: p. 195 (centre) · Studio Grünke, Hamburg: p. 18 · © Basil Langton/Photo Researchers: p. 193 (bottom) · Leinster Fine Art, London; courtesy Ketterer Kunst AG, Munich: p. 13 (top) · Jim McHugh, Los Angeles: p. 196 (bottom) · Patrick McMullan, New York: p. 195 (top) · Courtesy Stephen Mazoh & Co., Inc., New York: p. 52 (left) · © William Nettles Photography: p. 22 (left) · Steve Oliver: pp. 121 (top), 178, 185 · Geoffrey Reeve: p. 197 (bottom) · Richard Schmidt/Photographics, Los Angeles: pp. 166, 167, 182, 187, 188, 190, 197 · Elke Walford, Hamburg: pp. 19, 23, 47, 77, 79 · © 1994 Ray Charles White, New York: p. 196 (top) · Graham Wood/The Times, London: frontispiece